Perspective and Sketching for Designers

Jessica Newman

Jack Beduhn, FIDSA

Boston Columbus Indianapolis New York San Francisco Upper Saddle River
Amsterdam Cape Town Dubai London Madrid Milan Munich Paris Montreal Toronto
Delhi Mexico City São Paulo Sydney Hong Kong Seoul Singapore Taipei Tokyo

Editorial Director: Vernon R. Anthony
Acquisitions Editor: Sara Eilert
Editorial Assistant: Doug Greive
Director of Marketing: David Gesell
Executive Marketing Manager: Harper Coles
Senior Marketing Coordinator: Alicia Wozniak
Marketing Assistant: Crystal Gonzales
Associate Managing Editor: Alexandrina Benedicto Wolf
Project Manager: Alicia Ritchey
Operations Specialist: Deidra Skahill
Cover Designer: Suzanne Duda

Cover Art: Jessica Newman
Back Cover Art: Kara Krukowski, Leslie Stephen, Gloria Paulsen
Lead Media Project Manager: Karen Bretz
Full-Service Project Management: Michael B. Kopf, S4Carlisle Publishing Services
Composition: S4Carlisle Publishing Services
Printer/Binder: Banta dba RRD – Menasha
Cover Printer: Lehigh-Phoenix Color
Text Font: 9/13, Frutiger LT Std 45 Light

Credits and acknowledgments borrowed from other sources and reproduced, with permission, in this textbook appear on appropriate page within text.

Library of Congress Cataloging-in-Publication Data

Newman, Jessica.
 Perspective and sketching for designers / Jessica Newman, ASID, Jack Beduhn, FIDSA. — First edition.
 pages cm
 ISBN-13: 978-0-13-257494-5—ISBN-10: 0-13-257494-2 1. Perspective. 2. Drawing—Technique.
I. Beduhn, Jack. II. Title.
 NC750.N49 2012
 742—dc23

 2012001186

10 9 8 7 6 5 4 3 2 1

ISBN 10: 0-13-257494-2
ISBN 13: 978-0-13-257494-5

CONTENTS

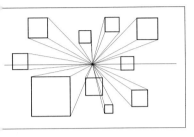
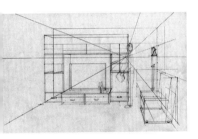
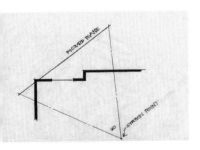

LESSON 4

Two-Point Perspective Proportioning Methodologies 59

LESSON 5

Use of a Measuring Line to Proportion a Two-Point Perspective 81

LESSON 6

Perceived Scale and Multiple Vanishing Points 106

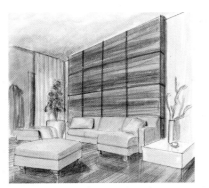

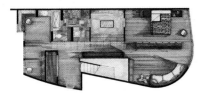

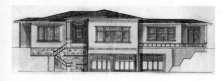
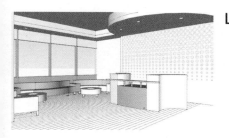

Proportion, Perspective, and Sketching

About This Book

We have been teaching perspective and drawing courses at the Art Institute of California-San Diego for over 5 years. During this time we have not been able to find the right textbook for the classes we teach. Our ineffective search is the driving force behind this book. Problems with books we've considered include:

- Many are beautiful books filled with professional renderings and verbose text leading you through techniques used by the artist. The problem with these books is that the techniques are so advanced that most beginning students cannot re-create the effects.

- Other books focus only on the technical aspects of perspective drawing, requiring the use of drafting tools and complex methodologies. These books give the reader an understanding of perspective geometry but do not develop the quick sketch skills we believe are required for professional success. Drawings created using these techniques are often rigid in character and time consuming to create. The techniques are difficult, if not impossible, to use for creative ideation.

- Many of the books we looked at are too broad in focus. The books devote too much instruction to advanced techniques not required for entry-level employment in many of the design professions. These techniques include plotting complex shadows and reflections, three-point perspective geometry, and complex surface development.

- We did not find perspective books that use student work as the primary means to measure progress.

This book includes sections of the rigid perspective methodology that we disliked in some of the books just summarized, but they are kept to a minimum and presented in an easy-to-understand format. We describe many shortcuts and simplified drawing techniques that are important for beginners. Your skill will progress and you will develop a keen sense of scale and proportion as you complete the lessons in this book. As you progress, you will find that your drawings will depend more and more on your eye as the primary tool used in creating effective and believable perspective drawings. All lessons are backed up with examples of student work. Most lessons include video demonstrations for visual learners.

Sketch Intro. 1.1 is a typical starting point for students before taking our drawing classes. We ask beginning students to create a two-point perspective drawing with a reception desk in the corner of a room with windows behind the desk. The students are asked to complete the drawing, including grayscale marker rendering, in an hour. They are not given floor plans or any reference drawings.

Sketches Intro.1.2 through Intro.1.7 are examples of perspective drawings done by students who have partially or fully completed instruction as presented in this book. We believe these drawing reflect industry expectations for students seeking the best entry-level jobs in design.

If you follow the lessons and homework assignments in this book, your drawing skills should be comparable.

Perhaps even more important than the skills used to create the presentation drawings shown here is the skill to use perspective drawing as a design tool. We believe it is difficult, at best, to create design excellence with plan, elevation, and section drawings alone. We believe designers who use perspective as a design tool to quickly visualize and develop ideas are most often the designers with the best total design solution. It is, however, important for students and instructors using this book to understand that the focus of this book is proportion, perspective, and sketching. It is NOT a design book.

Any student who aspires to become a professional illustrator or architectural renderer must understand that it will require thousands of hours of work beyond this book to further develop the skills and techniques necessary for success. You will also be competing with computer artists who can produce photo-realistic renderings more quickly and cheaply.

Using This Book

This book is divided into lessons and each lesson is divided into sections. You will spend approximately 4 hours going over each lesson and approximately 4 hours on each lesson's homework assignment. Depending on your learning style, some lessons and homework may require more time, and some may require less.

You will need some drawing supplies to complete the lessons. Drawing supplies are expensive, and we try to give you options to save money whenever possible. Drawing supplies for the earlier lessons include:

- Paper. Your choice of paper is very important. There are many options, and different papers work for different artists, so it is imperative that you experiment to discover what works for you. We recommend you start the lessons with inexpensive trace paper and bond (copy) paper.

 The least expensive trace paper can be purchased in rolls. If you choose a roll, make sure it is white (not yellow) and at least 18 inches wide. Make sure it is trace paper, NOT vellum. An option many prefer is to purchase a pad of trace paper, even though it is slightly more expensive. You do not have to trim your drawings and the pad lies flat on the drawing surface. The main disadvantage to trace paper is that it is fragile and tears and wrinkles easily. Bond paper can be purchased in bulk in 11-by-17-inch sheets inexpensively.

 For the first few lessons, you may find that laying out drawings on bond paper is a good idea because the paper can handle erasing. As the drawing progresses, it will require overlays of trace paper, and the final drawing will be a line drawing on trace paper. Another option is to do the whole drawing on one piece of trace paper. This will result in a much looser, sketchy look, as all of your layout lines will be visible.

 Later in the course we will experiment with different kinds of paper, including marker paper, bond paper, and vellum. We will, at that time, discuss the strengths and weaknesses of each.

- Markers. Markers come in two basic categories—alcohol based and xylene based. Because xylene markers have been shown to have toxic fumes, there is only one brand still on the market (Chartpak® AD markers), and we do not recommend them. All other brands, including Prismacolor® and Copic®, are alcohol based. You cannot blend xylene and alcohol markers, but you can blend alcohol markers of different brands together. Xylene markers take longer to dry, which allows the artist more time to blend and work with the color.

We will be using only black and gray markers for the earlier lessons. Although it is nice to have every value of grayscale marker in your kit, you can get by with the purchase of every other one (gray 2, 4, 6, 8, and 10). The least expensive option, although it will somewhat limit you, is to purchase one black marker, one light gray (1 or 2), one medium gray (5 or 6), and one dark gray (9 or 10) for now.

Markers come in cool gray (slight blue cast), warm gray (slight brown cast) and French gray (neutral cast). Select the one you like the best, but do not mix them.

- Other supplies. You will need drafting dots or masking tape to tape your drawings to a work surface or overlay. You will need a large clear triangle (either a 45 or 30/60 works) and an architectural scale. Fine-line pens are also a requirement. We find that the Sharpie® brand with an extra-fine tip works well, although alcohol markers will cause the Sharpie lines to bleed. They can be purchased in a box of 12 for less than $10. Uni-ball® fade- and water-resistant fine-line pens (0.5 mm) are slightly more expensive and do not bleed. A 36" steel rule will come in handy but is not required.

 It is important to have a drawing surface with appropriate lighting. A drafting table is a nice option, and tables can be purchased in a wide range of prices. Stick to something in the low-cost range or use a flat-surface table that can take some marker abuse. We suggest that you do not use a T-square or parallel rule when laying out your drawings. They will, more often than not, make your drawings look much too technical and slow you down. The finished drawing should have an artistic flair, so that the viewer can tell a human being and not a computer created it.

A Word about Drawing Style

You will develop a unique look to your drawings as you complete the lessons in this book and become comfortable with the techniques. It seems, however, results can be grouped into two different drawing styles:

- A loose and sketchy style is exemplified by the student drawing in Sketch Intro.1.8, and is usually drawn on one piece of paper with construction lines visible. This style of drawing is fast and preferred by many designers. It is a perspective technique that is used as a design tool because the designer is not constrained by perfection.

- A tighter, more constrained style (Sketch Intro.1.9) is usually laid out on one piece of paper, then traced for final rendering on another piece of paper with no visible construction lines. This style is preferred by many, but is generally more time consuming to complete and often more detailed. This type of drawing does not lend itself to sketch ideation and is often drawn for presentation after the design is complete.

The sketches in Sketch Intro.1.8 and 1.9 were both drawn by students for Lesson 3 homework. No matter which style you prefer, your drawing ability will improve as you progress through this book. Save your drawings from the early lessons and compare them to the drawings you are creating in Lessons 8, 9, and 10. We are confident you will be pleased with your skill-level improvements and even more pleased after completing the remainder of the lessons. This book is meant to be hard work, but rewarding.

We introduce ourselves and a little more about this book in the Introduction video.

—Jessica Newman and Jack Beduhn, FIDSA

Download Instructor Resources from the Instructor Resource Center

To access supplementary materials online, instructors need to request an instructor access code. Go to www.pearsonhighered.com/irc to register for an instructor access code. Within 48 hours of registering, you will receive a confirming e-mail including an instructor access code. Once you have received your code, locate your text in the online catalog and click on the Instructor Resources button on the left side of the catalog product page. Select a supplement, and a login page will appear. Once you have logged in, you can access instructor material for all Prentice Hall textbooks. If you have any difficulties accessing the site or downloading a supplement, please contact Customer Service at http://247pearsoned.custhelp.com/.

MyInteriorDesignKit for Perspective and Sketching for Designers

MyInteriorDesignKit is a resource site containing tutorial videos to accompany each lesson in the text as well as additional student and instructor resources. Student can purchase access to MyInteriorDesignKit directly at www.myinteriordesignkit.com with a credit card, or they can purchase an access card bundled with their textbook. To request this package ISBN, please visit www.pearsonhighered.com or contact your local Pearson Rep: http://www.pearsonhighered.com/educator/replocator/. Student may also purchase an e-text upgrade directly through MyInteriorDesignKit.

Instructor Resources:

All instructor resources can be downloaded from the Pearson Instructor Resources Website at www.pearsonhighered.com/irc.

Perspective Basics

Lesson Overview

Lesson 1 is written in two sections:

- Lesson 1, Section 1 will review the basics of one-point perspective.
- Lesson 1, Section 2 will review the basics of two-point perspective.

Some students reading this book have experience with perspective drawing and use of markers. For those students, we recommend reading Lesson 1 for a review of perspective basics and understanding of the importance of creating depth, dimension, and form with markers.

For those students who have little or no experience with perspective and/or markers, it is recommended they concurrently read and sketch each step of the process outlined in Sections 1 and 2. The sketching is best done on trace paper with use of a pencil or fine-line pen and a clear 45- or 30/60-degree triangle. Do not use an architectural scale or ruler; rather, estimate proportion and scale. As you will see in the following lessons, the ability to estimate scale and proportion is critical in developing your perspective drawing skills.

Repeat the two sections of Lesson 1 until you are comfortable sketching and estimating one-point perspective and two-point perspective cubes in space.

PERSPECTIVE REVIEW—OPTIONAL READING

Lesson 1 Section 1

One-Point Perspective Basics

BACKGROUND—FIGURE 1.1.1

Your ability to estimate the proportions of a cube in perspective is an important skill to develop. This will become evident in future lessons.

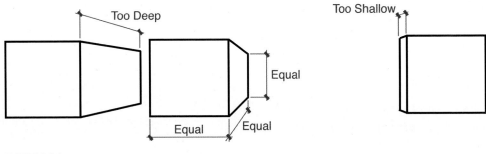

FIGURE 1.1.1

HORIZON LINE—FIGURE 1.1.2

For our first drawing, we will use trace paper and a pencil or fine-line pen to draw 10 cubes in one-point perspective with the height, width, and depth all appearing equal. Begin every perspective drawing with a horizon line. The horizon line is your eye level in the drawing, and should be a line approximately in the middle of your page.

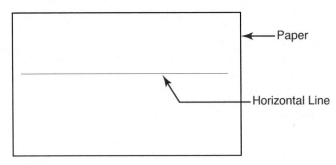

FIGURE 1.1.2

VANISHING POINT—FIGURE 1.1.3

The vanishing point can be placed anywhere on the horizon. For now, we will place it approximately in the center of the page.

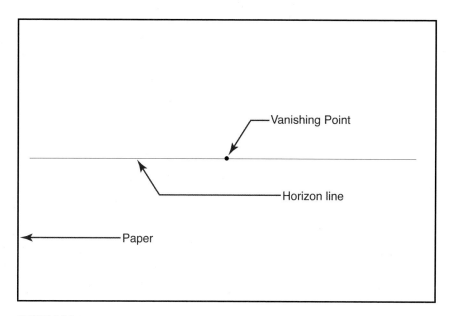

FIGURE 1.1.3

SQUARES—FIGURE 1.1.4

Draw 10 squares on the sheet of trace paper. Make the squares different sizes, but the width and height of each must look equal. Do not use an architectural scale or ruler to determine width and height. Use your eye to estimate size and proportion. Draw some squares above the horizon line, some below, and some on the horizon line.

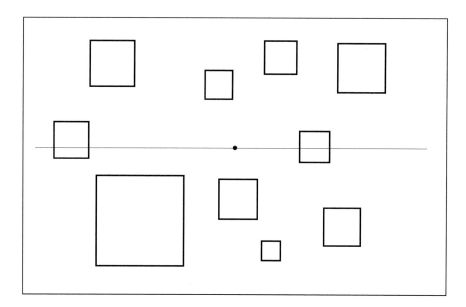

FIGURE 1.1.4

USING THE VANISHING POINT—FIGURE 1.1.5

With the squares complete, use a straight edge and draw a lightweight line from each corner of each square to the vanishing point.

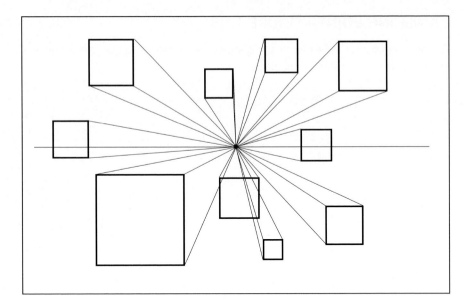

FIGURE 1.1.5

CUBES—FIGURE 1.1.6

Use your sense of scale and proportion to crop the diagonal lines where the cubes look equal in all three dimensions. Increase the line weight of each cube so that the diagonal guidelines are less noticeable.

For the next step, we will begin to give some dimension and interest to the drawing. You will need a light grayscale marker (gray 1 or 2), a medium grayscale marker (gray 5 or 6), and a dark grayscale marker (gray 9 or 10). The first rule of working with value is that everything has a light side (the side of the object receiving the most direct light), a dark side (the side of the object in shadow), and a medium side (the side of the object receiving reflected or indirect light).

Observe objects around you and notice the differences in value on each side of an object.

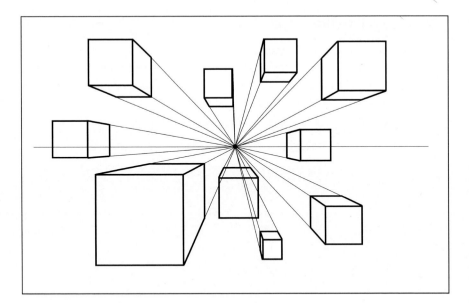

FIGURE 1.1.6

LIGHTEST VALUE—FIGURE 1.1.7

In perspective drawings, we are trying to create the illusion of space (3-D) on a piece of paper (2-D). One way to do this is to make objects closer to the viewer lighter in value, and objects further away darker in value. Although this may not always be true in real life, in the picture plane (your paper), dark objects recede into the background, and light objects come forward. It is one of the tricks we will use to create a sense of depth. There are many more tricks you will learn as the lessons progress, but for now remember: LIGHTER CLOSER TO YOU, DARKER FURTHER AWAY.

To begin shading this drawing, apply color to the front of each cube with the lightest grayscale marker, as this is the surface of the cube that we want to come forward.

Loosen up with the marker application. Do not be overly concerned with staying within the lines; this is not a coloring book exercise.

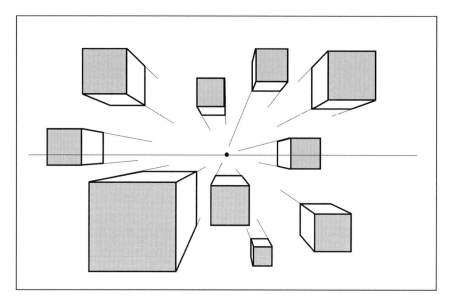

FIGURE 1.1.7

MEDIUM VALUE—FIGURE 1.1.8

Use the medium grayscale marker for the top or bottom of each cube, whichever is visible. Again, be quick and loose with the marker application.

NOTE
Marker on trace paper will never be perfectly uniform, so don't try to smooth it out or worry about inconsistency of application.

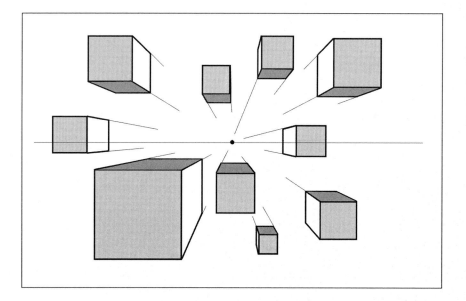

FIGURE 1.1.8

DARKEST VALUE—FIGURE 1.1.9

Use the darkest grayscale marker to color the remaining sides.

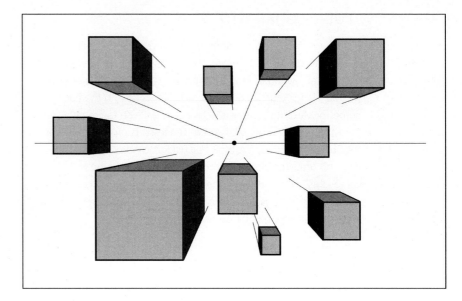

FIGURE 1.1.9

EXPERIMENT—FIGURE 1.1.10

Experiment with your markers. For example, make some of the cubes hollow so that you can see the interior.

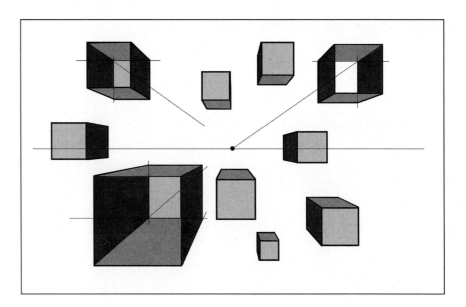

FIGURE 1.1.10

PERSPECTIVE REVIEW—OPTIONAL READING

Lesson 1 Section 2
Two-Point Perspective Basics

BACKGROUND—FIGURES 1.2.1–1.2.2

Two-point perspective (Figure 1.2.1) is similar to one-point perspective (Figure 1.2.2) in that they both show depth and scale. Two-point perspective is the type of perspective drawing that we use the most in design. It is visually more interesting, and tends to look more realistic than one-point perspective. Student sketches (Figures 1.2.1–1.2.2) are from lessons covered later in the book.

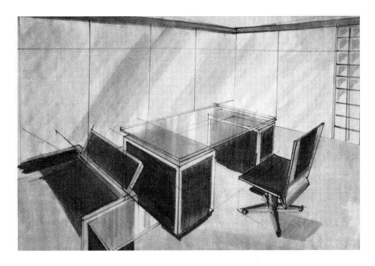

FIGURE 1.2.1

FIGURE 1.2.2

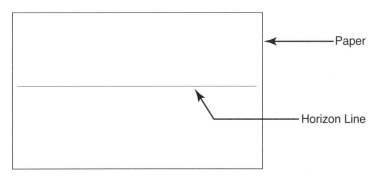

FIGURE 1.2.3

HORIZON LINE—FIGURE 1.2.3

For our first drawing, we will use trace paper and a pencil or fine-line pen to draw 10 cubes in two-point perspective, with the height, width, and depth of each all appearing equal. Begin every perspective drawing with a horizon line. The horizon line is your eye level in the drawing, and should be a line approximately in the middle of your page.

VANISHING POINTS—FIGURE 1.2.4

Vanishing points can go anywhere on the horizon line. However, the further apart they are from each other, the less distorted your drawing will look. It is typically safe to put one vanishing point on each end of your horizon line. We will discuss more about vanishing point locations in future lessons.

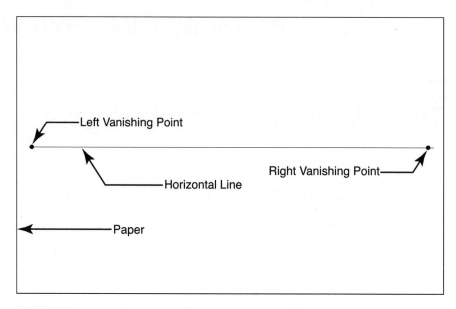

FIGURE 1.2.4

FRONT EDGE OF CUBES—FIGURE 1.2.5

Draw 10 vertical lines on the page. Draw some lines above the horizon line, some lines below the horizon line, and some on the horizon line.

NOTE
In a two-point perspective, there is always one vertical line that can be scaled. It is a true measure or measuring line. We will discuss measuring lines in future lessons.

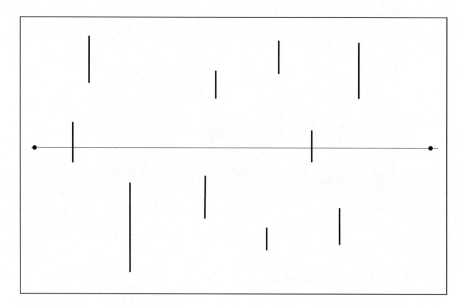

FIGURE 1.2.5

LINES TO THE VANISHING POINTS—FIGURE 1.2.6

Using a straight edge or triangle, draw guidelines from the top and bottom of each line to the left vanishing point.

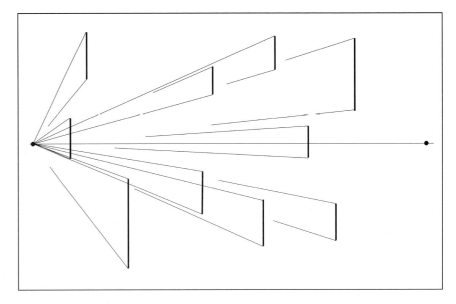

FIGURE 1.2.6

LINES TO THE VANISHING POINTS—FIGURE 1.2.7

Using a straight edge or triangle, draw guidelines from the top and bottom of each line to the right vanishing point.

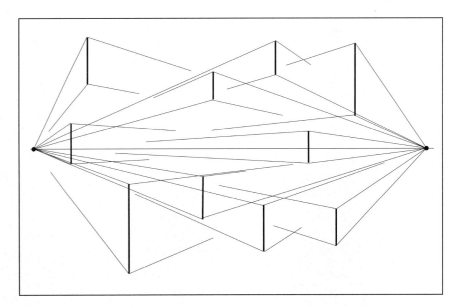

FIGURE 1.2.7

CUBES—FIGURE 1.2.8

Use your sense of scale to crop the diagonal lines at a spot where the cubes look equal in all three dimensions.

Finish off the cubes by completing the tops and bottoms that are missing.

Increase the line weights of the cubes so that the diagonal guidelines are less noticeable.

Let's begin using markers to give some dimension and interest to the drawing, as we did in Section 1. You will need a light marker (gray 1 or 2), a medium marker (gray 5 or 6), and a dark marker (gray 9 or 10).

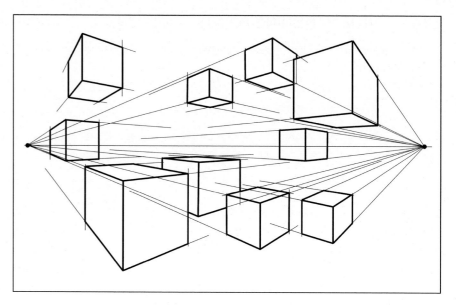

FIGURE 1.2.8

MARKERS, LIGHTEST VALUE—FIGURE 1.2.9

In Section 1 we learned a trick for making your drawing look three-dimensional: LIGHTER CLOSER TO YOU, DARKER FURTHER AWAY.

Use the lightest grayscale marker to add color to the plane of each cube that is closest to you and receives the most light. In this drawing, looking at the cubes, the closest part of the cube is the front corner, in which case you should choose one side to be the lightest gray. In Figure 1.2.9, imagine the light is coming from a source front center of the cubes.

NOTE
If the light source were coming from right of the cubes, then the right side of each cube would be the lightest gray. If the light source were coming from the cubes' left, then the left side of the cubes would be the lightest gray.

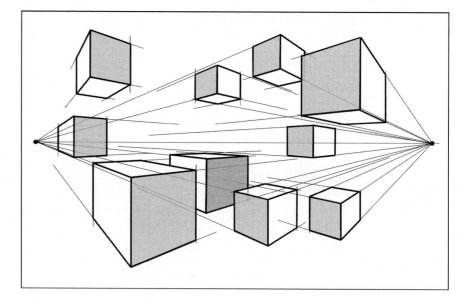

FIGURE 1.2.9

MARKERS, DARKEST VALUE—FIGURE 1.2.10

Use the darkest value for the top or bottom surface (whichever is visible). Be loose with the marker application and don't worry about staying in the lines or applying an even coat of gray.

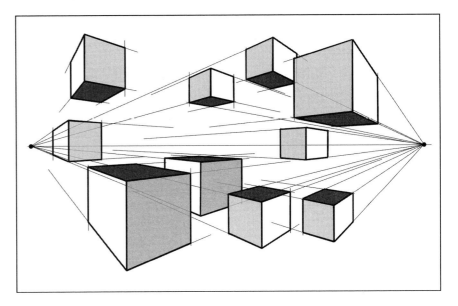

FIGURE 1.2.10

MARKERS, MEDIUM VALUE—FIGURE 1.2.11

Use the medium marker on the remaining sides.

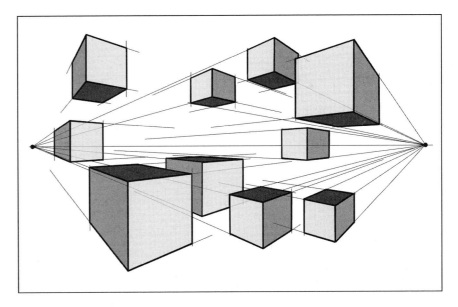

FIGURE 1.2.11

EXPERIMENT—FIGURE 1.2.12

Now that you've finished the cube exercise, on a separate piece of trace paper, practice combining cubes of different sizes and showing the cube interiors. Begin your drawing with a horizon line and vanishing points and add cubes either freehand or with the help of a triangle. Add grayscale marker to communicate interest, a sense of depth, and form.

Don't just copy Figure 1.2.12; rather, be creative and experiment. When you are comfortable with the skills learned in Lesson 1, move on to Lesson 2.

Lesson 1 skills are the important first step in developing the more advanced techniques used to create the sketches in Figures 1.2.13 through 1.2.15.

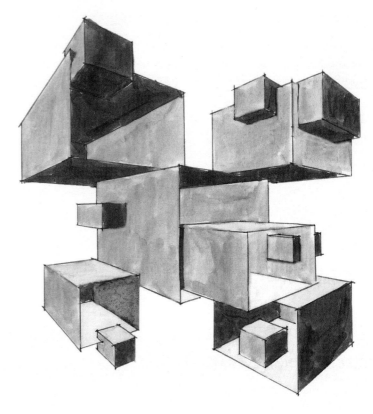

FIGURE 1.2.12

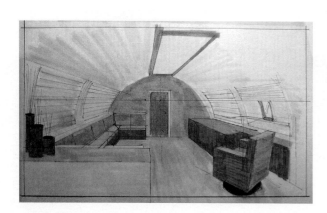

FIGURE 1.2.13

FIGURE 1.2.14

FIGURE 1.2.15

One-Point Perspective

Lesson Overview

Lesson 2 is written in five sections. Sections 1 through 3 will progress from a left-brain, process-orientated, projection methodology to a right-brain, more creative implementation of a one-point perspective drawing.

- Lesson 2, Section 1 reviews the plan projection method to create an accurate one-point perspective drawing.
- Lesson 2, Section 2 simplifies the methodology of creating an accurate one-point perspective drawing.
- Lesson 2, Section 3 further simplifies methodology and begins to develop a sense of scale and proportion necessary to create a believable, presentation-quality one-point perspective drawing.
- Lesson 2, Section 4 is a homework exercise.
- Lesson 2, Section 5 includes samples of student work with instructor comments.

It is recommended that the student follow each lesson by both reading and sketching each step of the processes outlined in Sections 1, 2, and 3. The sketching is best done freehand by estimating proportion and scale. The homework assignment in Section 4 will require a more precise layout drawing.

It is possible to skip Sections 1 and 2, although it is not recommended. These sections provide a clear understanding of perspective, including geometry and process, and give the reader a good foundation for a more complete understanding of Section 3 and the following lessons in this book.

NOTE
Most design students are visual learners. MyKit instruction for this lesson includes:
- Section 3, Video 1 demonstrates the layout of an interior space drawn in one-point perspective.
- Section 3, Video 2 demonstrates marker-rendering techniques applied to the interior layout.

OPTIONAL READING

Lesson 2 Section 1
Creating a One-Point Perspective from Plan

BACKGROUND—FIGURE 2.1.1

The picture plane (PP) is an important concept in understanding perspective (Figure 2.1.1).

Imagine the PP is a glass window. You are standing in front of the window at a station point (SP) looking at an object on the other side of the window. In Figure 2.1.1 the object is an open box.

Your eye level is on the horizon line (HL). It is important to note that the horizon line is always at eye level. Stand outdoors where you can see the horizon. Note that the horizon line will remain relative to your eye level as you shift your position lower or higher.

Looking at the center of a window, you could draw, on the window, the object (or scene) you see on the other side. You would be drawing in perspective. Try standing in front of the window and imagine drawing the scene outside on the window. Visualize that you would be drawing in perspective.

NOTES
The following illustrations (Figures 2.1.2 through 2.1.8) depict the process of constructing an accurate one-point interior perspective by projecting a floor plan to the picture plane as viewed from a station point.

Due to the precision of this method, a triangle and T-square should be used to complete finished drawings. The student may, for better understanding, follow the text instruction by sketching each step freehand.

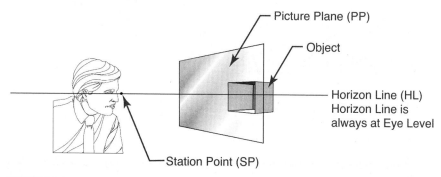

FIGURE 2.1.1

PICTURE PLANE—FIGURE 2.1.2

- Begin your perspective layout by creating a picture plane (PP), as shown in Figure 2.1.2. The picture plane is shown as a front elevation.

- Note: The picture plane rectangle is drawn to show concept only. One typically would not actually draw the picture plane. The picture plane is the paper you are using to construct a perspective.

- Project the picture plane up and draw a horizontal line (AB) representing the picture plane in top view.

- Project the picture plane to the left and draw a vertical line (CD) representing the picture plane in side view.

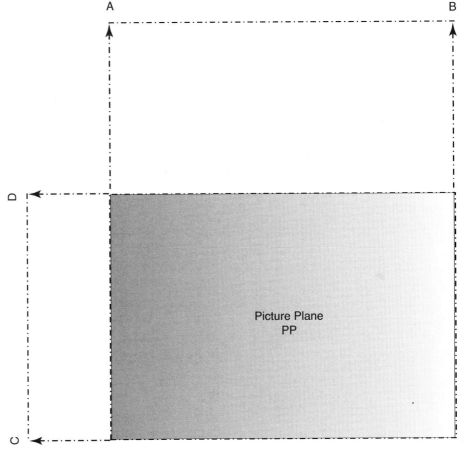

FIGURE 2.1.2

ORTHOGRAPHIC VIEWS—FIGURE 2.1.3

- Scale an 8'-0" × 8'-0" square (plan-view room) with the front edge on the top-view PP.

- Note: It is not necessary to draw wall thickness. Typical interior perspectives do not show wall thickness.

- Scale an 8'-0" line on the side-view PP elevation.

- Drop vertical guidelines (lines A and B) from the top-view PP to the front-view PP.

- Project horizontal guidelines (lines C and D) from the side-view PP to the front-view PP.

- Connect points AC, BC, BD, and AD. Increase the line weight of the resulting square. The square represents the front wall of the perspective we are drawing.

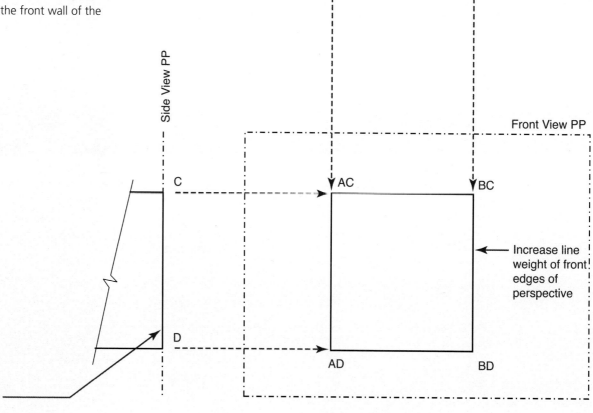

Note: It is unnecessary to draw the side elevation of the room. The front wall height as represented by line CD is adequate.

FIGURE 2.1.3

STATION POINT, HORIZON LINE, AND CENTRAL VANISHING POINT—FIGURE 2.1.4

- Draw a station point (SP) approximately room depth (8'-0") below the top-view PP.

NOTES
- Your final perspective drawing will usually look proportionally best if the SP is located approximately room depth below the front-view PP—too close and the perspective will look too deep; too far away, the perspective will look too shallow.

- The completed perspective drawing will be more interesting if the SP is located slightly to the left or right of the room's center. In Figure 2.1.4, the SP is located slightly to the right of center.

- From the SP, construct guidelines to the far corners of the plan-view room. Mark where guidelines cross the PP, points B and C.

- Draw a horizon line (HL) across the front view of the room.

- Note: Interior perspectives locate the HL at normal standing eye level, or between 5' and 6' above the floor. This measure is based on human anthropometrics.

- Drop a vertical line from the SP to the HL. Mark the intersection as the central vanishing point (CVP).

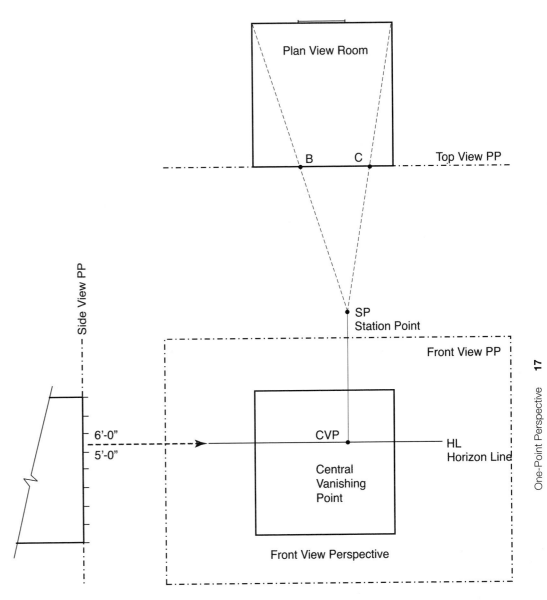

FIGURE 2.1.4

PROJECTING THE PERSPECTIVE—FIGURE 2.1.5

- Draw guidelines from corners E, F, G, and H on the front-view perspective to the CVP.

- Drop vertical lines from points B and C on the top-view picture plane to the front-view perspective. These lines will determine the depth of the room.

- We can now create a basic one-point perspective on the front-view PP.

- Make a square by connecting points where lines from E, F, G, and H intersect with lines from points B and C. This represents the back wall of the perspective.

- Increase the line weight of the perspective back wall.

- Increase the line weights from corners E, F, H, and G to the point where they intersect lines B and C. These lines represent the corners at the floor/walls and ceiling/walls.

- The one-point perspective of the 8'-0" × 8'-0" × 8'-0" room is now complete.

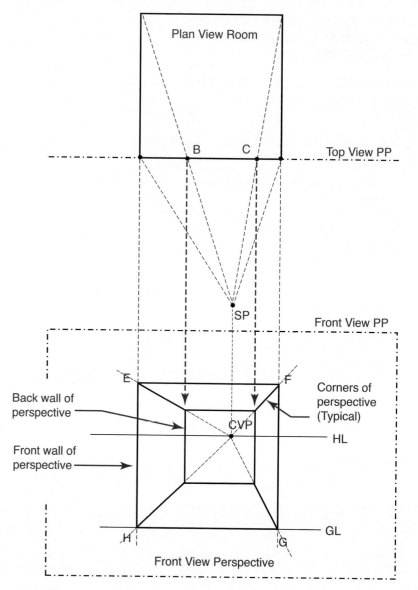

FIGURE 2.1.5

THE GRID—FIGURE 2.1.6

Many designers will place a grid on the completed perspective to facilitate placing objects in space. Objects might include architectural details, furniture, entourage, and so forth.

Use the following steps to construct a grid on the completed perspective:

- Using a scale, add 1'-0" tick marks as shown on the left wall of the plan-view room.
- Draw guidelines from the SP to the 2-ft., 4-ft., and 6-ft. scale measurements on the left side of the plan view.
- Mark where these guidelines cross the top-view PP.
- From the guideline and top-view PP intersection, drop vertical guidelines A, B, and C down to the front-view perspective.
- Draw fine vertical grid lines A, B, and C, connecting the floor and ceiling.
- Where lines A, B, and C touch the floor of the perspective, draw fine horizontal grid lines to the right wall.
- The grid lines could be carried to the ceiling and right wall, but most designers consider this unnecessary.
- Scale 1'0" tick marks horizontally on the floor and vertically up the left wall of the front-view perspective.

It should be noted that in a one-point perspective drawing, one set of horizontal and vertical lines can be used as true measures. Lines that are true measures are commonly called measuring lines. In Figure 2.1.6, the measuring lines are on the front wall of the perspective and are represented with horizontal and vertical tick marks.

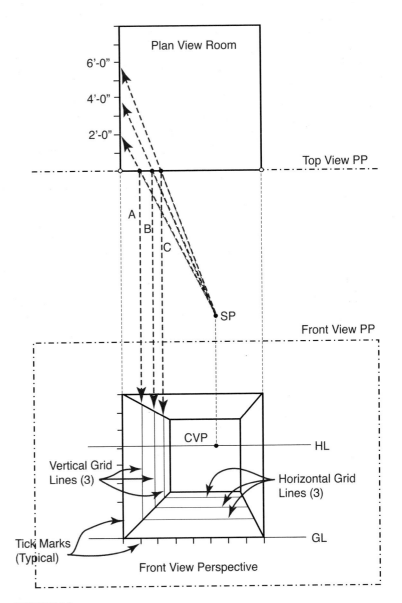

FIGURE 2.1.6

COMPLETING THE GRID—FIGURE 2.1.7

- Run guidelines from the 2-ft., 4-ft., and 6-ft. vertical and horizontal scale measurements on the front-view perspective to the CVP.

- Increase the line weight of the guidelines connecting the left front and rear wall.

- Increase the line weight of the grid lines connecting the front and rear of the room as indicated in Figure 2.1.7. The grid is now complete.

NOTE

Many designers prefer to make the grid on 1'-0" increments. The 2'-0" grid is shown for simplicity and illustration purposes.

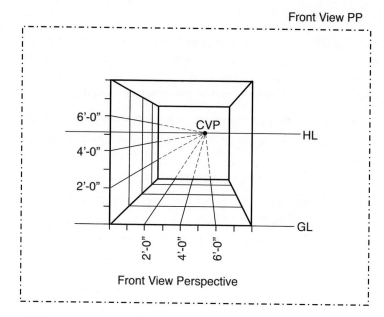

Front View PP

Front View Perspective

FIGURE 2.1.7

USING THE GRID—FIGURE 2.1.8

With the perspective and grid complete we can add furniture, objects, entourage, and even people to our drawing and keep them all in perspective and proportion.

To demonstrate how the grid is used, we will place a 2'-0" × 2'-0" × 2'-0" box 2 feet back from the front of the perspective, 4 feet from the left wall of the perspective, and 2 feet above the floor. Note: Each grid square in Figure 2.1.8 is 2 feet × 2 feet.

- Using the grid, draw a 2'-0" square (A) on the floor located 2 feet back from the front edge of the room and 4 feet to the right of the left wall.

- Using the grid, draw a 2'-0" square (B) on the left wall located 2 feet above the floor and 2 feet back from the front edge of the room.

- Project guidelines horizontally to the right from the square drawn on the left wall.

- Project guidelines vertically from the square drawn on the floor.

- Connect appropriate lines in space to complete the box floating in space (C).

With practice, one can use the grid to proportion complex objects in the perspective drawing. I'm sure the reader must be thinking by now, "there has to be an easier way," and there is.

Section 2, Creating a One-Point Perspective from a Diagonal, will take you through the process.

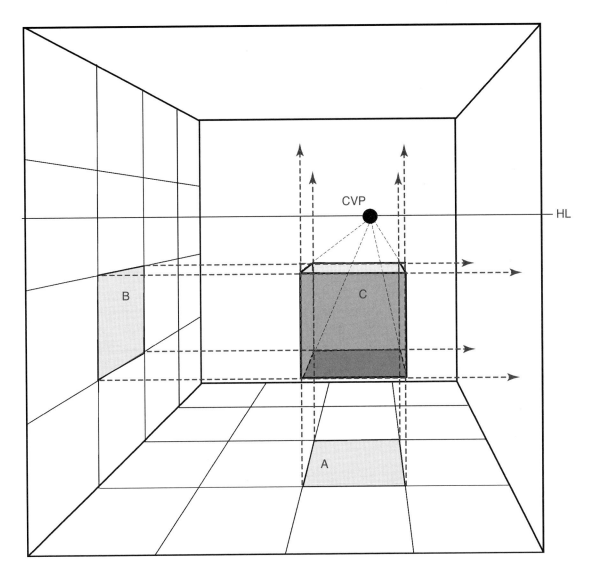

FIGURE 2.1.8

RECOMMENDED READING

Lesson 2 Section 2

Creating a One-Point Perspective from a Diagonal

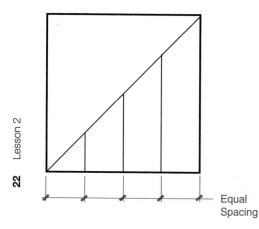

FIGURE 2.2.1

Equal Spacing

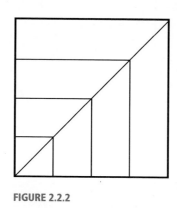

FIGURE 2.2.2

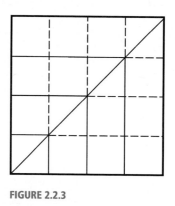

FIGURE 2.2.3

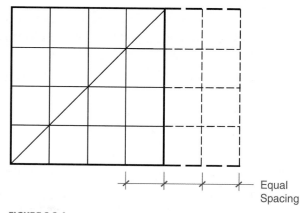

Equal Spacing

FIGURE 2.2.4

BACKGROUND—FIGURES 2.2.1–2.2.5

- In the plan view in Figure 2.2.1, a square is divided into four equal spaces along the base line. A diagonal is drawn from the upper-right to lower-left corner. Equally spaced lines are extended from the base to the diagonal.

- In the plan view in Figure 2.2.2, horizontal lines are drawn from the intersection of the vertical lines and the diagonal to the left side of the square. Note: The original square is divided into four smaller squares.

- In the plan view in Figure 2.2.3, the horizontal and vertical lines are extended (dotted lines) to create a 4'-0" × 4'-0" grid.

- In the plan view in Figure 2.2.4, the grid is extended horizontally using a scale and simple drafting tools.

- Note: A geometric process that works in plan view (Figures 2.2.1–2.2.4) will work in perspective (Figure 2.2.5).

- The diagonal line in the perspective drawing in Figure 2.2.5 intersects the corners of four 2'-0" × 2'-0" floor grids. The intersection is exactly the same as in the plan-view drawings, except it's in perspective.

- We will use the diagonal and a floor square to develop an accurate one-point perspective from start to finish in the following steps and Figures 2.2.6 through 2.2.10.

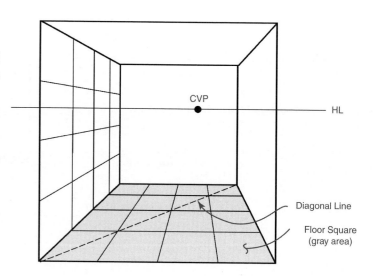

CVP

HL

Diagonal Line

Floor Square (gray area)

FIGURE 2.2.5

LAYING OUT A 14' W × 11' H × 10' D ONE-POINT PERSPECTIVE ROOM USING A SPECIAL VANISHING POINT AND A DIAGONAL—FIGURE 2.2.6

- Begin your drawing with a scaled rectangle 14'-0" W × 11'-0" H representing the width and height of the room.

- Mark off scaled 1'-0" tick marks along the floor line and left wall.

- Draw the horizon line (HL) between 5' and 6' above the floor. (Note: Interior perspectives locate the HL at normal standing height, between 5' and 6' above the ground. This measure is based on average human eye level.)

- Locate the central vanishing point (CVP) on the HL. Your drawing will be more interesting if the CVP is slightly off center. It's located to the right of center in Figure 2.2.6.

- Locate the special vanishing point (SVP) approximately room depth to the right of the CVP. (Note: If the SVP is located close to the CVP, the perspective room depth will look too deep. If it is located too far away, it will look too shallow.)

- Note: The process we are using to create this perspective will also work with the SVP located to the left of the CVP.

- Draw a diagonal guideline from the SVP to the far lower corner of the 14'-0" × 11'-0 wall.

- Draw a guideline from the CVP to the 10'-0" floor mark.

- The intersection of the two guidelines represents the 10'-0" room depth. This will become clear in Figure 2.2.7.

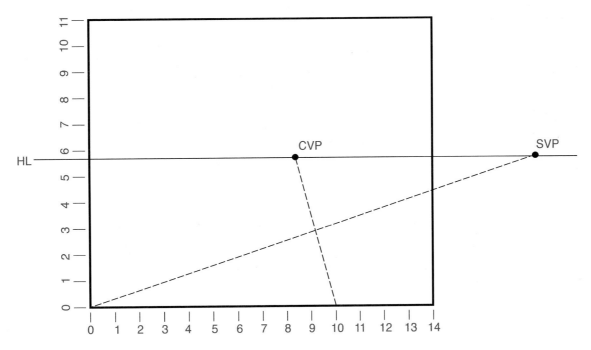

FIGURE 2.2.6

DETERMINING THE ROOM DEPTH WITH THE DIAGONAL OF A SQUARE; ADDING WALLS, FLOOR, AND CEILING—FIGURE 2.2.7

- Draw guidelines Aa, Bb, Cc, and Dd to the CVP.

- Draw guideline ab through point E.

- Draw guidelines bc, cd, and da, completing the rear wall of the one-point perspective.

- Increase the line weight of the above guidelines. Do not increase the line weight beyond the rear wall.

- The 14′ W × 11′ H × 10′ D one-point perspective room is now complete.

- The 10′-0″ × 10′-0″ perspective square on the floor (Aa, aE, Ee, and eA) with a diagonal connecting AE can now easily be seen. For illustration purposes, the square is shaded in gray.

- You can use an SVP and diagonal to proportion the room depth of any one-point perspective:

 - In Figure 2.2.7a, the room depth is drawn at 5′-0″. The intersection of the line from the CVP to the 5′ mark with the diagonal from the SVP determines the room depth. See the 5′ shaded floor square.

 - In Figure 2.2.7b, the room depth is drawn at 13′-0″. The intersection of the line from the CVP to the 13′ mark with the diagonal from the SVP determines the room depth. See the 13′ shaded floor square.

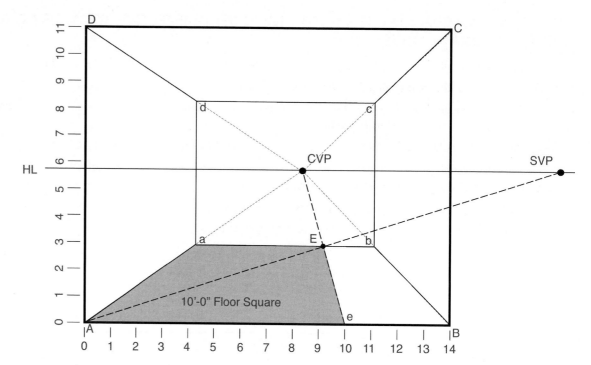

FIGURE 2.2.7

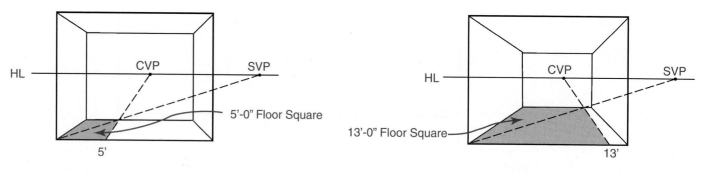

FIGURE 2.2.7a

FIGURE 2.2.7b

ADDING A FLOOR AND WALL GRID—FIGURE 2.2.8

- Draw lightweight lines from the vertical- and horizontal-scaled 1'-0" tick marks toward the CVP. Do not extend the guidelines past the rear wall.

- Draw horizontal lightweight lines through points A, B, C, D, E, F, G, H, and I. Each line spans the width between the left and right walls.

- On the left wall, draw vertical lightweight lines between the floor and ceiling. (Note: Start the lines at the termination of horizontal lines A, B, C, D, E, F, G, H, and I at the left wall.)

- Complete the grid lines on the floor and left wall.

- The grid lines are not complete in this drawing. See Figure 2.2.9 for completed grid lines and their use.

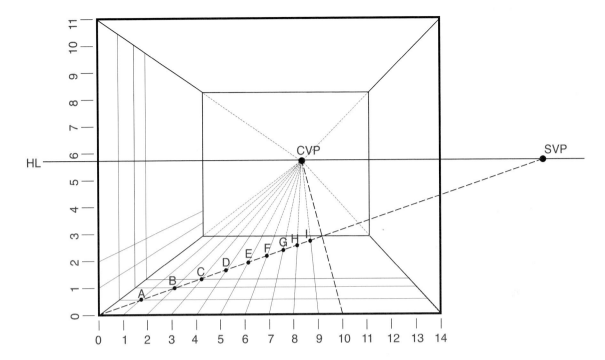

FIGURE 2.2.8

COMPLETING THE GRID AND ITS USE—
FIGURES 2.2.9–2.2.10

- The grid started in Figure 2.2.8 is shown completed in Figure 2.2.9.

- The grid could be continued to the rear wall, ceiling, and right wall. If a grid is used, most designers use only the floor and one wall to locate objects in space.

- Once the grid is complete, designers will often use a trace-paper overlay to lay out furniture, architectural details, and entourage.

- With a little practice, it is a relativity simple exercise to locate accurately scaled objects in space.

- As an example, the sofa drafted in Figure 2.2.10 is placed in the one-point perspective room, using the grid to facilitate the layout.

- Refer to Figure 2.1.8 in Lesson 2, Section 1 for a more complete grid use illustration.

For those of you who took the time to understand Section 1, I'm sure you agree that this is a simpler way to create an accurate one-point perspective drawing.

Although faster and easier, the problem with this methodology is:

- The drawing process is still too time consuming.

- Drawings need not be this accurate if they are well drawn and believable.

- Drawings created with an overreliance on the grid look forced, and less creative, than drawings generated using a more artistic, right-brain approach to drawing in perspective.

Section 3 begins to develop your sense of scale and proportion and an ability to efficiently create believable presentation-quality perspective drawings.

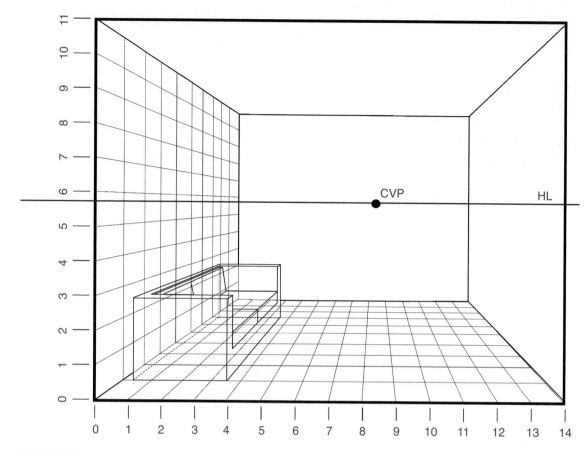

FIGURE 2.2.9

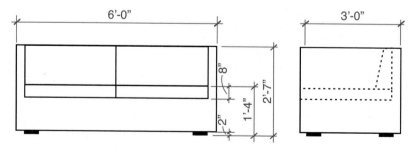

FIGURE 2.2.10

Lesson 2

26

OPTIONAL READING

WHY THE SVP AND DIAGONAL WORK—FIGURE 2.2.11

If you read Section 1 and completed Section 2, Figure 2.2.11 explains the geometry of how the diagonal works to create an accurate one-point perspective.

As demonstrated in Lesson 2, Section 2, we can simplify the drawing of a one-point perspective by creating a special vanishing point (SVP) on the horizon line (HL) and a diagonal (from the SVP) to determine room depth.

This simplification works because:

- In Figure 2.2.11 the distance from the SP to the top-view PP (dimension A) is exactly the same as dimension B. Sides A and B of a 45° triangle are equal.

- Dimension C is projected from the top-view PP to the HL and is equal to dimensions A and B. The intersection with the HL is labeled the special vanishing point (SVP).

- We can see that the use of an SVP eliminates the need for a top-view PP and SP.

- As shown in Figure 2.2.11, a diagonal from the SVP to the far corner of the front-view perspective creates the diagonal of the square 8'-0" × 8'-0" floor. This duplicates the room layout from Section 1.

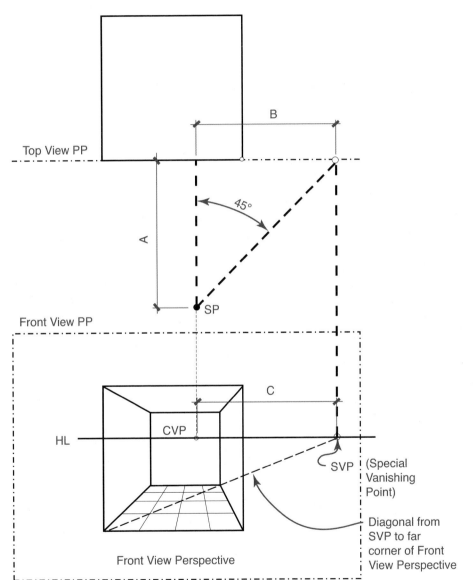

FIGURE 2.2.11

Lesson 2 Section 3

One-Point Perspective, a Designer's Method

BACKGROUND—FIGURE 2.3.1

- Hand-drawn, precise, geometrically accurate, highly realistic interior design renderings are increasingly rare. This type of drawing is faster and arguably better if created on a computer.

- Profitable design firms and design consultants must concentrate on driving bottom-line results through communication, efficiency, and design excellence.

- Efficient client communication includes believable perspective drawings that are quickly sketched and rendered.

- Design excellence is, at the very least, difficult to achieve through plan and elevation drawings alone. The ability to quickly sketch and visualize your ideas in perspective is a tool that can be used to optimize a design solution.

- The primary focus of this book, starting with this section, is developing the skills necessary to both use perspective as a design tool and communicate design intent efficiently and effectively.

- Figures 2.3.1a and 2.3.1b are examples of a graphic design student sketch using skills and techniques taught in this section. The sketch was laid out on trace paper, then retraced and rendered with fine-line pen and grayscale marker.

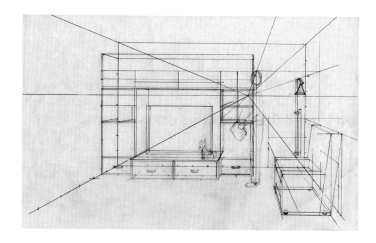

FIGURE 2.3.1a

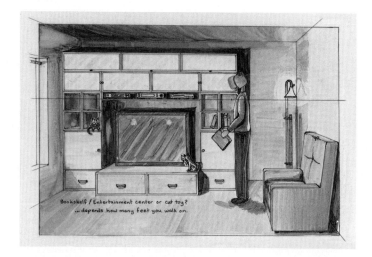

FIGURE 2.3.1b

STARTING THE SKETCH—FIGURE 2.3.2

- We will draw a one-point perspective of a room 14′ W × 11′ H × 10′ D.

- Using only a triangle and a fine-line pen or pencil, we will start the sketch by drawing the back wall of the one-point perspective. Draw a horizontal floor line and a vertical left wall line.

- Estimate 1-foot increments on the horizontal and vertical lines. It is not necessary to use a scale. With a little practice, it is simple to create relatively equal spacing.

- Draw the ceiling and right wall lines forming the back-wall rectangle 11′ H × 14′ W.

- Add a horizon line (HL). Interior perspectives generally locate the HL at normal standing eye level, between 5′ and 6′ above the floor. This measure is based on average human scale.

- Locate the central vanishing point (CVP) slightly to the right or left of center for a more interesting drawing. In Figure 2.3.2, it is slightly to the right.

- Lightly draw the corners of the room projecting forward from the CVP.

- It is not necessary to label the tick marks, HL, or CVP.

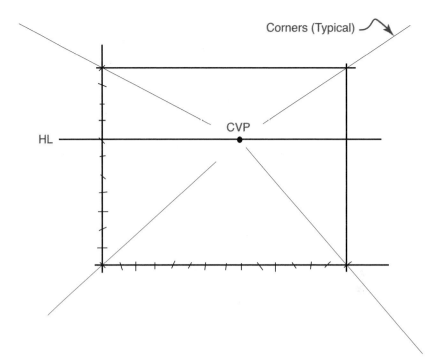

FIGURE 2.3.2

ESTIMATING THE 10'-0" ROOM DEPTH—FIGURE 2.3.3

- Note: If you did not complete Section 2 of this lesson, it would be a good idea to review Figures 2.2.1–2.2.5 before proceeding. We will use the geometry illustrated in these five drawings to proportion the depth of the one-point perspective documented in this section.

- As shown in Figure 2.3.3, lightly draw guideline A from the CVP through the estimated 10' tick mark on the back floor line and extend the line forward.

- Using your sense of scale and proportion, draw a diagonal (line B) of an estimated square on the floor (gray shaded area of Figure 2.3.3). The diagonal is drawn from the 10' mark on the back floor of the perspective to an intersection with line E.

- A crucial step in determining the estimated 10'-0" room depth is estimating the diagonal to create a floor square with width and depth appearing equal. This is illustrated in Figure 2.3.3 by the gray shaded area.

- Note: The estimated 10' floor square in Figure 2.3.3a is too shallow and the estimated 10' floor square in Figure 2.3.3b is too deep.

- From the CVP, draw guidelines through each of the back-floor tick marks to diagonal line B. Mark the intersection with another tick mark. (Line C is drawn as an example.)

- Use a T-square to project a horizontal line from each tick mark on the diagonal to line E. Add additional tick marks where the horizontal projections from the diagonal intersect with line E. (Dotted-line D represents the horizontal projection from the diagonal to line E.)

- We now have tick marks representing 1'-0" increments on all three dimensions (height, width, and depth) of the one-point perspective. Note how the tick marks on line E appear closer together as they get closer to the CVP. This is linear perspective.

- We can now complete the perspective drawing.

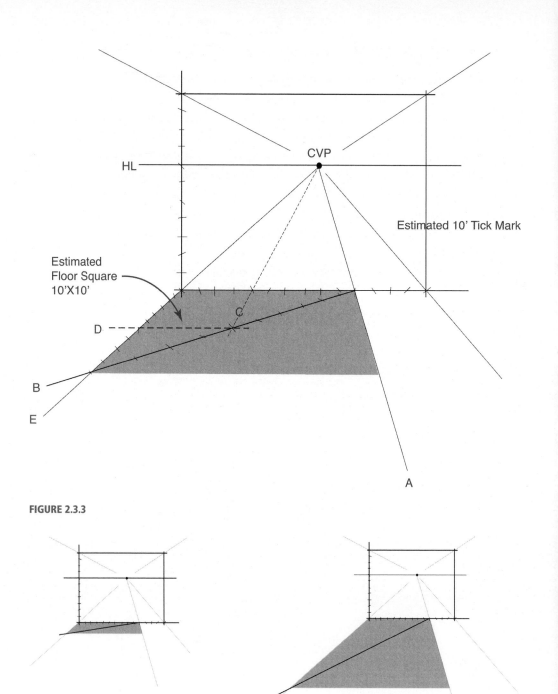

FIGURE 2.3.3

FIGURE 2.3.3a

FIGURE 2.3.3b

CLEANING UP THE LAYOUT—FIGURE 2.3.4

- You may want to erase all the unnecessary lines on your drawing or use a trace-paper overlay to complete your interior perspective.

- Note: As you gain experience and comfort with perspective drawing, it will be unnecessary to erase any line work. The layout lines will give your drawing a looser, sketchy look.

- It is possible to construct grid lines on the floor and wall of your drawing, and it may be easier, at first, to do so. In the long run, however, your drawings will be completed faster and with a freer style if you leave the grid lines off your drawing.

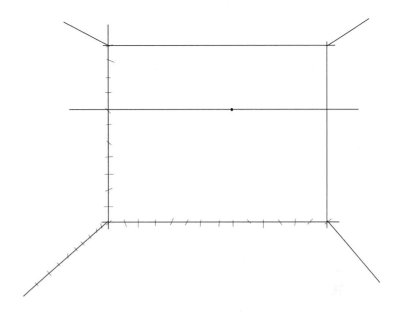

FIGURE 2.3.4

LAYING OUT THE DRAWING—FIGURE 2.3.5

- The first step in completing your drawing is to lay out the furniture and objects in the room. Lightweight guidelines are used to lay out a sofa (1), coffee table (2), two club chairs (3), and a fireplace (4) on the floor. A window (5) on the rear wall and a picture (6) and beam (7) are indicated on the left wall. The height, width, and depth tick marks that were previously constructed are used to proportion and position the furniture and objects. Detail is kept to a minimum.

- This is an important skill to develop. As you further develop your sense of scale and proportion, the layout lines can be easily tweaked to make the drawing more believable in scale.

- You may also adjust and add to the layout lines to develop and enhance a design solution.

- Figure 2.3.6 shows the completed line drawing.

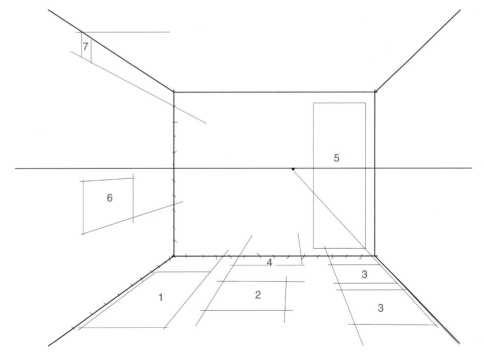

FIGURE 2.3.5

COMPLETING THE LINE DRAWING—FIGURE 2.3.6

- The line drawing started with a footprint of the furniture.

- Furniture is then "drawn up" using the height, width, and depth tick marks that were previously laid out as proportioning guides.

- Drawing furniture and architectural detail in a believable perspective is not a simple exercise the first few times attempted. It does become much easier as you gain experience. Practice, practice, practice!

- Note: If you skipped Sections 1 and 2, refer to Figures 2.1.8, 2.2.9, and 2.2.10 for a more complete understanding of the "draw-up" process.

- Line weights are refined to define form and detail.

- The line drawing can now be finished with marker, colored pencil, pastel, or other media.

NOTES
- The slight overlapping of lines adds character and interest to your drawing.

- The front wall of the room is purposely left off the drawing. The vignette style with paper space or white space around the drawing again adds character and interest.

- A minor example of using perspective as a design tool is the interlocking fireplace mantel and its relationship to the pictures on the left wall. The design idea was developed in this perspective drawing, not in plan and elevation.

- Visit MyKit online for a video demonstration of the layout process and helpful marker application techniques.

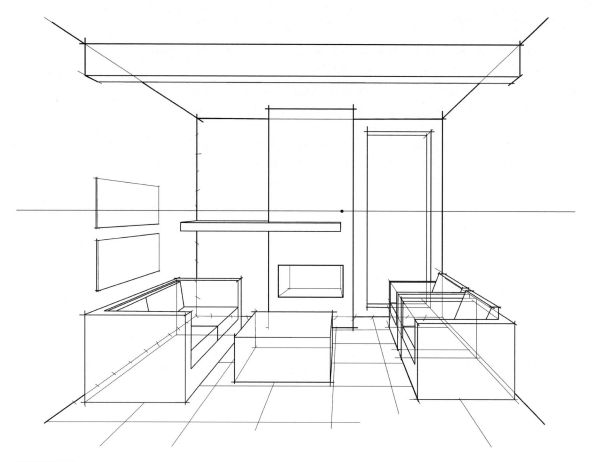

FIGURE 2.3.6

VIDEO DEMONSTRATION—FIGURE 2.3.7

- The process to create Figure 2.3.7 is documented in Video Lesson 2, Section 3 in MyKit.

- All sketch lessons are documented in real time without a script or editing, and are done quickly.

- You will use the processes demonstrated in the Video Lesson to complete your homework assignment as detailed in Section 4. We do expect you will take more time and care to create a drawing with a little more detail and a little more refinement.

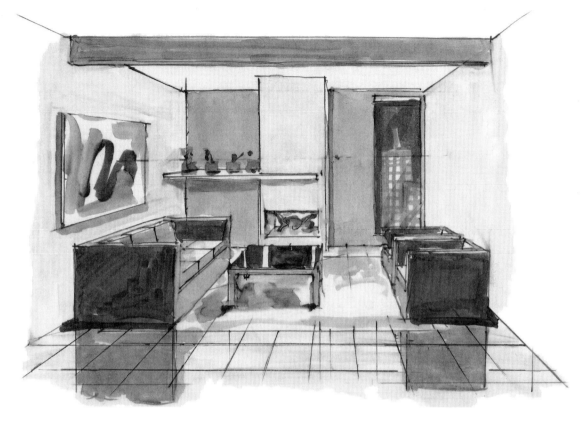

FIGURE 2.3.7

REQUIRED ASSIGNMENT

Lesson 2 Section 4
Homework

HOMEWORK ASSIGNMENT—FIGURES 2.4.1–2.4.2 (4 HOURS)

- Use the methodology illustrated and discussed in Lesson 2, Section 3 to draw, on trace paper, a one-point perspective of the room drafted in Figure 2.4.1 (plan) and Figure 2.4.2 (elevation).

- The room is 14'-0" wide × 10'-0" deep × 11'-0" high and is scaled at 1/4" = 1'- 0". Lay out the back wall of your perspective at a scale not less than 1/4" = 1'-0" and not more than 1/2" = 1'-0".

- Use your creativity to add architectural interest and draw objects or details that are not fully defined in Figures 2.4.1 and 2.4.2. Animators and game artists may want to add characters to the drawing, and graphic designers may want to add typography.

NOTES
- You may have to use a tape measure on furniture in your residence to best determine furniture heights.

- This is a challenge: The planter box in the foreground is turned 45° to the picture plane. The planter box must therefore be drawn as a two-point perspective. Your challenge is to figure out the left and right vanishing point locations. Think about diagonals and the horizon line.

- Render your finished line drawing with grayscale marker. Use marker, line, and value techniques discussed in Lesson 1 and use the Lesson 2 Video for reference.

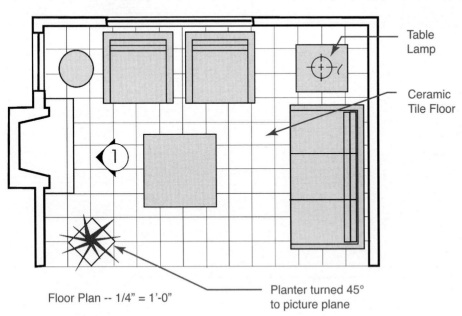

Table Lamp

Ceramic Tile Floor

Floor Plan -- 1/4" = 1'-0"

Planter turned 45° to picture plane

FIGURE 2.4.1

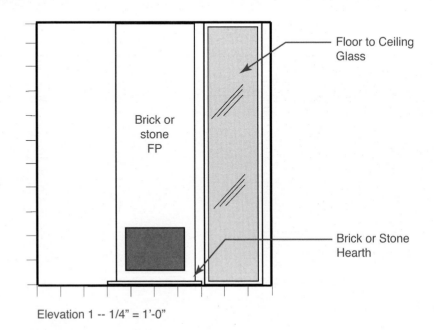

Floor to Ceiling Glass

Brick or stone FP

Brick or Stone Hearth

Elevation 1 -- 1/4" = 1'-0"

FIGURE 2.4.2

REQUIRED READING

Lesson 2 Section 5
Homework Examples

Figures 2.5.1–2.5.7 are examples of homework completed by students at the Art Institute of California–San Diego.

FIGURE 2.5.1

This is a nice first perspective drawing. The interpretation of the floor plan and elevation from Section 4 is complete and understood. The chairs in the background, however, are slightly narrow. The coffee table is interesting, but how does it stand up? The value change on the left side of the planter and fireplace is very nice. The plant is a well-done abstract indication. The ceiling has interesting detail.

FIGURE 2.5.2

This also is a good first perspective drawing. The drawing differs in room width from the floor plan and elevation suggested in Section 4. As in Figure 2.5.1, overall proportions are well done and believable. The stonework on the fireplace could look more three-dimensional, especially on the left edge. It would be interesting to see an indication of the outdoors through the window. The details (wall art, fire, objects on the shelves, and window shades) make the room interesting and inviting. The crown and base moldings add finish detail to the drawing.

FIGURE 2.5.3

This is an exceptional first perspective drawing. Obviously, this student has previous perspective drawing experience. You will see more of his drawings in this book, and it's interesting to note that the quality of his drawing skill improves as he completes each lesson. Students who take this course seriously and complete lab and homework assignments will also show significant improvement as the course progresses.

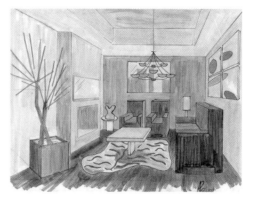

FIGURE 2.5.1

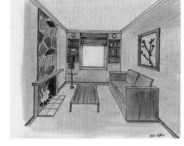

FIGURE 2.5.2

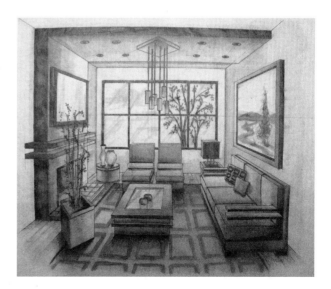

FIGURE 2.5.3

One-Point Perspective

The structure of this book has been used to teach proportion, perspective, and sketch techniques to interior design, graphic design, animation, and game art students. Figure 2.2.4 is an example of an animation student's Lesson 2 homework and Figure 2.3.5 is a game art student's homework. Both of these students obviously had drawing experience but the perspective content of this book was new to them.

FIGURE 2.5.4

The animation student who did this drawing had a lot of character-drawing experience but had not laid out perspective drawings that were scaled using a diagonal. She applied the techniques learned in Lesson 2 and added detail and entourage at an exceptionally high level.

FIGURE 2.5.4

FIGURE 2.5.5

The game art student who created this drawing also had a lot of character-drawing and some perspective-drawing experience before completing this assignment. The shadows and reflections in this drawing are advanced and will be covered in later lessons. Game art students always have an interesting approach to their drawing content, and Figure 2.5.5 is no exception. Notice that although the majority of this drawing is a one-point perspective, the two cabins on the right are turned slightly to the picture plane and are drawn as a two-point perspective.

We will start developing two-point perspective drawing skills in Lesson 3.

FIGURE 2.5.5

FIGURE 2.5.6

The graphic design student who did this sketch had minimal perspective-drawing experience. It was her first drawing using markers and a diagonal to proportion a one-point perspective drawing. She applied the techniques learned in Lesson 2 and added detail and entourage at a high level.

FIGURE 2.5.6

FIGURE 2.5.7

The game art student who created this drawing had some perspective-drawing experience before completing this assignment. This was her first experience with markers, and using a diagonal and measuring lines to proportion the one-point perspective. The drawing tells a story and captures emotion. The use of shadow, detail, and texture is very nicely done for a beginning student.

FIGURE 2.5.7

3 Two-Point Perspective
and Ellipses

Lesson Overview

Lesson 3 is written in five sections:

- Lesson 3, Section 1 documents a rotated plan projection methodology to create an accurate two-point interior perspective drawing.

- Lesson 3, Section 2 is a discussion of the importance of developing a sense of scale and proportion, and the ability to estimate a cube and a circle (ellipse) in perspective.

- Lesson 3, Section 3 documents drawing and estimating ellipses in one-point and two-point perspective.

- Lesson 3, Section 4 is a homework exercise that requires estimating cubes and ellipses and rendering them in grayscale marker.

- Lesson 3, Section 5 includes samples of student work with instructor comments.

It is recommended that students both read and sketch each step of the processes outlined in Sections 1 and 2. The sketching is best done freehand by estimating proportion and scale.

It is possible to skip Section 1, although it is not recommended. Section 1 documents perspective geometry and process and gives the reader a solid foundation for a more complete understanding of two-point perspective drawing.

NOTE
Most design students are visual learners. MyKit instruction for this lesson includes:

- Section 1, Video 1 demonstrates the plan projection method of laying out an accurate two-point perspective.

- Section 3, Video 1 demonstrates estimating the proportions of a cube and sketching ellipses.

- Section 3, Video 2 demonstrates rendering cubes and ellipses in grayscale marker.

RECOMMENDED READING

Lesson 3 Section 1

Creating a Two-Point Perspective from Plan

BACKGROUND—FIGURES 3.1.1 AND 3.1.2

Planning your interior view is an important first step in the construction of a two-point perspective drawing.

It is critical to establish the view of the interior with a station point (SP). From the SP, use a normal cone of vision of approximately 60° to assure your view will include all the required information. In Figure 3.1.1, the view includes the window and important interior angles.

NOTE
In a perspective drawing, objects that are outside the 60° cone of vision will appear distorted. If there are no objects outside the normal 60° cone of vision, then the viewing angle may be increased.

Sometimes it may be important to locate the SP outside the room to assure the desired view is complete. In Figure 3.1.2, the SP is located outside the room and the wall closest to the SP would have to be dissolved in the perspective drawing. The view in Figure 3.1.2 is compromised because the window and an important corner of the room (dotted-line viewing angle) are not completely visible within the 60° cone of vision.

The view represented by Figure 3.1.1 is better, and we will use it as the basis for the construction of our two-point perspective drawing on the following pages.

The importance of the picture plane (PP) will become evident as this section progresses.

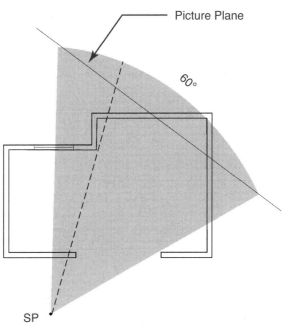

Picture Plane

60°

SP

FIGURE 3.1.2

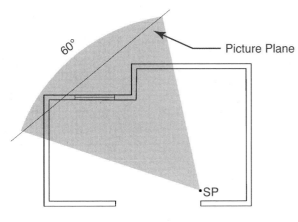

60°

Picture Plane

•SP

FIGURE 3.1.1

PICTURE PLANE—FIGURE 3.1.3

- Begin your perspective layout by creating a picture plane (PP) as shown in Figure 3.1.3. The PP is shown as a front elevation.

- Note: The PP rectangle is drawn to show concept only. One typically would not actually draw the PP in elevation. The PP is the paper you are using to construct a perspective.

- Project the PP up and draw a horizontal line (AB) representing the PP in plan view.

FIGURE 3.1.3

CONSTRUCTING A TWO-POINT PERSPECTIVE—FIGURE 3.1.4

- Rotate and draw the floor plan so that the interior corner furthest from the station point (SP) and still within the cone of vision is touching the plan-view PP. This is represented by point A on the drawing.

- From the SP, draw guidelines parallel with the orientation of the room to the picture plane. Lines B and C on the drawing represent the guidelines. The intersection of lines B and C with the PP will establish vanishing point locations later in the drawing process.

- Note: Any point of the floor plan that is touching the PP (point A) will be represented as a true measure (commonly called a measuring line) in the elevation view.

- Establish a measuring line in the elevation view of the PP by dropping a guideline from point A. This is represented by line D.

- Before moving to Figure 3.1.5, scale the measuring line in the PP elevation at 10'-0". The scale must be consistent with the scale of the room in plan view. It is important to indicate the 1'-0" tick marks on the measuring line. The tick marks will help scale all vertical measurements as the drawing progresses.

- Note the approximate location of the measuring line in elevation. The importance will become evident as we progress through the drawing.

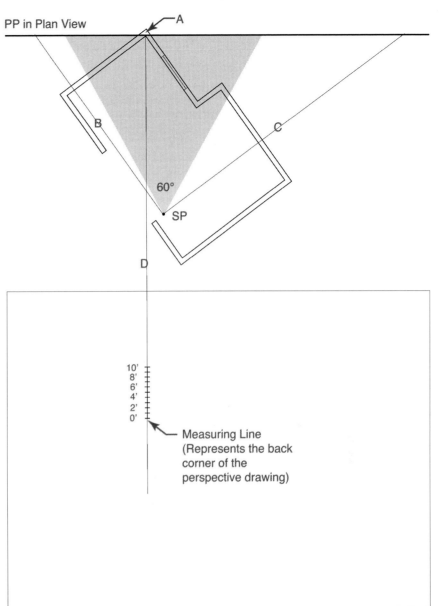

PP in Plan View

PP in Elevation

FIGURE 3.1.4

CONSTRUCTING A TWO-POINT PERSPECTIVE—FIGURE 3.1.5

- Draw a horizon line (HL) between 5'-0" and 6'-0" above the floor. Note the HL drawn through the 6-foot increment on the measuring line.

- Note: Interior perspectives typically locate the HL at normal standing eye level, or between 5' and 6' above the floor. This measure is based on average human eye level.

- Drop line E from the intersection of line B and the PP in plan view to the HL. The intersection of line E with the HL is the left vanishing point.

- Drop line F from the intersection of line C and the PP in plan view to the HL. The intersection of line F with the HL is the right vanishing point.

- Note: The measuring line is the only true measurement in a two-point perspective. All other vertical measurements must be projected from the measuring line. This will become evident as the drawing progresses.

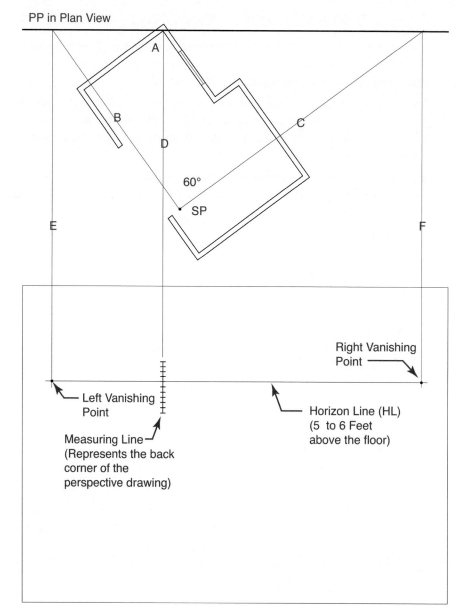

PP in Plan View

PP in Elevation

FIGURE 3.1.5

CONSTRUCTING A TWO-POINT PERSPECTIVE—FIGURE 3.1.6

- For understandability, all construction lines drawn in Figures 3.1.1 through 3.1.5 have been removed in Figure 3.1.6.

- Begin the construction of the interior perspective with walls that are located to the right of the measuring line.

 - Draw lines A and B from the left vanishing point (LVP) through the top and bottom of the measuring line. These lines represent the ceiling and floor of your right-wall perspective.

 - Extend lines from the SP through the window edges and corners of the room to the PP in plan view. These lines terminate on the PP at points 1, 2, 3, 4, and 5.

 - From points 1, 2, 3, 4, and 5, drop lines vertically to the perspective layout. These lines represent the vertical edges of the window and the vertical corners of the room's dogleg. A dashed line in plan view represents the dogleg.

 - Complete walls to the right of the measuring line with guidelines from the left and right vanishing points (LVP and RVP). Increase the line weights of the lines defining the room.

 - Note: The window height is determined by projections from the 8'-0' and 3'-0" tick marks on the measuring line.

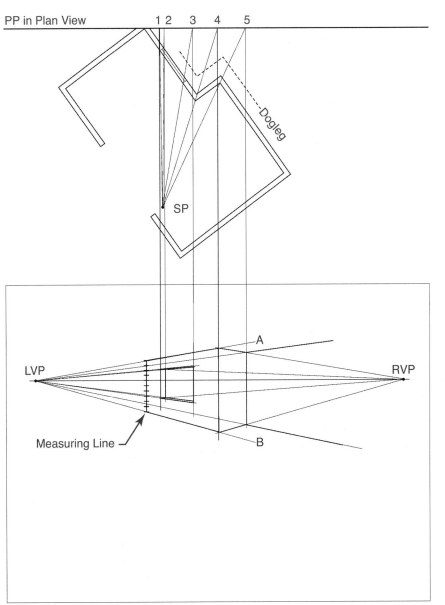

PP in Elevation

FIGURE 3.1.6

CONSTRUCTING A TWO-POINT PERSPECTIVE—FIGURE 3.1.7

- For understandability, all construction lines drawn in Figure 3.1.6 have been removed.
- Complete the interior-perspective walls:
 - Draw lines A and B from the RVP through the top and bottom of the measuring line. These lines represent the ceiling and floor of the left wall in the perspective.
 - Note: A "vignette" style of perspective drawing is generally preferred. Termination of walls on the right and left are blended with the background rather than defined by a hard edge.
- Add a cube to the perspective drawing:
 - Add the cube in plan view to the floor plan drawing.
 - Extend the sides of the cube to the walls with guidelines (see dotted lines in plan view).
 - From the SP, draw guidelines from the dotted-line intersection with the walls to the PP. Points 1, 2, 3, and 4 on the plan-view drawing represent the intersection with the PP.
 - Drop lines from points 1, 2, 3, and 4 vertically to the perspective. The lines touch the floor line in the perspective at points 5, 6, 7, and 8. Project lines from the LVP through points 5 and 6 and from the RVP through points 7 and 8 to define the base shape and location of the cube on the floor.
 - Determine the height of the cube with projection line C from the RVP through the appropriate measuring line tick mark. Complete the cube with projections from the LVP and RVP.
 - The perspective layout is now complete.

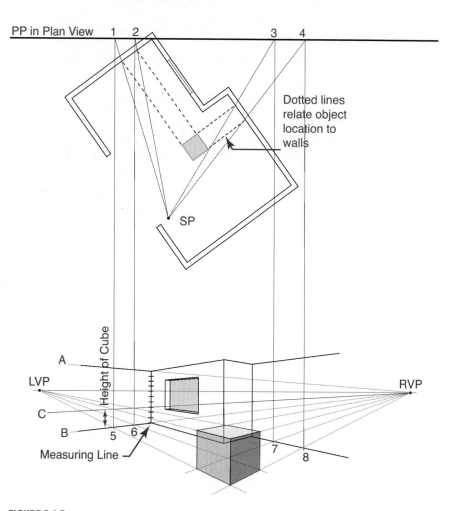

FIGURE 3.1.7

THE COMPLETED PERSPECTIVE DRAWING—FIGURE 3.1.8

- In Figure 3.1.8, all construction lines have been removed and people were added to the drawing.

- Note: We will learn about adding people to perspectives in later lessons. For now, it can be seen that it is easy to proportion people in a perspective drawing when the HL is at standing eye level. Adult heads will always be close to the HL no matter where they are located in the perspective. The man in the background is smaller in relation to the woman in the foreground because of perspective, yet both of their heads are on the HL.

- This drawing is a very simple perspective, yet it took considerable time and effort to complete. Imagine the time it would take if the room were populated with complex pieces of furniture, objects, and details. The drawing would lose all accuracy if the layout were not done on a drawing board with drafting tools and great care taken with projections.

- In today's world where efficiency is so important, a designer does not usually have the luxury of time to produce a complete perspective with furniture and details using this methodology. If the perspective needs to be that accurate, the use of a computer is much faster.

- This methodology, however, is often used by designers to lay out the basic room proportions and perhaps a footprint of the major furniture pieces. Vertical perspective proportions are then established using the vertical measuring line. In this example, the vertical measuring line is the rear corner. Design details and proportions are then estimated and completed, using an understanding of perspective and a sense of scale.

- This process is handy for presentation-type drawings. It is *not* an effective design tool where creativity and drawing skill are combined to explore design ideas three-dimensionally.

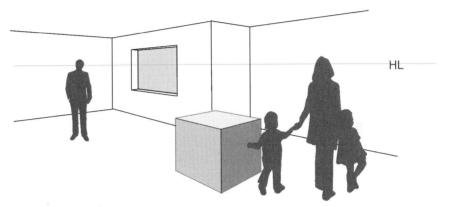

HL

FIGURE 3.1.8

VIDEO DEMONSTRATION— FIGURES 3.1.9 AND 3.1.10

- The process to create the trace-paper layout in Figure 3.2.10 is documented in Video Lesson 3, Section 1 in MyKit.

- All sketch lessons are documented in real time without a script or editing, and they are done quickly.

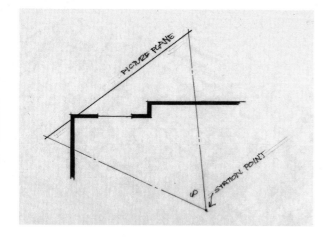

FIGURE 3.1.9

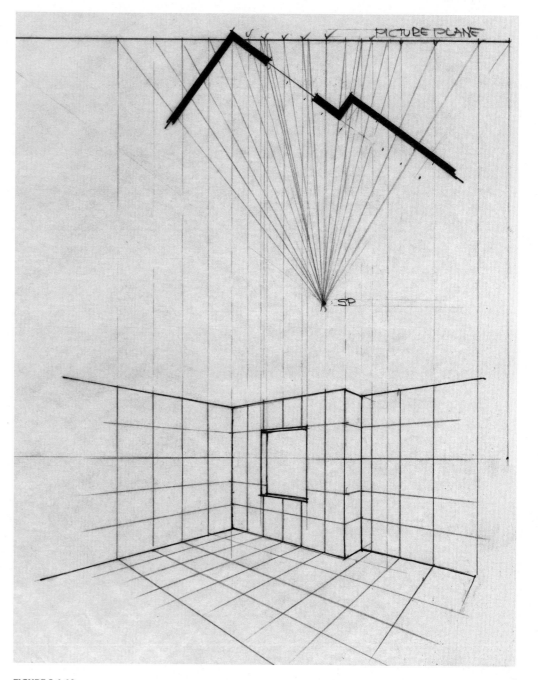

FIGURE 3.1.10

CONSTRUCTING A TWO-POINT PERSPECTIVE OBJECT—FIGURE 3.1.11

The same process used to develop a two-point perspective of an interior can be used to construct an object. In Figure 3.1.11, the object is a cube.

In Figure 3.1.11, the object is placed behind the picture plane in plan view. This results in a perspective drawing with the leading edge of the perspective drawn as a true measure or measuring line.

Interior perspectives using this methodology place the interior in front of the measuring line in plan view.

Visualize trying to use this methodology to construct a complex object. It would be difficult and time consuming. Most designers do not have the luxury of time to use this process. The remainder of the book will use estimation and simple proportioning methodologies to create believable (as opposed to accurate) perspective drawings.

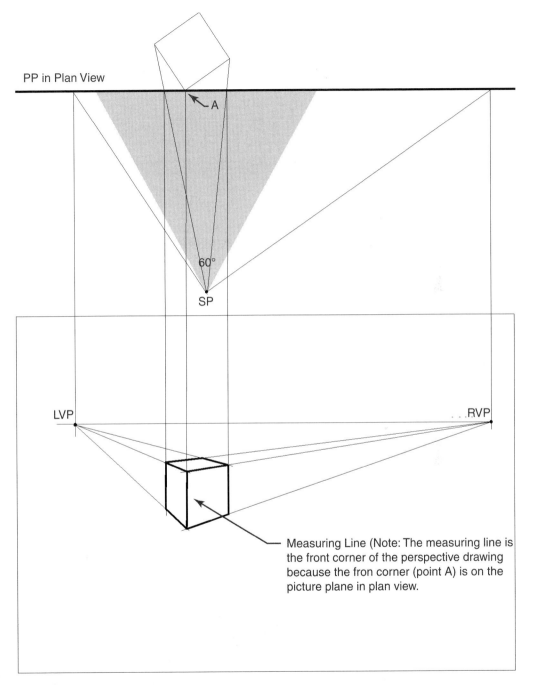

PP in Plan View

A

60°

SP

LVP

RVP

Measuring Line (Note: The measuring line is the front corner of the perspective drawing because the fron corner (point A) is on the picture plane in plan view.

PP in Elevation

FIGURE 3.1.11

RECOMMENDED READING

Lesson 3 Section 2
Perspective Discussion

In Lesson 2, Section 3, we learned a simple designer's method of creating a one-point perspective drawing. There is no equivalent process for creating a two-point perspective drawing. We have to either use the rotated plan method from Lesson 3, Section 1 to develop a two-point perspective, or rely on:

- An ability to estimate* scale and proportion as emphasized in the remainder of this lesson.

- An understanding of proportioning methodologies taught in Lessons 4 and 5. Figures 3.2.1–3.2.5 are student homework assignments from Lesson 4. Figure 3.2.6 is an instructor demonstration from Lesson 5.

 It is also important to develop an ability to sketch a circle (ellipse) in perspective. You will learn that skill in Section 3 of this lesson.

 In Lesson 1 we began development of our sense of scale and proportion by estimating cubes in one-point and two-point perspective. We will continue the development with the Lesson 3, Section 4 homework assignment.

*Estimating implies a higher level of skill and a deeper understanding of perspective than simply guessing.

FIGURE 3.2.1

Sketches based on the ability to estimate a cube and a circle in perspective (Figures 3.2.2–3.2.6).

FIGURE 3.2.2

FIGURE 3.2.3

FIGURE 3.2.4

FIGURE 3.2.5

FIGURE 3.2.6

Two-Point Perspective and Ellipses

Lesson 3 Section 3
Ellipses (Circles in Perspective)

BACKGROUND

We learned in previous lessons the importance of estimating a cube and a square in perspective. It is just as important to master the ability to estimate and draw circles (ellipses) in perspective. The cube and the ellipse are the basis for drawing complex objects and interiors.

ELLIPSES—FIGURE 3.3.1

- The ellipse is a foreshortened circle in perspective.

- Ellipse guides are common but are not always useful because they are made in limited sizes and angles. The ability to sketch believable ellipses therefore becomes very important.

- The closer to the horizon line, the flatter the appearance of the ellipse. Note in Figure 3.3.1 how the ellipse opens as it gets further above or below the horizon line (HL).

- A circle in Figure 3.3.1 is a line when located on the horizon.

- Each ellipse in Figure 3.3.1 has a major axis (the longer axis) and a minor axis (the shorter axis). The major and minor axes cross each other at 90° through the center of the ellipse. The minor and major axes will become important later in this section.

- In Figure 3.3.1, notice how the major axis remains the same size in each ellipse. The minor axis changes in size due to foreshortening, as the circle gets closer to the HL.

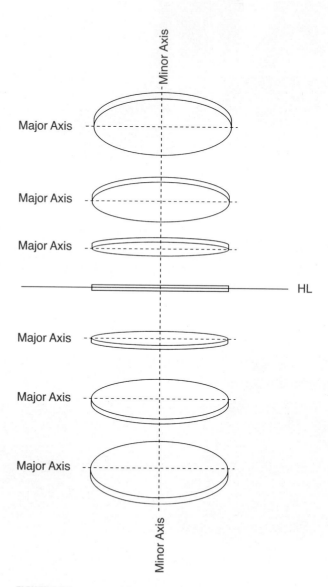

FIGURE 3.3.1

A CIRCLE IN PLAN VIEW—FIGURES 3.3.2 AND 3.3.3

- A circle in plan view (Figure 3.3.2) is shown encompassed by a square. Drawing a vertical and a horizontal through the center point of the circle divides the circle into four equal quadrants.

- The square surrounding the circle in Figure 3.3.3 is further divided with two diagonals. Note that the distance from point A to point B is approximately 1/3 (actually a little less than 1/3) of the distance between points A and C. The same is true for all four quadrants.

- We will use this geometry as illustrated in Figures 3.3.4–3.3.6 to sketch circles in perspective.

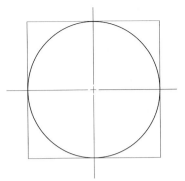

FIGURE 3.3.2

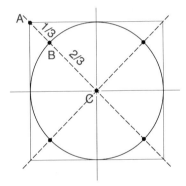

FIGURE 3.3.3

USING AN ESTIMATED SQUARE TO PROPORTION ELLIPSES IN A ONE-POINT PERSPECTIVE—FIGURES 3.3.4–3.3.5

- Begin the sketching of an ellipse by estimating a square in perspective (Figure 3.3.4).

- Add two diagonals to determine the center point of the perspective square.

- Add a vertical to the CVP and a horizontal line through the center of the square. The two dotted lines in Figure 3.3.4 represent the minor and major axes of the ellipse about to be drawn.

- Note: The center of a square (or rectangle) in perspective is always located at the intersection of two diagonals.

- As in Figures 3.3.3 and 3.3.4, estimate a point (point B) on a diagonal approximately 1/3 the distance from point A to point C. Repeat the point mark from each corner of the estimated square.

- Mark the minor axis and major axis points of the ellipse where the vertical and horizontal lines cross the estimated square.

- In Figure 3.3.4, there are now a total of eight points that are located on the diagonals and on the major and minor axes. These points are used to sketch an ellipse.

- Using a full arm motion (not just your hand and wrist), sketch ellipses through the eight points as represented in Figure 3.3.4. Use a thicker line weight, as in Figure 3.3.5, to smooth out the curves and finalize the ellipse.

- The cylinders in Figure 3.3.5 were constructed using this process.

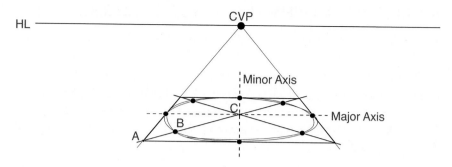

FIGURE 3.3.4

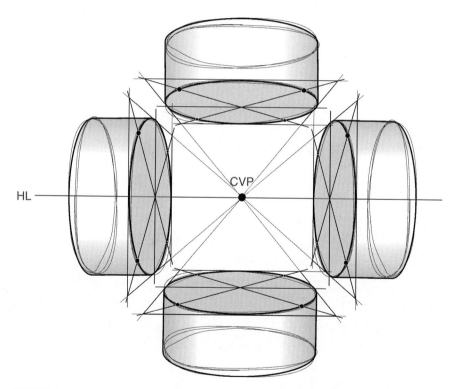

FIGURE 3.3.5

REQUIRED EXERCISE

- Using a straight edge, a horizon line, and central vanishing point, lay out a one-point perspective interior similar to that in Figure 3.3.6.

- Estimate squares on the floor, ceiling, and left and right walls, which represent the base of a round coffee table, a large wall clock, a hanging lamp, and an arched door opening.

- Using the eight-point methodology, sketch the cylindrical objects in the interior space.

- In a one-point perspective, any ellipse projected forward from the central vanishing point, or drawn on the back wall, is drawn as a circle. This is represented by cylinder A and circle B in Figure 3.3.6.

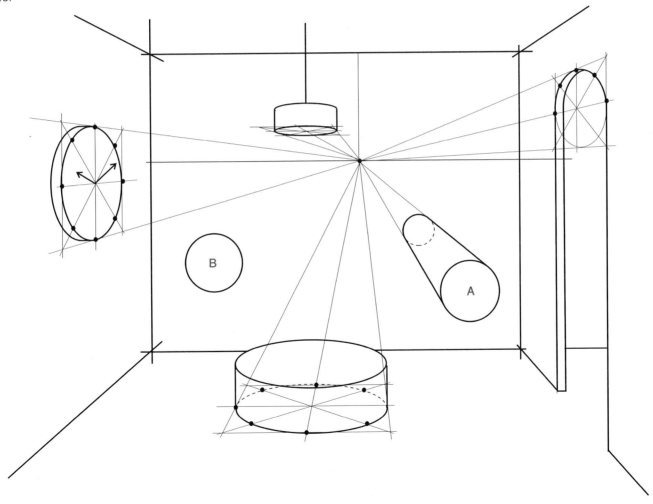

FIGURE 3.3.6

USING AN ESTIMATED SQUARE TO PROPORTION ELLIPSES IN A TWO-POINT PERSPECTIVE—FIGURE 3.3.7

- The same geometric process used to sketch a one-point-perspective circle (ellipse) can be used in a two-point perspective.

- Estimate a square or a cube in perspective. Draw guidelines dividing the square diagonally, then divide through the midpoint to the vanishing point. Divide it again vertically through the midpoint.

- Plot the eight points on the guidelines and freehand sketch the ellipse. Complete the ellipse by increasing the line weight of a smoothed-out curve.

- With a little practice, the perspective square or cube is enough to estimate an ellipse. The eight-point plot becomes unnecessary. This is illustrated on the small cube in Figure 3.3.7.

- There is another way of estimating an ellipse in a two-point perspective that some find simpler and with a more believable result, as discussed next.

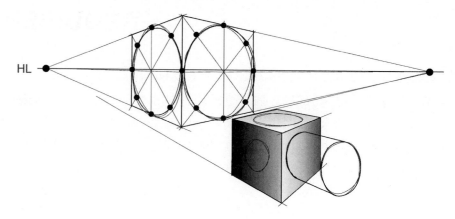

FIGURE 3.3.7

AN ALTERNATE METHOD OF ESTIMATING AND SKETCHING AN ELLIPSE IN A TWO-POINT PERSPECTIVE—FIGURES 3.3.8–3.3.10

- The basis for this method of estimating and sketching an ellipse is to always think of an ellipse as a cylinder.

- Figure 3.3.8 illustrates a cylinder in two-point perspective originating from:

 - A—the left vanishing point
 - B—above the horizon line
 - C—the ground
 - D—the right vanishing point

FIGURE 3.3.8

THREE SIMPLE RULES TO ESTIMATE AN ELLIPSE IN TWO-POINT PERSPECTIVE

- ***Always think of an ellipse as a cylinder, even if it's not.*** For example, a clock on a wall could be drawn as an ellipse and not a cylinder. Think of it as a cylinder projecting through the wall.

- ***The direction of the cylinder is the minor axis.*** The direction of the cylinder's minor axis in Figure 3.3.9 is either vertical or coming from the left or right vanishing points.

- ***The major axis always crosses the minor axis at 90° (a right angle).*** Note that the major axis of each ellipse in Figure 3.3.10 is at a true right angle to the minor axis.

- Note: Refer to Figure 3.3.1 for a more thorough review of the minor and major axes.

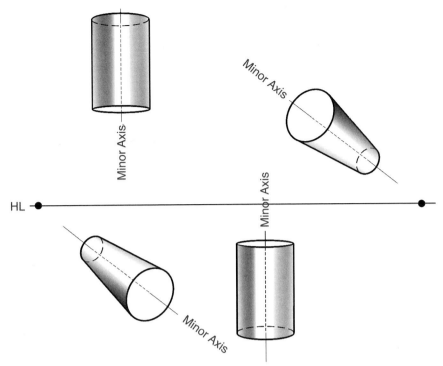

FIGURE 3.3.9

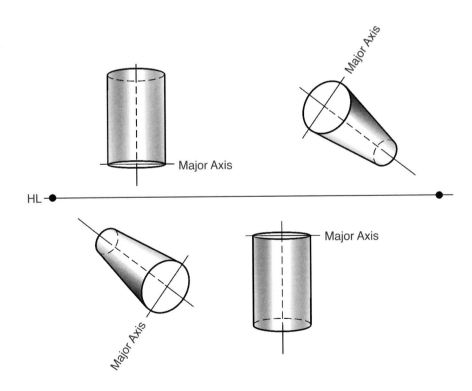

FIGURE 3.3.10

APPLYING THE THREE SIMPLE RULES

- Note: You can use an estimated square in perspective to help determine how open (or closed) the ellipse is to be drawn. As you become more comfortable drawing ellipses, the estimated square becomes unnecessary.

- Begin by determining the direction of the imagined cylinder. If the cylinder is coming down from a flat ceiling or up from a floor, the minor axis will be vertical. If the cylinder is not vertical, the minor axis will be projected from either the left or right vanishing point.

- When the minor axis is determined, add the major axis at a true right angle (90°) to the minor axis and sketch the ellipse.

- This process results in an ellipse that is rotated slightly off vertical when projected from a vanishing point. In two-point perspective, this methodology results in an ellipse that appears more accurate than one drawn using the eight-point methodology. Compare ellipses using this methodology with ellipses drawn using the eight-point method, and see which you prefer.

- The process used to create the trace paper and marker sketch in Figure 3.3.11 is documented in Video Lesson 3, Section 3, Part 1 and Part 2 in MyKit.

- All sketch lessons are documented in real time without a script or editing, and they are done quickly.

- You will use the processes demonstrated in the Video Lesson to complete your homework assignment as detailed in Section 4. We do expect that you will take more time and care to create a drawing.

FIGURE 3.3.11

REQUIRED ASSIGNMENT

Lesson 3 Section 4
Homework

HOMEWORK ASSIGNMENT (4 HOURS)

- Use your sense of scale and proportion to estimate 10 cubes in space. Draw cubes above, below, and on the horizon line. Be creative. Some cubes in your drawing may overlap and some may appear hollow.

- When the cubes are sketched, add 10 ellipses to the cubes. Use one of the two ellipse construction methodologies reviewed in Section 3 to estimate believable, well-proportioned ellipses. Note: The use of the minor and major axes to determine the ellipse will appear slightly more accurate.

- Render the cubes and ellipses with grayscale markers. Refer to the video demonstration (Lesson 3, Section 3, Part 1 and Part 2) and Figures 3.3.11 and 3.4.1 for reference.

NOTES
- The renderings of the first few cubes and ellipses may not turn out as well as you wish. Don't be discouraged. Keep sketching, and by the time the assignment is finished, the quality will have improved.

- The purpose of estimating cubes will become more apparent as we continue with Lessons 4 and 5. The cube is the basis for drawing other forms, objects, and interiors. It is important that you master this skill.

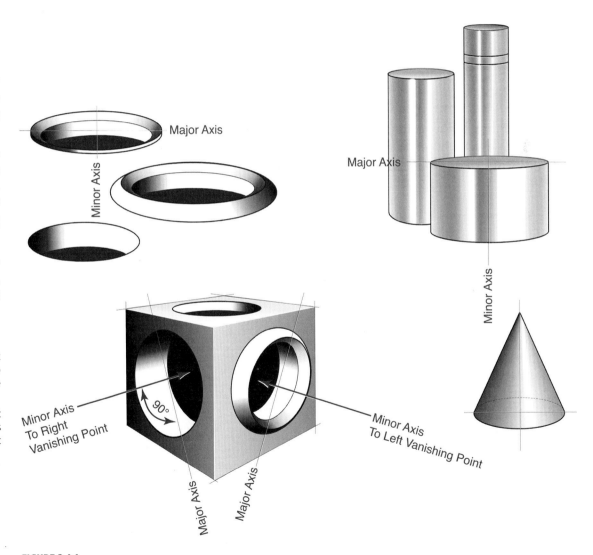

FIGURE 3.4.1

REQUIRED READING

Lesson 3 Section 5
Homework Examples

Figures 3.5.1, 3.5.2, 3.5.3, and 3.5.4 are examples of homework completed by students at the Art Institute of California–San Diego.

FIGURE 3.5.1

This is a very nice perspective drawing. The cubes and ellipses are well estimated and are believable. The fan detail on the lower-right cube is a nice detail. The ellipses are well drawn and used the minor and major axes method.

FIGURE 3.5.2

This is a very creative perspective drawing. The ellipse within a cube, within an ellipse, within a cube, and so on, is a fresh look at the assignment. The ellipses were constructed using the eight-point method.

FIGURE 3.5.3

This is a well-proportioned drawing and the marker application is nicely done. The ellipses are believably drawn and effectively use the eight-point method of construction.

FIGURE 3.5.4

This is a carefully controlled drawing and well rendered. The student used a Q-tip to blend the marker strokes and an ellipse guide to draw the ellipses. A close look at the drawing reveals that a few of the ellipses were compromised by the fact that the ellipse guide did not have the required angles. The student displays an excellent understanding of the use of the minor and major axes to lay out the ellipses. The black background looks great but uses a lot of marker.

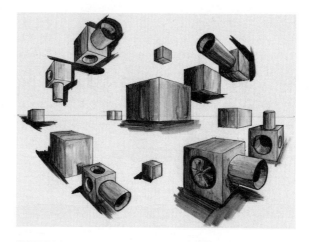

FIGURE 3.5.1

FIGURE 3.5.2

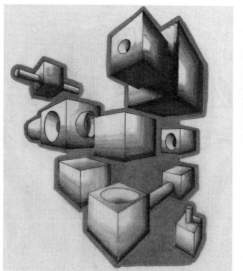

FIGURE 3.5.3

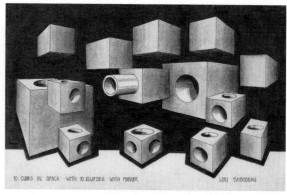

FIGURE 3.5.4

Two-Point Perspective
Proportioning Methodologies

Lesson Overview

Lesson 4 is written in five sections:

- Lesson 4, Section 1 introduces the concept of proportioning objects in two-point perspective by expanding and subdividing an estimated cube.

- Lesson 4, Section 2 leads you through the process of laying out an object in perspective using the methodologies discussed in Section 1.

- Lesson 4, Section 3 begins with a video demonstrating the process to lay out the object from Section 2. Section 3 also includes a lab assignment and additional videos focused on perspective layout and marker technique.

- Lesson 4, Section 4 is a homework exercise that requires laying out objects in perspective using the methodologies learned in this lesson and rendering them in grayscale marker.

- Lesson 4, Section 5 includes samples of student work with instructor comments.

It is recommended that students both read and sketch each step of the processes outlined in Sections 1 and 2. In Section 1, sketching is best done freehand by estimating proportion and scale. Use a large triangle or straight edge to complete the Section 2 exercise. Students should also complete the lab exercise in Section 3 before starting the homework assignment.

NOTE
Most design students are visual learners. MyKit instruction for this lesson includes:

- Section 3, Video 1 demonstrates laying out a stereo receiver and DVD player in two-point perspective.
- Section 3, Video 2, Part 1 demonstrates the perspective layout of a commuter train.
- Section 3, Video 2, Part 2 demonstrates grayscale marker rendering techniques used to complete the commuter train sketch.

Lesson 4 Section 1

Subdividing and Expanding a Cube in Perspective

FIGURE 4.1.1

FIGURE 4.1.2

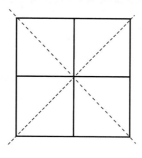

FIGURE 4.1.3

FIGURE 4.1.4

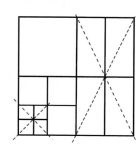

FIGURE 4.1.5

SUBDIVIDING A SQUARE—FIGURES 4.1.1–4.1.5

- A square is estimated in plan view in Figure 4.1.1 and diagonals are drawn in Figure 4.1.2. The crossing point of two diagonals in a square identifies the center of the square. In Figure 4.1.3, a vertical and a horizontal line are drawn through the center of the square, subdividing the original square into four smaller squares.

- Diagonals can be used as shown in Figures 4.1.4 and 4.1.5 to further subdivide the original square.

SUBDIVIDING AN ESTIMATED CUBE—FIGURES 4.1.6–4.1.10

- Note: The geometric process that works in plan view (Figures 4.1.1–4.1.5) also works in perspective (Figures 4.1.6–4.1.10).

- The diagonals subdivide the estimated cubes in linear perspective. The vertical subdivisions in Figure 4.1.10 appear closer together as they converge to the vanishing point.

FIGURE 4.1.6

FIGURE 4.1.7

FIGURE 4.1.8

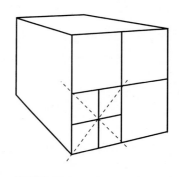

FIGURE 4.1.9

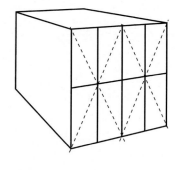

FIGURE 4.1.10

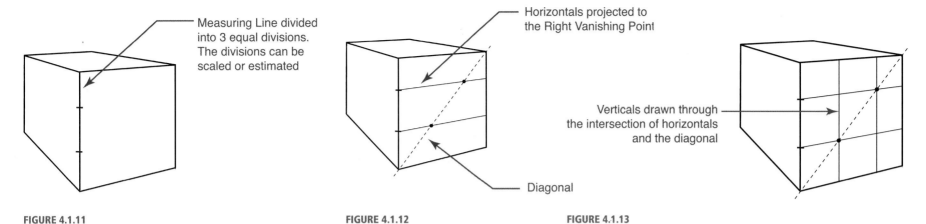

FIGURE 4.1.11 **FIGURE 4.1.12** **FIGURE 4.1.13**

Measuring Line divided into 3 equal divisions. The divisions can be scaled or estimated

Horizontals projected to the Right Vanishing Point

Verticals drawn through the intersection of horizontals and the diagonal

Diagonal

AN ALTERNATE METHOD OF SUBDIVIDING A CUBE—FIGURES 4.1.11–4.1.15

- In any two-point perspective, there is one measuring line that can be scaled. When drawing an object, the measuring line is typically the leading edge of the object. As we learned in Lesson 3, Section 1, when drawing an interior, the measuring line is usually the rear corner of the interior.

- In Figure 4.1.11, the measuring line (the leading edge of the cube) is divided into three equal increments.

- In Figure 4.1.12, a diagonal is drawn connecting the upper-right corner with the lower-left corner. Horizontal lines are drawn from the measuring line divisions to the right vanishing point.

- In Figure 4.1.13, verticals are drawn through the intersection of the horizontal lines and the diagonal.

- This methodology comes in handy when trying to subdivide a cube into an uneven number of increments, as in Figure 4.1.13. In Figure 4.1.15, the measuring line and diagonal are used to add a door and a window to an 8'-0" H X 8'-0" W 8'-0" D cube. The proportions are based on the elevation shown in Figure 4.1.14. This proportioning methodology only works with a cube. Do not try to proportion a rectangular surface in this manner.

FIGURE 4.1.14

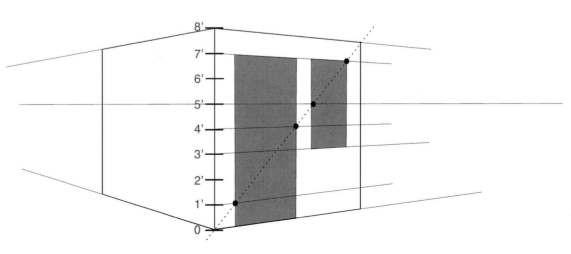

FIGURE 4.1.15

FIGURE 4.1.16

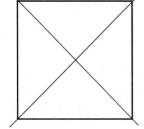

FIGURE 4.1.17

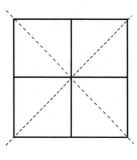

FIGURE 4.1.18

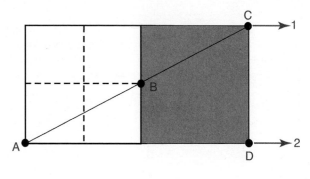

FIGURE 4.1.19

EXPANDING A SQUARE—FIGURES 4.1.16–4.1.19

- A square is estimated in plan view in Figure 4.1.16 and diagonals are drawn in Figure 4.1.17. The crossing point of two diagonals in a square identifies the center of the square. In Figure 4.1.18, a vertical and a horizontal line are drawn through the center of the square, subdividing the original square into four smaller squares.

- The top and bottom of the estimated square is extended to the right. The extensions are represented by extension lines 1 and 2 in Figure 4.1.19.

- A line is drawn from point A, through point B, to point C at the intersection with line 1. From point C, a vertical line is dropped to point D at the intersection with line 2. This simple geometric process results in a perfect duplication of the original square. Try this process and expand the original square upward, to the right, and downward. Start the duplicating process from a corner opposite the direction of the expansion.

EXPANDING AN ESTIMATED CUBE—FIGURES 4.1.20–4.1.23

- Note: The geometric process that works in plan view (Figures 4.1.16–4.1.19) also works in perspective (Figures 4.1.20–4.1.23). An exception is illustrated in Figure 4.1.25.

- This process expands the sides of the original cube in linear perspective. Note that the expanded cube (gray area in Figure 4.1.23) appears to be more rectangular than the original. Verticals appear closer together as they converge to a vanishing point. Try expanding a cube upward and downward.

FIGURE 4.1.20

FIGURE 4.1.21

FIGURE 4.1.22

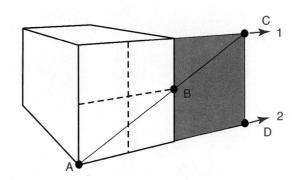

FIGURE 4.1.23

EXPANDING A CUBE—FIGURES 4.1.24–4.1.25

- On the previous page of this lesson it was stated, "The geometric process that works in plan view also works in perspective." I am sorry to mislead you, but it seems there is an exception to the rule: Expanding a cube side forward DOES NOT WORK.

- The reasoning is simple. In linear perspective, objects appear to compress as they converge to a vanishing point.

- In Figure 4.1.25, notice that cubes A1, A2, and A3 are duplicated following the rules of linear perspective, and appear to compress as they converge to the right vanishing point. It is impossible to proportionally expand the original cube away from the vanishing point. Geometric shape D is distorted into a rectangular shape and inconsistent with the intent of expanding the cube.

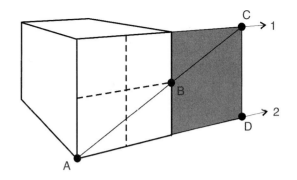

FIGURE 4.1.24

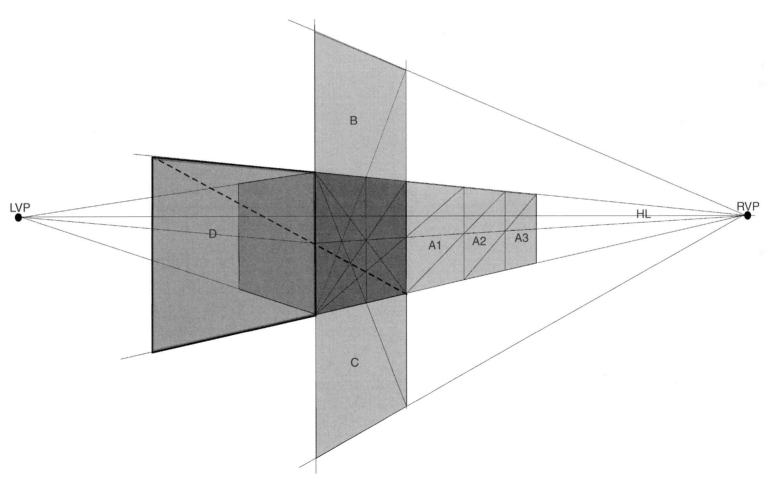

FIGURE 4.1.25

EXPANDING A CUBE BY ONE-HALF—FIGURE 4.1.26

- As you will see in Section 3 of this lesson, it is handy to be able to expand a cube by one-half.

- The estimated original cube (dark gray) is extended on the top (line 1) and bottom (line 2) toward the right vanishing point.

- A guideline is then drawn from point A (the vertical centerline of the original cube), through point B (the horizontal centerline of the original cube), to the intersection with line 1 at point C. From point C a vertical guideline is dropped to line 2. This simple geometric process duplicates a half-cube (middle gray) to the right vanishing point. The half-cube is duplicated again (light gray).

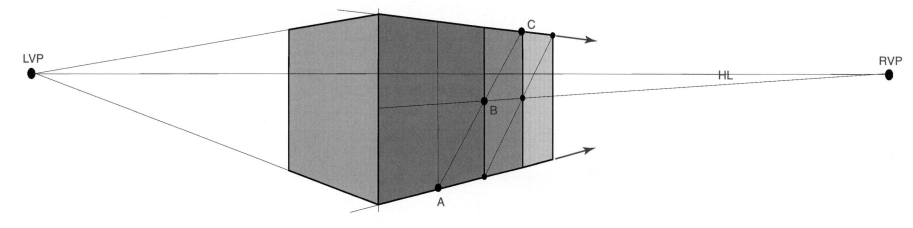

FIGURE 4.1.26

In Section 2 we will apply the methodologies learned in this section to lay out a component stereo system.

REQUIRED EXERCISE

Lesson 4 Section 2
Apply the Methodologies of Subdividing and Expanding a Cube

COMPONENT STEREO SYSTEM—FIGURE 4.2.1

- Figure 4.2.1 illustrates a side view and front view of a component stereo system with a receiver on the top layer and a DVD player on the bottom.

- In Figure 4.2.1, the gray shaded area represents a cube with the height, length, and depth being equal. X represents the proportions and dimensions of the stereo system. Each of the three 1X dimensions represents one side of the cube.

- Notice that the overall stereo system proportions are 1 cube high, 2 cubes in length, and 1-1/2 cubes in depth.

- The following pages will lead you through a step-by-step process to lay out the stereo system.

- Note: For those of you who are visual learners, there is a video demonstrating the layout process used to create the stereo drawing. It is the first video from Section 3 in MyKit. You may want to review it before starting this section.

Stereo Receiver / DVD Player

Side View Front View

FIGURE 4.2.1

BEGIN YOUR DRAWING BY ESTIMATING
A CUBE IN TWO-POINT PERSPECTIVE—FIGURE 4.2.2

- The cube is drawn below the horizon line because the typical viewing angle of an object this size would be at normal standing eye-level looking down.

- Draw diagonals on the right and left face of the estimated cube to identify the center points.

- Draw verticals and horizontals through the center of each set of diagonals. The horizontals extend to the vanishing points.

- On the leading edge of the cube, **estimate** tick marks subdividing the edge into eight equal increments. The process to subdivide the leading edge is as follows:

 - Simply place the first tick mark (A) on the center of the leading edge of the cube.

 - Divide the top half of the leading edge line into two (B) equal increments.

 - Divide the bottom half of the line into two (C) equal increments.

 - Divide the resulting increments again and you will have estimated eight visually equal spacings. Each increment equals 1/8 of the leading-edge line and will help to proportion horizontal lines consistent with the stereo dimensions.

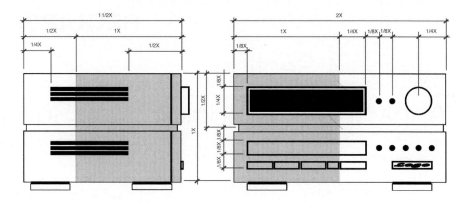

FIGURE 4.2.2 REFERENCE

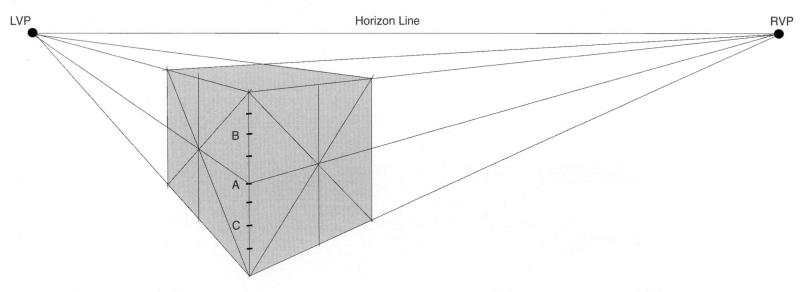

FIGURE 4.2.2

EXTEND THE RIGHT AND LEFT FACE
OF THE CUBE—FIGURE 4.2.3

- Extend the right face of the cube by proportionally duplicating the original surface. Use the methodology learned in Section 1 by extending a guideline from point A, through point B, to the top-edge extension line C. At the intersection, drop a vertical to the bottom-edge extension line D.

- Extend the left face of the cube by one-half. Use the methodology learned in Section 1 by extending a guideline from point E, through point F, to the top-edge extension line G. At the intersection, drop a vertical to the bottom-edge extension line H.

- Add guidelines from point G to the right vanishing point and point C to the left vanishing point.

- The stereo proportions (2 cubes to the right and 1-1/2 cubes to the left) are now complete.

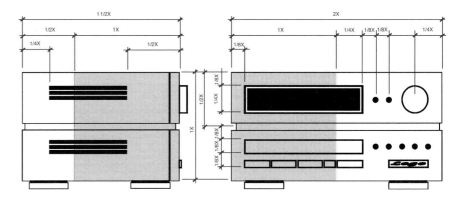

FIGURE 4.2.3 REFERENCE

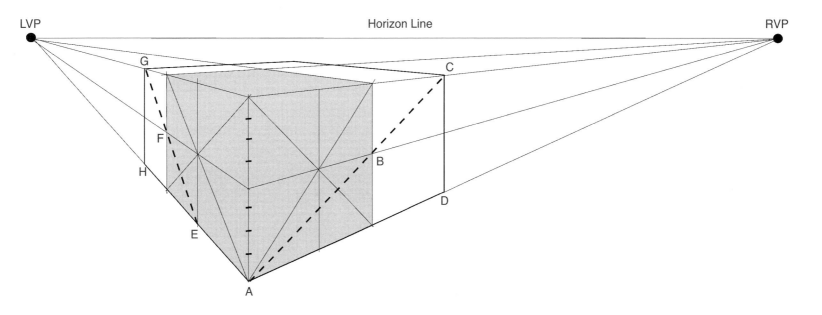

FIGURE 4.2.3

Two-Point Perspective Proportioning Methodologies

LAYING OUT THE DETAILS—FIGURE 4.2.4

- Use the reference drawing to lay out the horizontal guidelines on the right side of the stereo.

 - Guidelines A and B represent the top and bottom of the display window in the receiver.

 - Guidelines C and D represent the reveal separating the receiver and DVD player. Estimate the spacing.

 - Guidelines E and F represent the DVD drawer opening.

- Use the reference drawing to lay out the horizontal guidelines on the left side of the stereo.

 - Guidelines G and H represent the louver openings on the stereo receiver.

 - Guidelines J and I represent the reveal separating the receiver and DVD player. Estimate the spacing.

 - Guidelines K and L represent the louvers on the DVD player.

- All horizontal guidelines converge to the vanishing points.

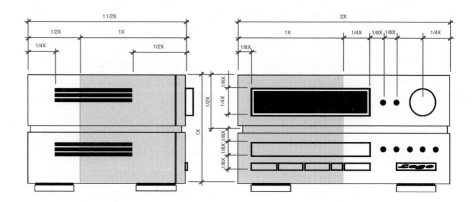

FIGURE 4.2.4 REFERENCE

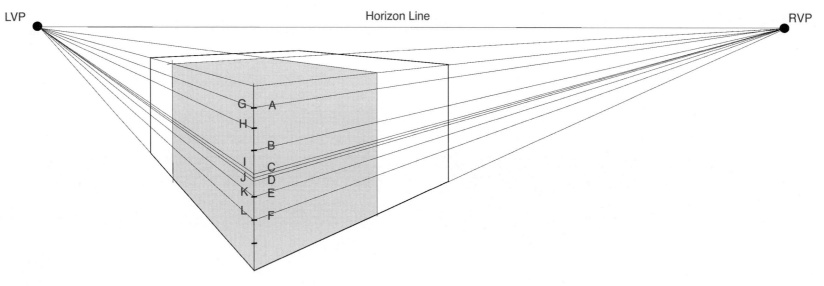

FIGURE 4.2.4

LAYING OUT THE DETAILS—FIGURE 4.2.5

- Use the reference drawing to lay out the vertical guidelines on the right side of the stereo.

 - Estimate square A on the top-left corner of the right face of the stereo.

 - Drop guideline B from the right side of estimated square A. This represents the left vertical of the stereo display window and the left vertical of the DVD drawer.

 - Use diagonals to locate the center of extended cube 1 and draw vertical guideline C.

 - Use diagonals to locate the center of the left half of extended cube 1 and draw vertical guideline D representing the right vertical of the display window and DVD drawer.

- Use the reference drawing to lay out the vertical louver opening guidelines on the left side of the stereo.

 - Guideline E represents the center of the original estimated cube and the right louver alignment.

 - Guideline F represents the center of the extended half-cube 2 and the left louver alignment.

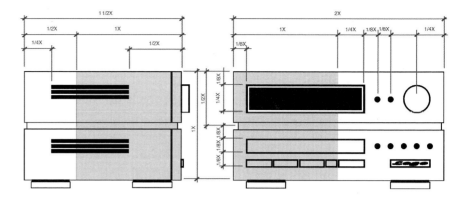

FIGURE 4.2.5 REFERENCE

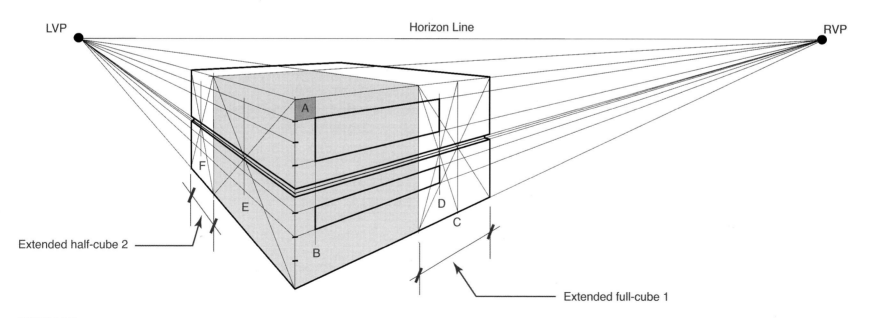

FIGURE 4.2.5

Two-Point Perspective Proportioning Methodologies

ADDING THE CONTROL KNOB—FIGURE 4.2.6

- The control knob diameter is the same as the height of the display window on the front face of the stereo. The centerline of the window opening is represented by line B. Line B is also the centerline of the control knob.

- The vertical centerline of the control knob is located on centerline A.

- The knob will be drawn using the minor and major axes of an ellipse.

 - Draw the minor axis of the knob through the intersection of vertical line A and horizontal line B.

 - Draw the major axis at a true right angle to the minor axis, as learned in Lesson 3.

 - Using a full arm motion, sketch the ellipse as indicated in Figure 4.2.6.

 - Extend the ellipse forward, creating a cylindrical knob.

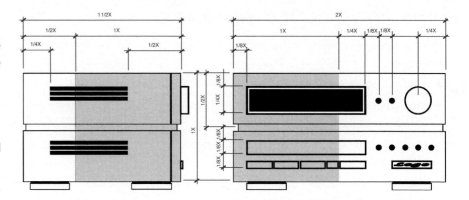

FIGURE 4.2.6 REFERENCE

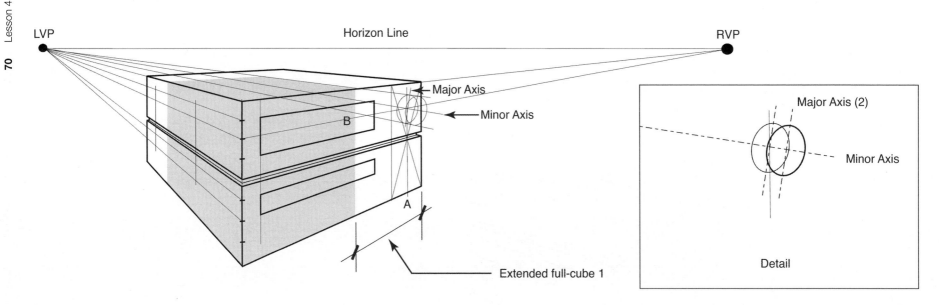

FIGURE 4.2.6

ADDING MORE DETAIL—FIGURE 4.2.7

- Use the reference drawing and guidelines created in Figure 4.2.4 to estimate the spacing and size of the louvers on the left side of the receiver and DVD player.

- Use the reference drawing and your sense of scale and proportion to lay out the control buttons on the right side of the DVD player. Estimate both the depth of the buttons and their spacing.

- Estimate the location and gap size of the cut lines separating the front bezel from the rear of the stereo components. This is represented by line A in Figure 4.2.7.

You may notice that estimating size and proportion is becoming important. The objective is to create a believable drawing, not necessarily an accurate drawing. We could carry subdividing and extending cubes and squares to a ridiculous extreme.

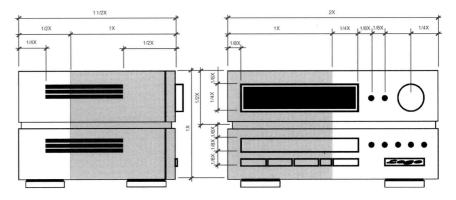

FIGURE 4.2.7 REFERENCE

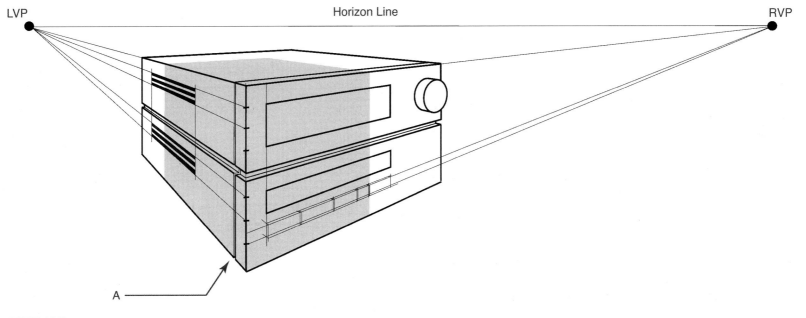

FIGURE 4.2.7

COMPLETING THE DRAWING—FIGURES 4.2.8–4.2.9

- Use the reference drawing, the guidelines created earlier, and your sense of scale and proportion to lay out the LEDs and the logo.

- Now would be a good time to start refining line weights to create a more expressive drawing.

- As illustrated in the reference drawing, the stereo system is floating off the ground on recessed cylindrical feet. From the viewing angle of the sketch, the feet would not be seen. To represent the slightly raised footprint, use the vanishing points to sketch a shadow as represented in Figure 4.2.9.

- You may want to add detail to the display window, knob, and logo. If you have time, add grayscale marker to your drawing.

- We will compare the technical drawing illustrated in Figure 4.2.9 with a hand-drawn sketch of the same object in Section 3. In Section 3, we will also lay out a more complex drawing and work on marker techniques.

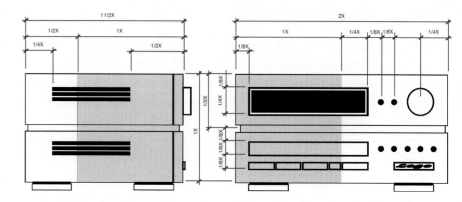

FIGURE 4.2.8 REFERENCE

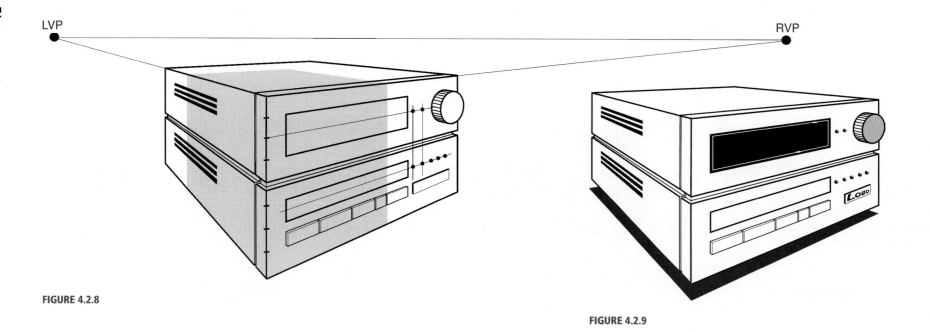

FIGURE 4.2.8

FIGURE 4.2.9

These drawings were done by students at the Art Institute of California–San Diego as an in-class exercise. The time limit for the exercise was 30 minutes.

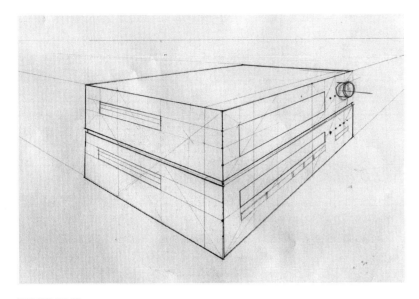

FIGURE 4.2.10

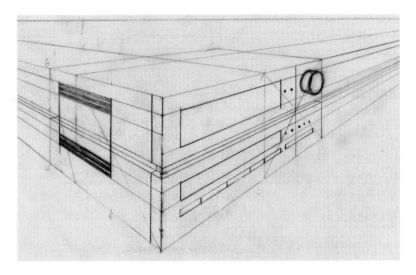

FIGURE 4.2.11

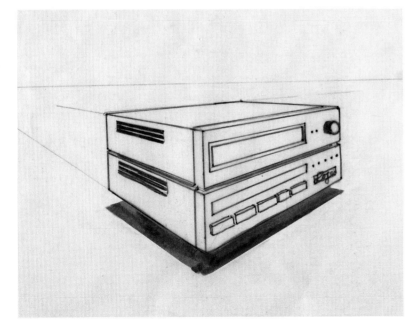

FIGURE 4.2.12

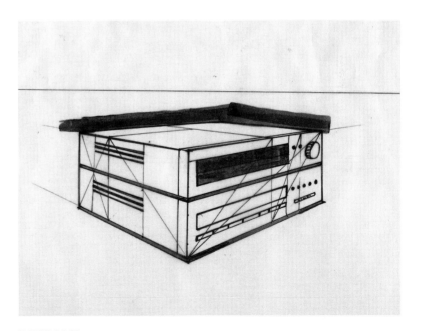

FIGURE 4.2.13

Two-Point Perspective Proportioning Methodologies

RECOMMENDED READING

Lesson 4 Section 3

Video Demonstrations and Lab Exercise 2

LESSON 4, SECTION 3, VIDEOS—FIGURES 4.3.1–4.3.3

- If you have not already viewed the videos for Lesson 4, now would be a good time.
- The first video takes you through the steps covered in Section 2 and will help you visualize the process to estimate, expand, and subdivide a cube. If you are having problems with the concepts in the video, it is recommended you revisit Section 2 of this lesson.
- The second set of videos takes you through the layout and rendering process for the sketch depicted in Figure 4.3.3.
- All of the lessons, exercises, videos, and homework assignments in this text are important steps in understanding perspective and developing your sense of scale and proportion.

NOTE
A perspective layout analysis of Figure 4.3.1 (Lesson 4, Video 1) and Figure 4.3.2 (Lesson 2 Exercise) can be found in Lesson 6, Section 1, Figures 6.1.4 and 6.1.5. You may want to review the analysis now.

FIGURE 4.3.1

FIGURE 4.3.2

LAYOUT AND MARKER EXERCISE OF A COMMUTER TRAIN OR AIRPORT TRAM—FIGURE 4.3.3

- Figure 4.3.3 is the trace-paper drawing done for Video 2, Part 1 and Part 2, from Lesson 4, Section 3. Please review the videos before starting the exercise.

- Lay out a perspective drawing of the vehicle in Figure 4.3.3 and render it in grayscale marker.

- The time limit to complete this exercise is 90 minutes.

- Refer to Figures 4.3.4, 4.3.5, and 4.3.6 for scale, proportion, and layout references.

FIGURE 4.3.3

REFERENCE DRAWINGS—FIGURES 4.3.4–4.3.6

- Figure 4.3.4 is a grid layout of the vehicle. The starting point for your drawing should be a 1X by 1X by 1X cube. Expand the cube by one-half six times.
- Figure 4.3.5 is another instructor reference drawing that is slightly different from Figure 4.3.3.
- Figure 4.3.6 is a perspective layout that may help you get started on your drawing. You may change the design and detail, but try to maintain the proportions.

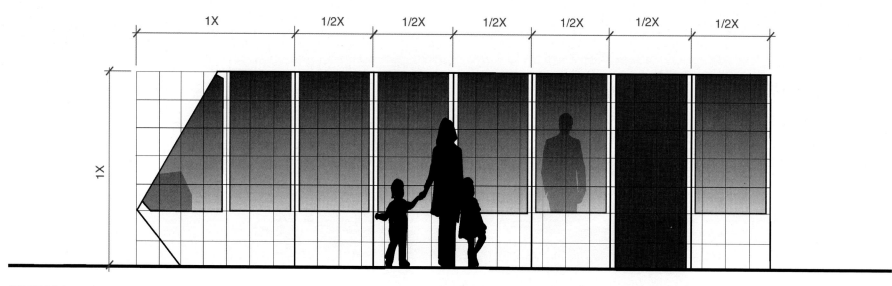

FIGURE 4.3.4

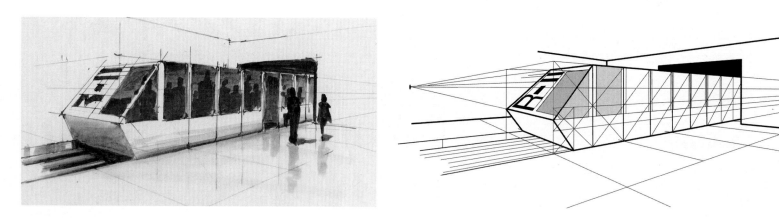

FIGURE 4.3.5

FIGURE 4.3.6

Students at the Art Institute of California–San Diego did these drawings as an in-class exercise. The time limit for the exercise was 90 minutes.

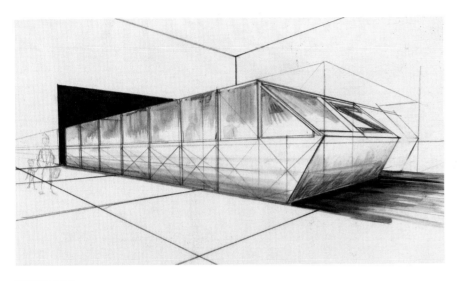

FIGURE 4.3.7

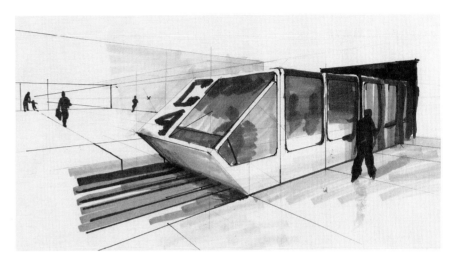

FIGURE 4.3.8

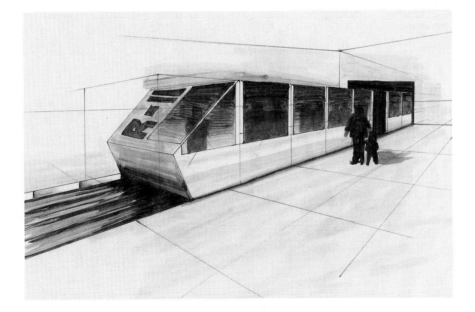

FIGURE 4.3.9

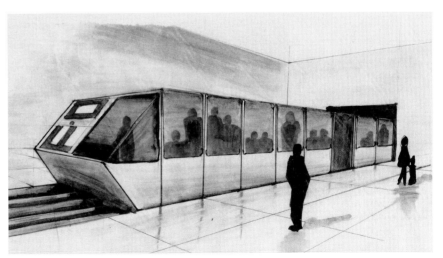

FIGURE 4.3.10

REQUIRED ASSIGNMENT

Lesson 4 Section 4
Homework

HOMEWORK ASSIGNMENT (4 HOURS)

- Interior Designers and Graphic Designers: Find a reference photo of a group of three architectural objects. Use the reference to lay out the objects on trace paper and render them with grayscale marker. If you trace your layout before rendering, save both the final rendering and the layout drawing. It is important to use the methodologies learned in this lesson to proportion the objects at a believable scale. Figure 4.4.1 is an example of a completed homework assignment.

- Game Artists and Animators: Find a reference drawing or photograph of a complex object or group of simpler objects consistent with your major. Use a pen or pencil to lay out the objects at a believable scale and render the objects with grayscale markers. You may modify the design but you must maintain the proportions. If you trace your layout before rendering, save both the final rendering and the layout drawing.

NOTES
- It is important that you do not copy or trace original work. These assignments are designed to develop your drawing skills and your sense of scale and proportion. Nothing is learned by tracing other people's work.

- Take your time with the layout. If you are having problems, walk away from your drawing for a while. You will have a fresh point of view when you return.

FIGURE 4.4.1

REQUIRED READING

Lesson 4 Section 5
Homework Examples

Figures 4.5.1 through 4.5.6 are examples of homework completed by students at the Art institute of California–San Diego.

FIGURE 4.5.1

This is a well-scaled perspective drawing of three architectural objects. The marker rendering shows excellent value differentiation as learned in Lesson 2. The sketch is loose with overlapping lines and nice detail. The shadows and reflections complete the drawing and give the objects a sense of place.

FIGURE 4.5.2

Although walls are not a requirement for this homework assignment, they add a nice touch to the drawing. The scale and proportion are well done, with just enough detail to communicate high-level understanding. The style of the drawing is loose and sketchy and looks like it was done effortlessly. This drawing, as do the other examples of student work, meets the high expectations for this assignment.

FIGURE 4.5.3

This is another example of a well-proportioned and well-rendered drawing. The sofa texture and form appear soft and inviting. This drawing would make a good concept layout for a furniture advertisement. All that's required is the typography.

FIGURE 4.5.1

FIGURE 4.5.2

FIGURE 4.5.3

FIGURES 4.5.4–4.5.6

The game art students who did these drawings applied a high-level understanding of the processes learned in this lesson to lay out and render these complex objects. The drawings are believable from a scale and proportion standpoint.

Contrasting line weights and detail on both drawings contribute to their high quality. The addition of a human figure helps to communicate scale.

FIGURE 4.5.4

FIGURE 4.5.5

FIGURE 4.5.6

Use of a Measuring Line 5

to Proportion a Two-Point Perspective

Lesson Overview

Lesson 5 is written in five sections:

- Lesson 5, Section 1 introduces the use of a measuring line and measuring point to proportion objects or interiors in two-point perspective. In addition, the Lesson 5, Section 1 Video is discussed.

- Lesson 5, Section 2 leads you through a perspective layout process using the methodologies discussed in Section 1 and reinforced with the Section 1 Video.

- Lesson 5, Section 3 amplifies application of the measuring line and measuring point.

- Lesson 5, Section 4 is a homework exercise that requires laying out a perspective drawing using the methodologies learned in this lesson. The layout is to be rendered with grayscale marker.

- Lesson 5, Section 5 includes samples of student work with instructor comments.

It is recommended that students follow the Section 1 and Section 3 instructions by drawing freehand and estimating proportion and scale. Use a large triangle or straight edge to complete the lab exercise in Section 2.

NOTE
Most design students are visual learners. MyKit instruction for this lesson includes:

- Section 1, Video 1 demonstrates the use of a measuring point in the layout of a two-point perspective interior space. The layout is fully documented in Section 2 of this lesson.

- Section 1, Video 2 demonstrates the use of grayscale marker to complete the rough interior sketch.

- Section 3, Video 1 demonstrates the use of a measuring point to lay out a perspective grid. The grid is used to transfer a complex shape to perspective.

REQUIRED READING

Lesson 5 Section 1
Using a Measuring Line and Measuring Point

ESTIMATE OVERALL PROPORTIONS OF A TWO-POINT PERSPECTIVE—FIGURES 5.1.1–5.1.2

- Use the cube expansion methodology learned in Lesson 4 to lay out a perspective drawing of a structure that is 8'-0" high × 16'-0" long × 8'-0" deep.

- Figure 5.1.1 represents the overall layout of the 16'-0" side of the structure. Note the dimensions representing the door and window locations.

- Figure 5.1.2 represents the perspective layout of the structure. The layout proportions were estimated, using a cube as a starting point. The cube methodology (line through points A, B, and C) was introduced in Lesson 4.

- Next, we will use the measuring line in Figure 5.1.1 to proportion the door and window location in perspective.

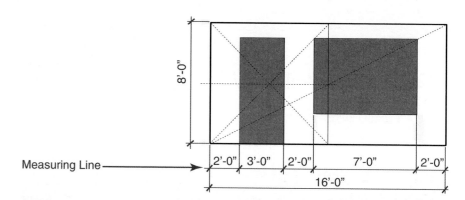

Measuring Line

FIGURE 5.1.1

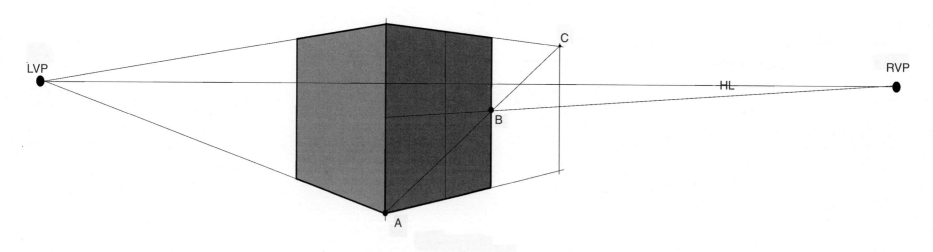

FIGURE 5.1.2

LAYING OUT THE MEASURING LINE (ML) AND MEASURING POINT (MP)—FIGURES 5.1.3–5.1.4

- As indicated in Figure 5.1.4, draw a measuring line (ML) parallel with the horizon line starting at the forward edge of the structure and extend it to the right.

- It is CRITICAL when using a measuring line of this type that the proportions of the object are believably scaled. Remember, the cube is the basis for proportioning an object. If the object is proportioned too long or too short, the measuring line will distort the perspective.

- It is CRITICAL that the starting point of the measuring line is the lowest point on the leading edge of the perspective. Note the starting point of the measuring line in Figure 5.1.4.

- Scale the ML to reflect the dimensions in Figure 5.1.3. Any scale will work, but try not to extend the ML too far to the right of the structure or stop too short of the overall length of the structure. In Figure 5.1.4, the ML extends slightly beyond the perspective length of the structure.

- Relate the ML to the structure with line AB. From the end of the ML (point A), extend a guideline through the bottom end of the structure (point B) and continue the guideline to the horizon line (point C).

- The intersection of line ABC with the horizon line is marked as the measuring point, or MP.

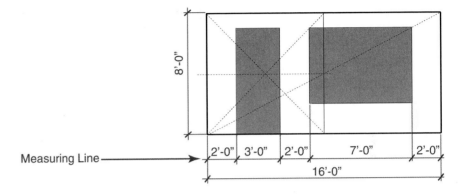

FIGURE 5.1.3

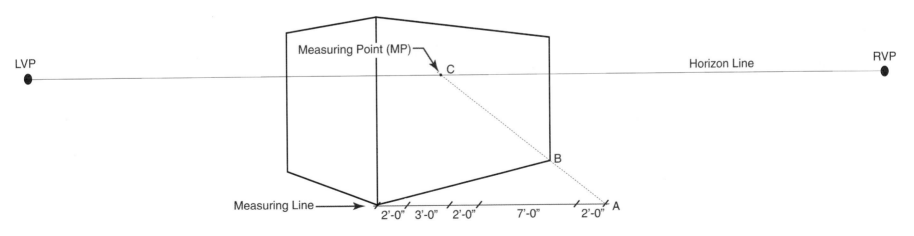

FIGURE 5.1.4

TRANSFER MEASURING LINE PROPORTIONS TO THE STRUCTURE—FIGURE 5.1.5

- From the MP, draw guidelines to each measurement on the ML.

- The ML proportions have now been transferred to the base of the structure at points A, B, C, and D in perfect linear perspective.

- Add tick marks at points A, B, C, and D. The ML and MP will no longer be used. Their function is complete.

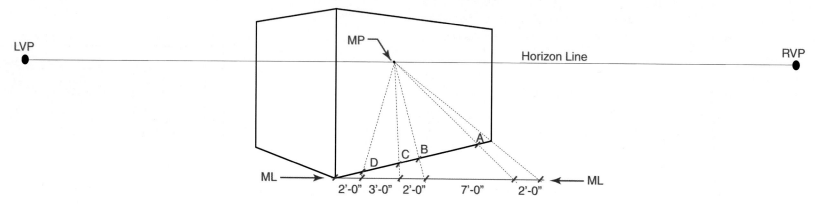

FIGURE 5.1.5

COMPLETING THE DOOR AND WINDOW LAYOUT—FIGURE 5.1.6

- You should recall from a previous lesson that the leading edge of a two-point perspective object is also a measuring line. Scale (or estimate) the leading edge of the structure into eight equal 1'-0" increments. Vertical tick marks representing the eight 1'-0" increments have been added to Figure 5.1.6.

- The door and window heights are 7'-0". The window is 2'-6" above the ground line.

- Use the tick marks on the leading edge and the ground line of the structure to add the door and window represented in Figure 5.1.6.

- You have completed the use of a measuring line and a measuring point to proportion a structure in perfect linear perspective. This process is useful when proportioning a perspective into unequal increments.

- Now would be a good time to view the Video Lessons (Parts 1 and 2) for Lesson 5, Section 1. The videos demonstrate using the ML and MP to proportion an interior.

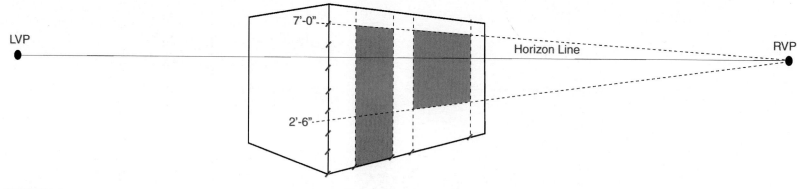

FIGURE 5.1.6

VIDEOS

Lesson 5 Section 1

PRINT OF VIDEO DEMONSTRATIONS— FIGURE 5.1.7

- The Video Lessons demonstrate the use of a measuring line and measuring point to create an interior drawing with believable proportions.

- The drawing was completed in about 30 minutes and is considered a rough. A rough will usually save considerable time when preparing a presentation drawing.

- The notes added to Figure 5.1.7 identify areas for improvement. A final drawing may take these items into consideration.

Section 2 of this lesson will take you step by step through the process to lay out this drawing.

Comments:

1. Add architectural detail to rail.
2. Add decorative elements above mantle.
3. Add height, logs, and fire to fireplace.
4. Reflections are too harsh.
5. Add end table.
6. Add two club chairs or small sofa.
7. Add pillows to sofa.
8. Add potted plants.
9. Increase size and add arms to chair.

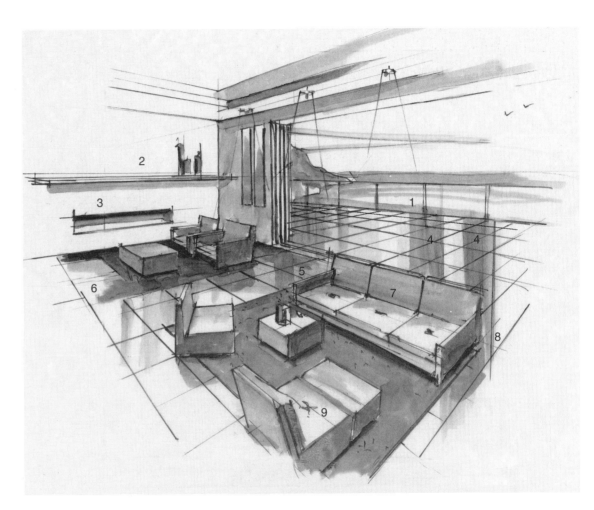

FIGURE 5.1.7

RECOMMENDED EXERCISE

Lesson 5 Section 2
Interior Perspective Lab Exercise

FLOOR PLAN AND CONE-OF-VISION ANALYSIS—FIGURES 5.2.1–5.2.2

- An important first step in creating an interior perspective is to lay out a scaled floor plan (Figure 5.2.1), and establish a cone of vision (Figure 5.2.2).

- The cone of vision is established by locating the point from which you are viewing the interior. As we learned previously, this point is called a station point (SP). The normal view of an interior is from inside the space. If the SP is located too far outside the room, the drawing will appear as though you are looking at it from too far away and compromise believability. Try to keep the station point within the room or just slightly outside it.

- From the station point, a normal cone of vision for an interior perspective is approximately 60 degrees. If you exceed 60 degrees, objects outside the cone of vision may appear distorted. Once the layout is under way, you may find you can extend some objects beyond the cone of vision. Compare Figure 5.2.2 with the video drawing (Figure 5.1.7), and notice that the sofa is extended beyond the cone of vision and still appears believable. After a drawing is started, use your sense of scale and proportion to make "outside-the-cone-of-vision" decisions. Do NOT make these decisions before starting the drawing.

- We generally start a drawing by proportioning a wall. In the video, we began with the right wall of the interior. If the starting point of the wall is outside the cone of vision, the proportions of your drawing may be compromised. It's a good idea to start a perspective layout within the cone of vision. The starting point for the right wall of this exercise is point A in Figure 5.2.2. Point A cuts the sofa about in half.

Great Room Lay-out Concept

FIGURE 5.2.1

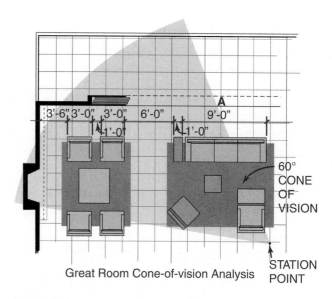

Great Room Cone-of-vision Analysis

FIGURE 5.2.2

STARTING THE DRAWING—FIGURE 5.2.3 AND FIGURE 5.2.3 REFERENCE

- The horizon line and vanishing points are the starting point of any perspective drawing. The horizon line is located at standing eye level or between 5'-0" and 6'-0" above the floor. As you lay out your drawing, keep the overall proportions similar to those in Figure 5.2.3, with the vanishing points located at the left and right edges of your paper.

- The 22'-0" right interior wall is proportioned by estimating a square in perspective that is 11'-0 high by 11'-0" wide. This is represented by the gray square in Figure 5.2.3.

- In any two-point perspective, there is always one vertical line that can be scaled. It is called a measuring line. In Figure 5.2.3, the leading vertical edge of the square is the measuring line. Scale the measuring line into 11 equal 1'-0" increments.

- Expand the 11'-0" square toward the left vanishing point with the use of diagonals as learned in Lesson 4. The expansion is represented by the dotted line in Figure 5.2.3.

- Duplicating the 11'-0" square will proportion the right wall at 22'-0" long by 11'-0" high. This keeps the right wall completely within the cone of vision as represented in Figure 5.2.3 Reference.

- From the rear edge of the right wall, draw the left wall by striking guidelines from the right vanishing point through the top and bottom of the rear vertical corner. The right and left walls are complete.

- Add a horizontal measuring line starting at the leading edge of the 11'-0" wall and extend it left keeping it parallel with the horizon line, as represented in Figure 5.2.3. Scale the measuring line consistent with the dimensions in Figure 5.2.3 Reference. Any scale will work, but try not to extend it too far beyond the corner of the room. Note the starting point of the measuring line.

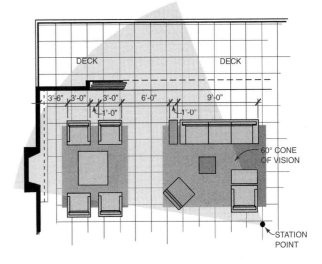

FIGURE 5.2.3 REFERENCE

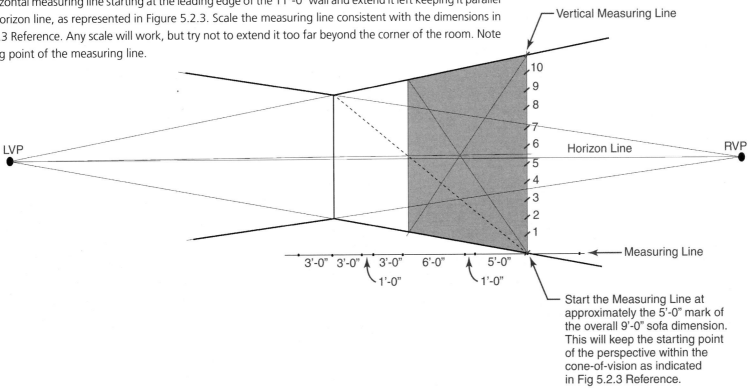

Start the Measuring Line at approximately the 5'-0" mark of the overall 9'-0" sofa dimension. This will keep the starting point of the perspective within the cone-of-vision as indicated in Fig 5.2.3 Reference.

FIGURE 5.2.3

MEASURING LINE AND MEASURING POINT—FIGURE 5.2.4 AND FIGURE 5.2.4 REFERENCE

- Relate the left end of the measuring line to the left end of the right interior wall. Line AB represents this.

- Extend line AB to the horizon line (HL) at point C. The intersection of line ABC with the HL is the measuring point (MP).

- Draw guidelines from the MP to each scaled increment on the measuring line (ML).

- Add tick marks where the guidelines connecting the ML and MP intersect with the bottom edge of the right wall.

- The bottom edge of the right wall is now proportioned in linear perspective consistent with the furniture layout dimensions in Figure 5.2.4 Reference.

- The ML and MP are no longer required to complete the drawing. They may be erased if you are using pencil.

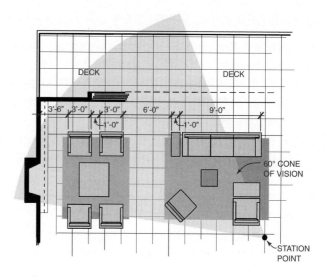

FIGURE 5.2.4 REFERENCE

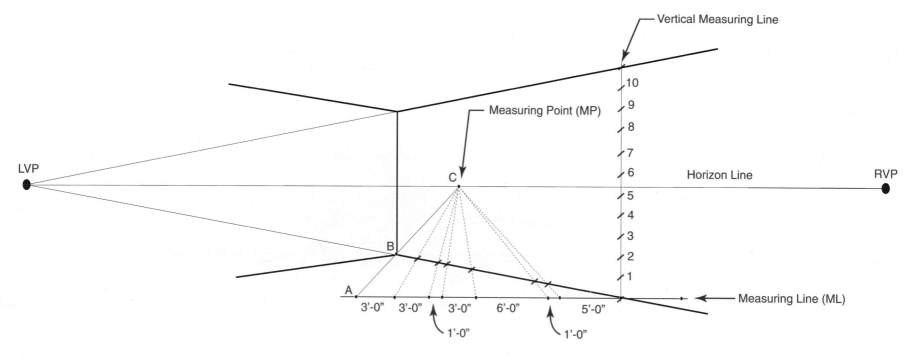

FIGURE 5.2.4

STARTING THE PERSPECTIVE FLOOR PLAN LAYOUT—FIGURE 5.2.5 AND FIGURE 5.2.5 REFERENCE

- The easiest way to draw interior furniture is by first laying out the furniture floor plan in perspective. We will use the measuring line tick marks on the right wall and our sense of scale and proportion to accomplish this.

- Strike guidelines from the right vanishing point through each tick mark on the base of the right interior wall. These lines represent the two club chairs toward the rear corner of the room (1), the aisle between the furniture groupings (2), the side table (3), and the sofa (4). Note that the sofa is extended and estimated at 9'-0" long.

- Now comes the tricky part. Use your sense of scale and proportion to estimate the depth of the sofa and the walkway behind the sofa. Both the sofa and walkway are approximately 3'-0" deep. Strike lines from the left vanishing point representing these dimensions.

- The footprints of the sofa, end table, and two club chairs are indicated in gray in Figure 5.2.5.

- Note: We could use a measuring line on the left wall to grid off the floor, but it would be too time consuming and counterproductive. To draw believable perspectives, it is important to use measuring and proportioning methodologies, but it is just as important to use a keen sense of scale and proportion. This sense of scale and proportion is a skill that is learned. The lessons, exercises, and homework in this text are designed to develop your sense of scale and proportion.

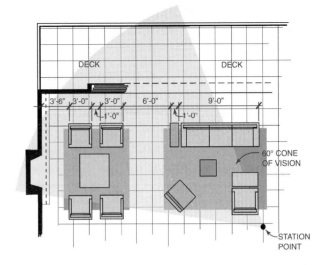

FIGURE 5.2.5 REFERENCE

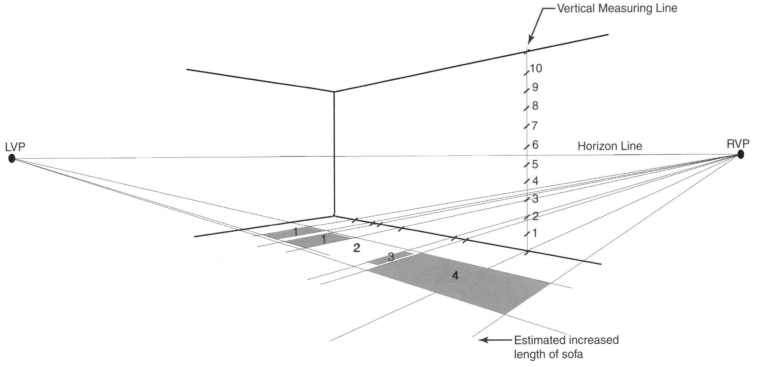

FIGURE 5.2.5

COMPLETING THE PERSPECTIVE FLOOR PLAN LAYOUT—FIGURE 5.2.6
AND FIGURE 5.2.6 REFERENCE

- Continue using your sense of scale and proportion to lay out the rest of the furniture in a perspective plan view. The furniture is represented as gray rectangles in Figure 5.2.6.

- Chair "A" is turned 45 degrees and is parallel with the picture plane. Whenever an object is rotated in a drawing, it will require new vanishing points. Because the chair is rotated parallel with the picture plane, it becomes an object in one-point perspective.

- The forward and rearward edge of chair A is parallel with the horizon line. The distance between the edges is estimated. The proportions of the chair appear to be square in Figure 5.2.6 Reference. Estimate these proportions on your drawing and run guidelines representing the front and rear edges of the chair to the horizon line as indicated in Figure 5.2.6. The intersection with the horizon line is a central vanishing point (CVP). If necessary, adjust the edges so they converge to the CVP.

- Now is the time to critically look at your drawing and compare it to Figure 5.2.6 Reference. Make proportional adjustments as required to your perspective floor plan. It is easier to adjust the drawing now rather than after the furniture has been lifted up, in perspective, off the floor.

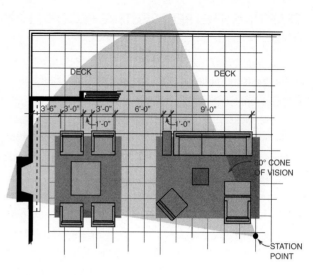

FIGURE 5.2.6 REFERENCE

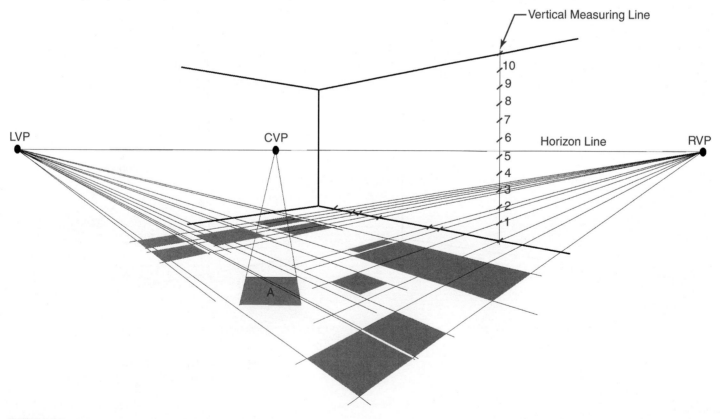

FIGURE 5.2.6

ADDING DIMENSION AND DETAIL TO THE DRAWING—FIGURE 5.2.7 AND FIGURE 5.2.7 REFERENCE

- Use the right and left vanishing points to draw the furniture up off the floor. The height of the furniture can be scaled using the vertical measuring line.

- The small square coffee table is drawn at approximately 16" off the floor line.

 - Line AB is drawn from the RVP through the bottom edge of the coffee table.

 - Line BC represents the 16" height of the coffee table and is determined by the vertical measuring line.

 - Line CD is drawn to proportion the height of the coffee table. The coffee table can now be completed. Points A and D represent the height of the leading vertical edge of the coffee table.

 - The seat height of the furniture is about the same height as the coffee table (16"). Line EF is projected from the coffee table to the one-point perspective chair. The chair can now be completed using the 16" measurement and the CVP.

 - The sofa and foreground club chair are partially laid out using the perspective floor plan and the vertical measuring line for proportions.

- Complete the furniture layout and add architectural detail to the drawing. Use the video demonstration drawing (Figure 5.1.7) as reference. Be creative with your drawing. When the layout is complete, add grayscale marker to finish the exercise.

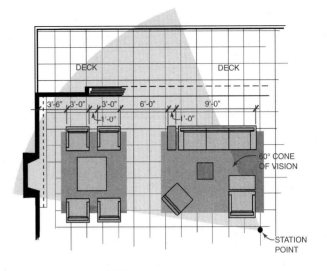

FIGURE 5.2.7 REFERENCE

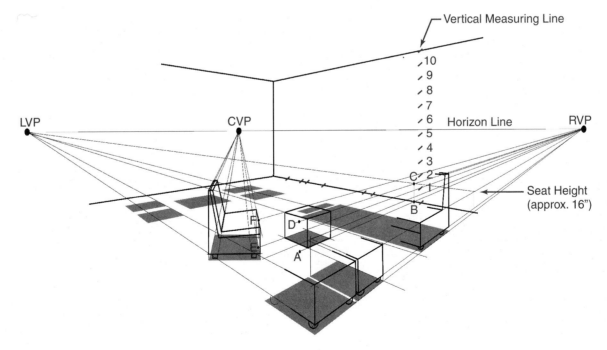

FIGURE 5.2.7

STUDENT WORK—FIGURES 5.2.8–5.2.10

- These drawings were all done as homework. The lab exercise rough was completed in class and finalized as homework.

- Each of these student drawings demonstrates an excellent understanding of the proportioning methodologies learned in this lesson. Students applied their sense of scale to create believable perspectives.

- Student marker skills are developing nicely and reflect abilities above expectations for this assignment.

- Each of these drawings was cropped to keep the furniture and architectural details within the cone of vision.

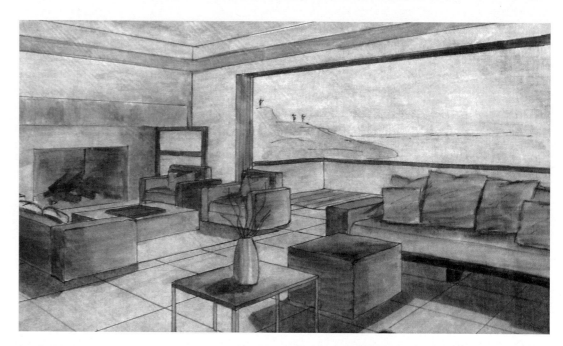

FIGURE 5.2.8

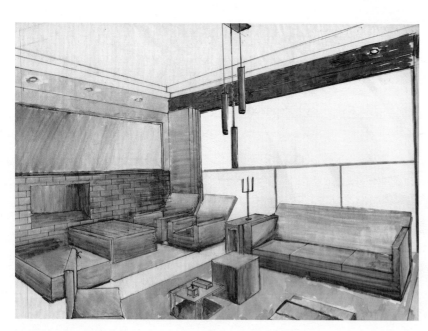

FIGURE 5.2.9

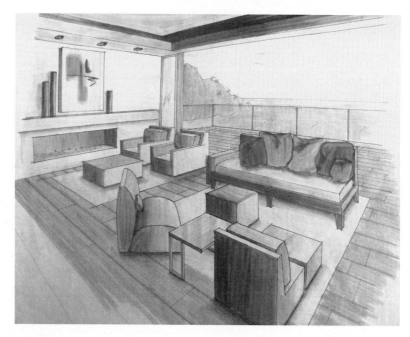

FIGURE 5.2.10

OPTIONAL EXERCISE

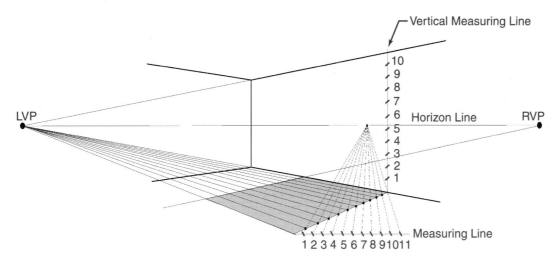

FIGURE 5.2.11

INTERIOR GRID—FIGURES 5.2.11–5.2.12

For those of you who are fans of the grid, the estimated square, measuring lines, and diagonals can be used to create a gridded perspective. Figure 5.2.11 was started by proportioning the 22' length and 11' height of the right wall (refer to Figure 5.2.3) and then estimating an 11' × 11' square on the floor (gray shaded area). A measuring line was created in Figure 5.2.11 to subdivide the gray floor square into 11 equal 1' increments, then 1' guidelines were then run through the gray floor square to the left vanishing point. The right wall was then divided horizontally in Figure 5.2.12 by using the vertical measuring line. In Figure 5.2.12, a diagonal on the 11' × 11' estimated right-wall square was added to proportion the verticals. The intersections of the verticals with the floor line are then used to complete the floor grid from the right vanishing point. An additional diagonal on the rear 11' × 11' wall square can be used to complete the right wall and floor grid. A T-square and triangle will facilitate construction of a grid.

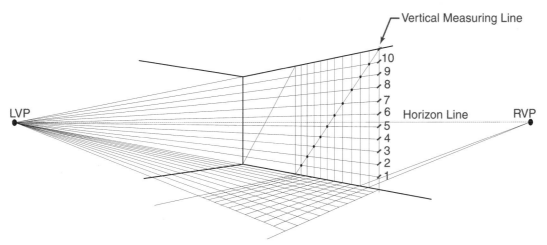

FIGURE 5.2.12

RECOMMENDED EXERCISE

Lesson 5 Section 3
Perspective Grid Exercise

CONVERTING ELEVATIONS OF COMPLEX OBJECTS OR GRAPHICS TO PERSPECTIVE—FIGURES 5.3.1–5.3.4

- We will use the graphic layout in Figure 5.3.1 and convert it to a two-point perspective using a measuring line and a perspective grid.

- We begin the drawing by constructing a two-dimensional grid on the elevation to be converted to a perspective (Figure 5.3.1).

- Use the process outlined on the following pages to complete a gridded perspective.

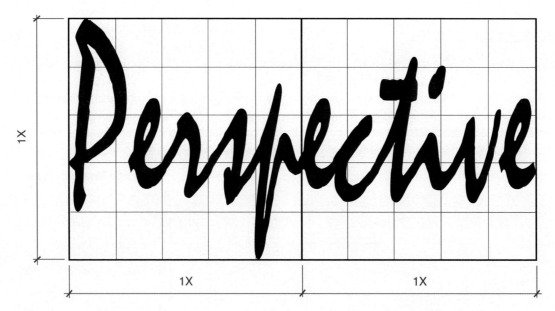

FIGURE 5.3.1

ESTIMATING PERSPECTIVE PROPORTIONS—FIGURE 5.3.2

- Begin your perspective by drawing a vertical measuring line. It is critical that the measuring line for the perspective start at the upper-left corner of the elevation grid (point A). Scale the vertical measuring line into the same number of increments as the two-dimensional elevation. In Figure 5.3.2, both the elevation and vertical measuring line are scaled into five equal vertical increments. The scale does not matter. It may result in a larger or smaller perspective than the elevation.

- Continue your perspective by laying out a horizon line (HL) and right vanishing point (RVP).

- Lay out the perspective proportions by estimating a square (gray shaded area) and expand the square to the right vanishing point with a diagonal. The perspective is now the same proportion as the elevation (1 square high by 2 squares deep).

- Align the elevation grid to the perspective by running a guideline from point B to point C. Extend line BC to the HL and mark the intersection as the MP (measuring point).

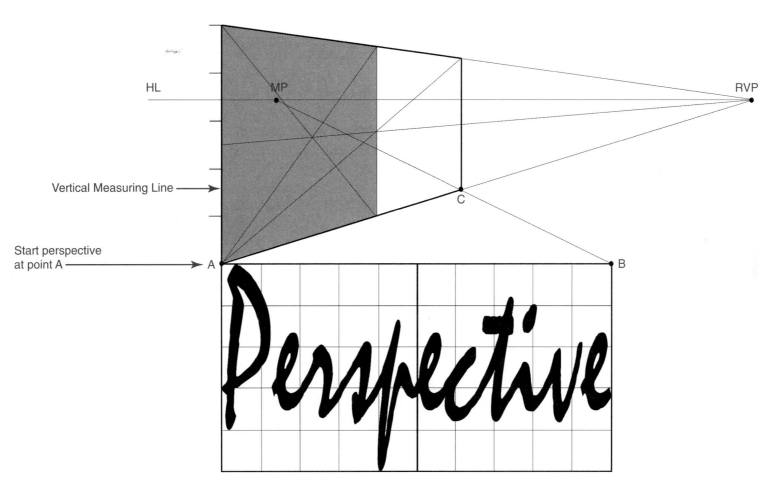

FIGURE 5.3.2

CONSTRUCTING VERTICAL GRID LINES ON THE PERSPECTIVE—FIGURE 5.3.3

- From the MP, draw guidelines to the top of each vertical grid line on the two-dimensional elevation (points A, B, C, D, E, F, G, H, I, J).

- From the intersection of these guidelines, with the base of the perspective, draw vertical grid lines on the perspective.

- Note how the vertical grid lines on the perspective appear to get closer together as they converge to the right vanishing point (RVP).

- From the vertical measuring line increments on the perspective (1, 2, 3, and 4), draw grid lines to the RVP.

- The perspective grid has been completed using measuring lines and a measuring point.

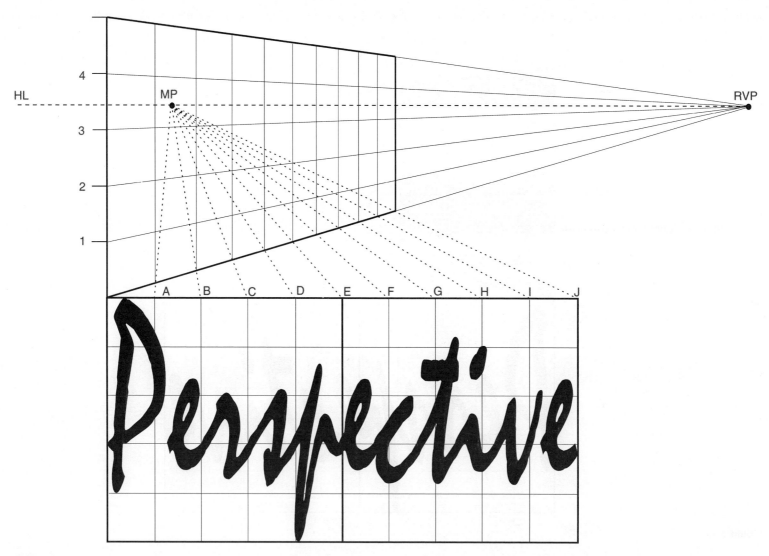

FIGURE 5.3.3

USING THE GRID TO SKETCH THE PERSPECTIVE—FIGURE 5.3.4

- With the perspective grid complete, it is a relatively simple matter to transfer the elevation typography to the perspective.

- This process can also be used to lay out complex objects.

- Depth can be added to the perspective by creating a left vanishing point (LVP).

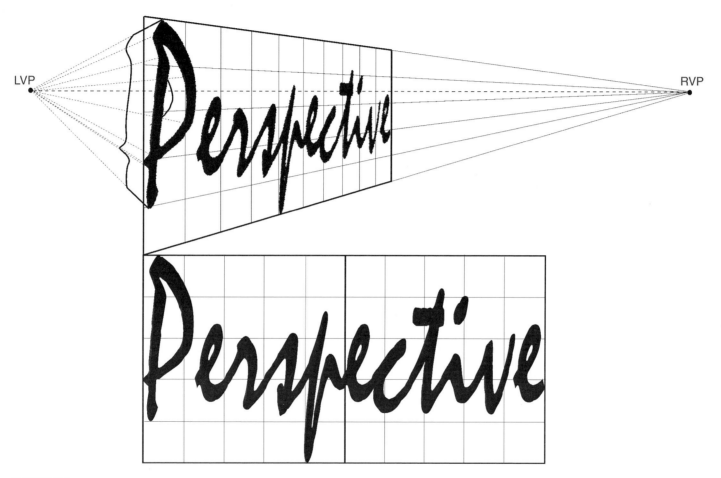

FIGURE 5.3.4

REQUIRED EXERCISE

GRID PRACTICE—FIGURE 5.3.5

- Add your signature to the elevation grid and transfer it to the perspective grid.
- Use the LVP to add depth to your signature.

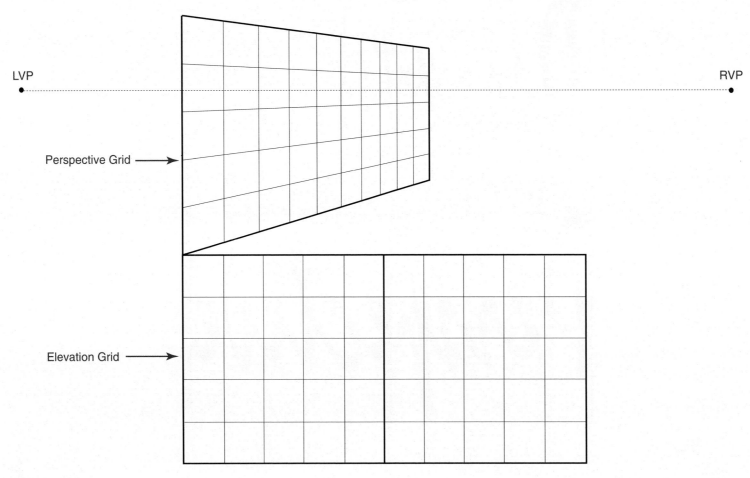

FIGURE 5.3.5

REQUIRED ASSIGNMENT

Lesson 5 Section 4
Homework

HOMEWORK ASSIGNMENT (4 HOURS)

- Interior Designers: Use Figure 5.4.1 and Section 2 of this lesson as a reference to lay out an interior perspective. Use a measuring line and a measuring point to proportion your sketch.

 Use Figure 5.4.3 as reference for dimensioning and cone of vision. Complete your drawing as a grayscale marker rough. Do not take more than 60 minutes to add marker to the layout drawing.

- Graphic Designers: Design a three-dimensional personal logo. Lay out a perspective drawing of your personal logo using the measuring line grid process reviewed in Section 3.

 Add depth to your logo design and complete your drawing with grayscale marker rendering.

 - Game Artists and Animators: Use Figures 5.4.2 and 5.4.4 as a basis for your drawing. Lay out your drawing using the methodologies learned in Lessons 4 and 5. Figure 5.4.5 offers one way to get started with your drawing.

 Complete your drawing with grayscale marker rendering.

FIGURE 5.4.1

Courtesy of Jupiterimages

FIGURE 5.4.2

REFERENCE DRAWINGS—FIGURES 5.4.3–5.4.4

- Interior Designers: Use Figure 5.4.3 as a reference layout for your homework assignment. You may choose an alternate location for the station point (SP) if desired.

- Animators and Game Artists: Use Figure 5.4.4 as a reference layout for the homework assignment.

Figure 5.4.4 is an interpretation of the inspiration piece (Figure 5.4.2) on the previous page. Dimensions are different but should be used for the homework assignment. Use the proportioning methodologies taught in Lessons 4 and 5 to lay out your drawing. Don't just eyeball it.

One way to proportion the space vehicle perspective is illustrated with Figure 5.4.5 on the next page.

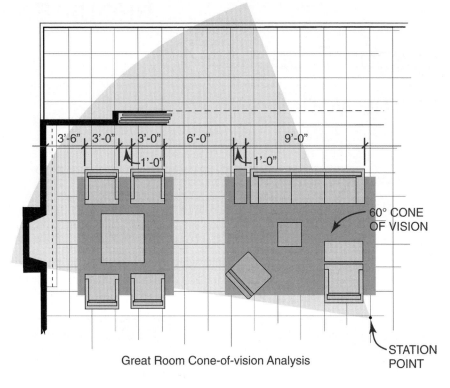

Great Room Cone-of-vision Analysis

FIGURE 5.4.3

FIGURE 5.4.4

PROPORTIONING THE SPACE VEHICLE PERSPECTIVE—FIGURE 5.4.5

There are many ways to apply the methodologies learned in Lessons 4 and 5 to proportion the space vehicle. One way is illustrated in Figure 5.4.5. A square is estimated on the ground and expanded 1/2 square to the left vanishing point and 3 squares to the right vanishing point. These proportions are consistent with Figure 5.4.4. A centered vertical plane, 1 square high and 3 squares deep, is projected to the right vanishing point. The space vehicle elevation is sketched, in perspective, onto the vertical plane. With this layout complete, it is fairly easy to use a trace-paper overlay and sketch the vehicle in perspective. It may take several overlay refinements to complete the sketch.

FIGURE 5.4.5

REQUIRED READING

Lesson 5 Section 5 Homework Examples

Figures 5.5.1 through 5.5.17 are examples of Lesson 5 homework completed by students at the Art Institute of California–San Diego.

FIGURE 5.5.1

The student who did this drawing had extensive perspective experience and was approved to lay out her drawing using Google SketchUp. With the layout complete, she used a fine-line pen and grayscale markers to finalize her drawing.

FIGURE 5.5.2

It's interesting to see the different techniques that develop as students progress through the lessons. This style is loose and sketchy and is laid out and rendered quickly.

FIGURES 5.5.3–5.5.4

This is an example of a graphic designer's personal logo converted to perspective.

NOTE
The interior design, graphic design, game art, and animation students whose work is featured in the first nine lessons are in their first year of design school.

FIGURE 5.5.1

FIGURE 5.5.2

FIGURE 5.5.3

FIGURE 5.5.4

102 Lesson 5

FIGURES 5.5.5–5.5.7

A game art student used both the homework photo in Section 4 and a shark as inspiration for a battleship in action.

FIGURE 5.5.8

This is another example of a graphic design student's two-dimensional personal logo design converted to perspective. Cupcakes are popular right now.

FIGURES 5.5.9–5.5.10

This game art student drawing is nicely rendered using grayscale marker on trace paper. The form of the ship is well communicated through marker gradation, detail, and shadow.

FIGURE 5.5.5

FIGURE 5.5.6

FIGURE 5.5.7

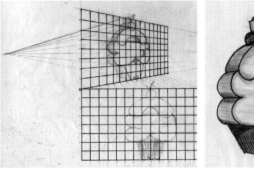

FIGURE 5.5.8

FIGURE 5.5.9

FIGURE 5.5.10

Use of a Measuring Line . . .

FIGURE 5.5.11

The original of this animation student's drawing is very small. The sketch is nicely rendered and detailed.

FIGURE 5.5.12

This game artist's drawing is creative. It is the only example of the spaceship assignment that is drawn and rendered from the rear view. The sketch is improved with a background depicting a landing area. Her layout drawings (not shown) reflect the design changes.

FIGURES 5.5.13–5.5.14

Graphic design students used the grid creatively and effectively to convert their logo designs to a perspective. Both were first-year students and had not yet taken typography courses.

FIGURE 5.5.11

FIGURE 5.5.12

FIGURE 5.5.13

FIGURE 5.5.14

DESIGN DEVELOPMENT— FIGURES 5.5.15–5.5.17

The advantage of trace paper in a design development process is illustrated with these drawings:

- In Figure 5.5.15, a thumbnail of the design idea is sketched in the upper-right-hand corner. The thumbnail is then converted to elevations superimposed on a grid.

- Figure 5.5.16 is a rough perspective developed from the thumbnail and elevations.

- Figure 5.5.17 is a final homework sketch refined on a trace-paper overlay of Figure 5.5.16.

FIGURE 5.5.15

FIGURE 5.5.16

FIGURE 5.5.17

6 Perceived Scale and
Multiple Vanishing Points

Lesson Overview

Lesson 6 is written in six sections:

- Lesson 6, Section 1: Horizon line and vanishing point location communicate perceived scale.
- Lesson 6, Section 2: Auxiliary vanishing points are used when drawing an inclined plane in perspective.
- Lesson 6, Section 3: Multiple vanishing points in a single drawing.
- Lesson 6, Section 4: A quick sketch-drawing exercise.
- Lesson 6, Section 5: Homework exercise.
- Lesson 6, Section 6: Samples of student work with instructor comments.

It is recommended that students follow the Sections 1, 2, and 3 instruction by drawing freehand, estimating proportion and scale. Use a large triangle or straight edge to complete the lab exercise in Section 4.

NOTE
Most design students are visual learners. MyKit instruction for this lesson includes:

- Section 2, Video 1 demonstrates the use of an auxiliary vanishing point required to lay out an inclined plane in two-point perspective.
- Section 2, Video 2 demonstrates the use of an auxiliary vanishing point in the layout of an interior sketch with a beamed vaulted ceiling.
- Section 3, Video 1 demonstrates the use of multiple vanishing points in a two-point perspective.
- Section 4, Video 1 demonstrates the layout and rendering of a quick sketch exercise.

Lesson 6 Section 1

Horizon Line and Vanishing Point Location

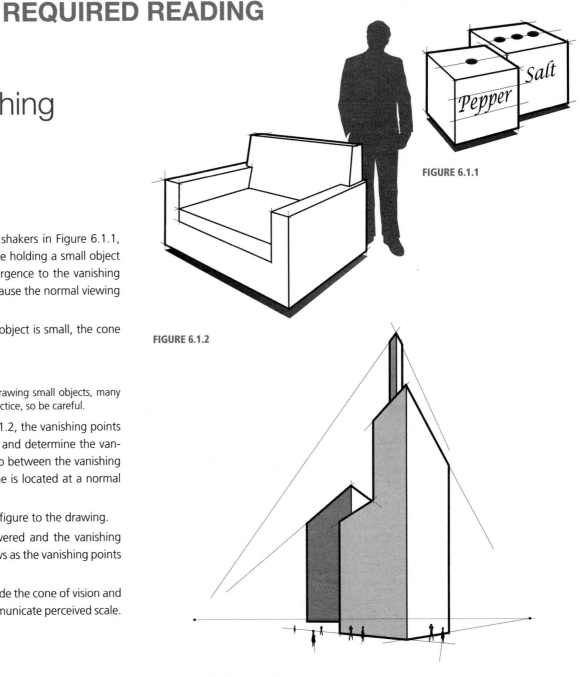

FIGURE 6.1.1

PERCEIVED SCALE—FIGURES 6.1.1–6.1.3

- When drawing small objects such as the salt and pepper shakers in Figure 6.1.1, the vanishing point locations are extremely distant. Imagine holding a small object in your hand. You would observe very little, if any, convergence to the vanishing points. The horizon line is located above a small object because the normal viewing angle is from above.

 When vanishing points are located far apart and the object is small, the cone of vision is large.

NOTE
The vanishing point locations are estimated in Figure 6.1.1. When drawing small objects, many designers do not use a horizon line or vanishing points. This takes practice, so be careful.

- When drawing larger objects such as the chair in Figure 6.1.2, the vanishing points are located a medium distance apart. Use a straight edge and determine the vanishing point location in Figure 6.1.2. Notice the relationship between the vanishing point location and the scale of the object. The horizon line is located at a normal viewing angle above the object.

 Perceived scale can be reinforced by adding a human figure to the drawing.

- When drawing very large objects, the horizon line is lowered and the vanishing points are moved closer together. The cone of vision narrows as the vanishing points are positioned closer together.

 Notice that the perspective of the building tops is outside the cone of vision and appears exaggerated. The exaggeration actually helps communicate perceived scale.

FIGURE 6.1.2

FIGURE 6.1.3

Perceived Scale and Multiple Vanishing Points **107**

VANISHING POINT ANALYSIS—FIGURES 6.1.4–6.1.5

- These drawings are both from Lesson 4, Section 3.

- A careful visual examination of Figure 6.1.4 reveals an exaggerated convergence to the vanishing point on the left side of the object. The exaggerated convergence results in a compromised perception of scale.

- Notice how Figure 6.1.5 has less convergence and appears to be a more appropriate and believable perspective.

- Both Figure 6.1.4 and Figure 6.1.5 are drawn using a horizon line and vanishing points. Why does Figure 6.1.5 appear to be a better perspective choice?

- The answer is quite simple:

 - Look at any object similar in size to a stereo and you will notice minimal convergence to vanishing points. Vanishing points on an object of this size should be quite far apart.

 - The left vanishing point on Figure 6.1.4 should be moved slightly further to the left to provide a more natural view of the object.

 - Use a straight edge and pencil to locate the left vanishing points of Figure 6.1.4 and Figure 6.1.5 and note the difference an inch makes.

- Vanishing point location is a skill that requires analysis and practice.

FIGURE 6.1.4

FIGURE 6.1.5

OPTIONAL READING

ANALYSIS OF A FLOOR PLAN LAYOUT—FIGURES 6.1.6–6.1.7

- Figure 6.1.6 is the layout from Lesson 5, Section 2.

- Look closely at the perspective layout in Figure 6.1.6 and note how narrow the two club chairs (1 and 2) appear.

- The reason for this distortion is that the right vanishing point (RVP) location distorts the perspective toward the rear of the drawing.

- This distortion can be corrected by moving the right vanishing point slightly to the left as illustrated in Figure 6.1.7. The vanishing point change, however, results in a cone-of-vision problem on the right side of the sofa.

- Perspective layout is often an interesting choice of compromises. You may, for example, choose to "cheat" the width of the chairs in Figure 6.1.6 and not move the RVP.

- Analysis of perspective layout and horizon line and vanishing point locations is an important skill that is developed through practice.

- The processes used in this text to lay out perspective drawings require a good sense of scale and proportion. If something in your drawing just doesn't look correct or is not believable, then fix it or cheat it.

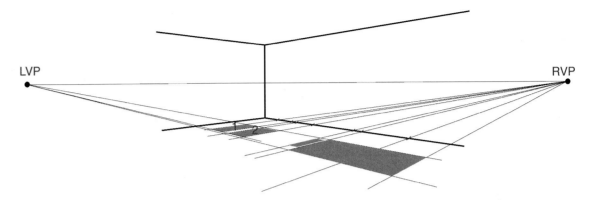

FIGURE 6.1.6

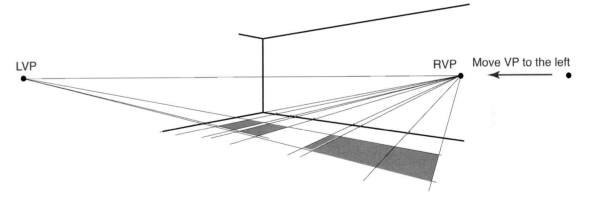

FIGURE 6.1.7

REQUIRED READING

Lesson 6 Section 2
Auxiliary Vanishing Points

AUXILIARY VANISHING POINTS—FIGURES 6.2.1–6.2.2

All lines indicating depth in a perspective drawing must converge to a vanishing point. The box tops pictured in Figure 6.2.1 are inclined planes and obviously cannot project to the left or right vanishing points. An auxiliary vanishing point (AVP) must be used. An AVP for an inclined plane is located directly above or below the left or right vanishing point.

- An AVP for an inclined plane that angles toward the viewer (inclined planes A and B in Figure 6.2.1) is located directly below a horizon line vanishing point.

- An AVP for an inclined plane that angles away from the viewer (inclined planes C and D in Figure 6.2.1) is located directly above a horizon line vanishing point.

- The distance of an auxiliary vanishing point above or below a horizon line vanishing point is determined by the angle of the inclined plane. In Figure 6.2.2, as the angle of the inclined plane increases, the distance of the AVP above the right vanishing point (RVP) increases.

- Turn this page upside down to view the AVP locations when the inclined plane is above the horizon line.

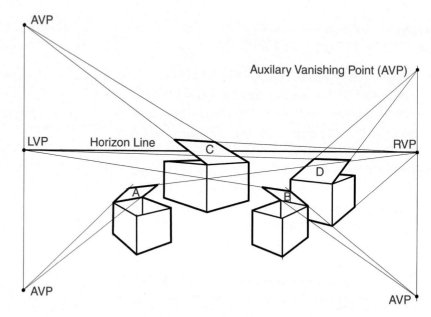

FIGURE 6.2.1

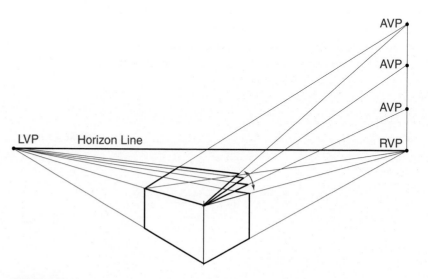

FIGURE 6.2.2

INTERIOR AUXILIARY VANISHING POINTS—FIGURE 6.2.3

- In Figure 6.2.3, an interior (gray shaded walls) is laid out using the left and right vanishing points (LVP and RVP).

- The angle of the vaulted ceiling is estimated at the rear corner of the room.

- The estimated angle is projected to a line dropped from the LVP. The intersection is the AVP for the interior vaulted ceiling.

- Beams are added to the vaulted ceiling using lines (dashed lines in Figure 6.2.3) projected from the AVP and RVP.

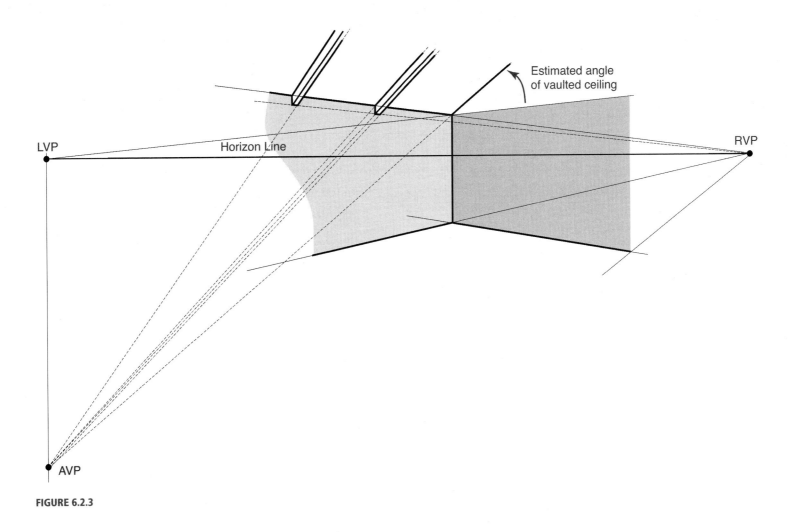

FIGURE 6.2.3

OPTIONAL READING

INTERIOR AUXILIARY VANISHING POINTS—FIGURE 6.2.4

- In Figure 6.2.4, interior walls are laid out using the left and right vanishing points (LVP and RVP).

- Proportions of the back wall are estimated and diagonals are used to determine the centerline of the wall. The centerline is used to lay out the vaulted ceiling angles. Unlike in Figure 6.2.3, the angles of the vaulted ceiling in Figure 6.2.4 are minimal and therefore allow both planes of the ceiling to be easily viewed in perspective.

- The ceiling inclined plane angled away from the viewer uses an AVP below the horizon line. The ceiling inclined plane angled toward the viewer uses an AVP above the horizon line.

- Beams are added to the vaulted ceiling using lines projected from the RVP and two AVPs.

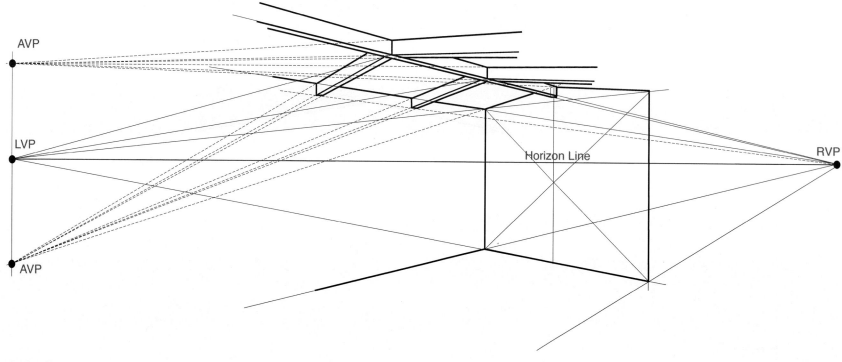

FIGURE 6.2.4

Lesson 6 Section 3
Multiple Vanishing Points

MULTIPLE VANISHING POINTS—FIGURES 6.3.1–6.3.3

Figure 6.3.1 is drawn using a horizon line and a left and right vanishing point for the walls and box number 1. Box number 2 is parallel with the picture plane (and the horizon line) and is drawn to a central vanishing point as a one-point perspective. To draw another object that is set at an angle different than box number 1 or 2:

- **Estimate** a plan view of the object (3) on the ground as illustrated in Figure 6.3.1. Your estimate will not be perfect because vanishing points are not used until the next step.

- Extend the forward left edge of the plan-view object to the horizon line. Mark the intersection of the extension line as LVP-2, as indicated in Figure 6.3.2.

- Extend the right side of the plan-view object to the horizon line. Mark the intersection as RVP-2. Object 3 is completed in Figure 6.3.3.

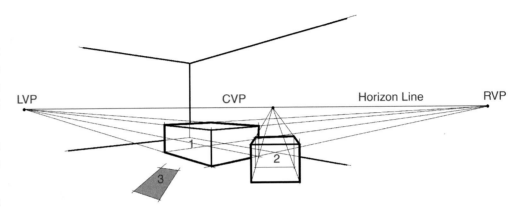

FIGURE 6.3.1

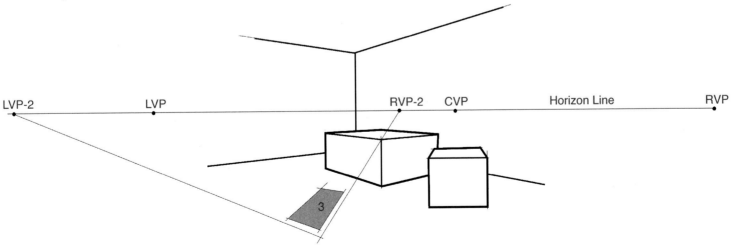

FIGURE 6.3.2

As described on the previous page, Figure 6.3.3 is drawn using a left and right vanishing point for the walls and box number 1. Box number 2 is parallel with the picture plane (and the horizon line) and is drawn to a central vanishing point as a one-point perspective. Object 3 is estimated as a plan-view shape on the ground. The ground shape is used to establish the locations of LVP-2 and RVP-2. To complete object 3:

- Fine-tune plan-view object 3 by projecting the sides of the object to the LVP-2 and RVP-2 as indicated with guidelines a, b, c, and d in Figure 6.3.3.

- Extend the leading edge of the object vertically to the desired height. The rear corner of the room may be used as a measuring line to determine the height of object 3. Measuring lines are discussed in detail in previous lessons.

- Run guidelines e and f from the top of object 3 to LVP-2 and RVP-2.

- Run vertical lines from the corners of the object connecting guidelines e and a, and guidelines c and f.

- Note: Any object in a two-point perspective that is not drawn as an inclined plane will project to vanishing points on the horizon line.

Once again we can see how important it is to develop your sense of scale and proportion to **estimate** objects in space. In this case, it would be difficult to draw object 3 and make it look believable by simply guessing.

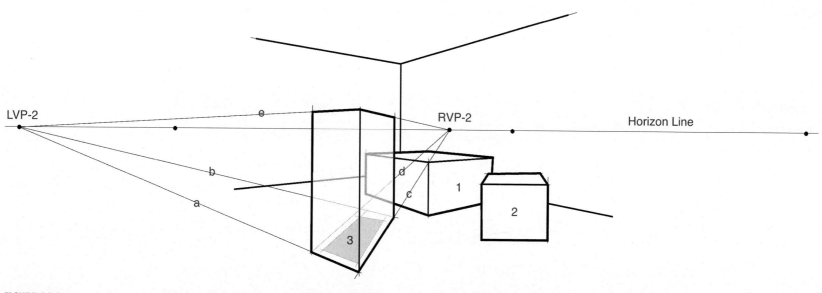

FIGURE 6.3.3

RECOMMENDED EXERCISE

MULTIPLE VANISHING POINTS—FIGURE 6.3.4

- Use a pencil and straight edge to identify the horizon line location and vanishing points used to construct the perspective drawing in Figure 6.3.4.

- There are multiple auxiliary vanishing points.

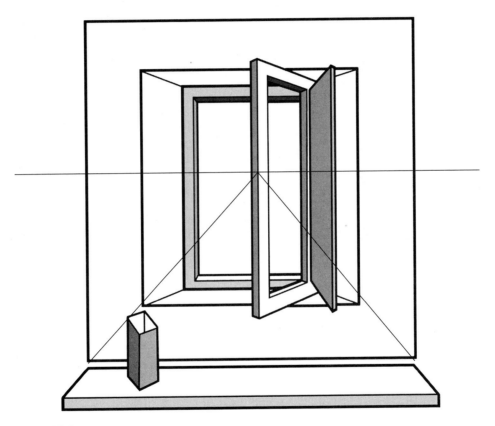

FIGURE 6.3.4

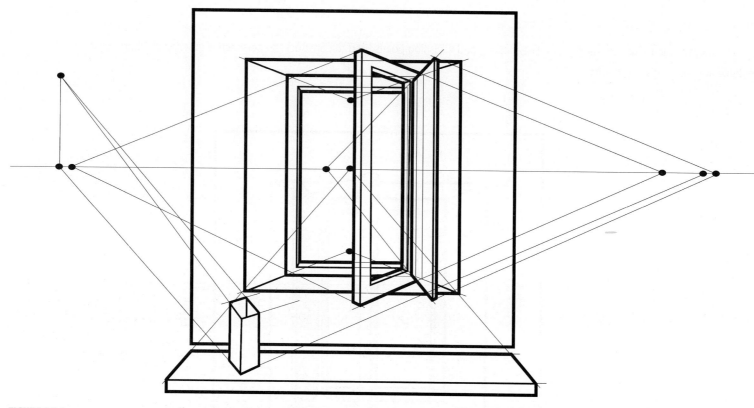

FIGURE 6.3.5

RECOMMENDED EXERCISE

Lesson 6 Section 4
Quick Sketch Exercise

FAUCET SKETCH —FIGURES 6.4.1–6.4.7

A cylindrical faucet can be a difficult object to draw if some basic perspective layout principles are not followed. Read the exercise material before beginning your 10-minute sketch exercise.

- The faucet is a relatively small object and the vanishing points are therefore located far apart. Use your sense of scale and proportion to sketch the cylindrical body of the faucet without the use of vanishing points.

- The spout is located vertically on the main cylinder with an ellipse marked (A). A radius of ellipse A is drawn between points B and C. Point B is the center of ellipse A. The radius is extended to point D, which is the estimated length of the spout. Line CD becomes the minor axis of the cylindrical spout.

- A major axis of the spout is drawn at a right angle to the minor axis. The use of a minor and major axis in creating an ellipse is detailed in Lesson 3, Section 3.

- A spout can be drawn in any direction by creating a radius from the center of ellipse A and extending it outward.

Courtesy of Superstock

FIGURE 6.4.1

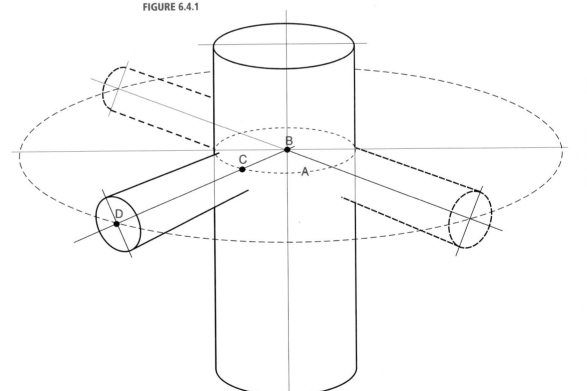

FIGURE 6.4.2

- Line A, at which the spout joins the main cylinder of the faucet, is an odd shape. The shape can be geometrically calculated but it is time consuming and difficult. It is best to estimate the shape as indicated in Figure 6.4.3.

- The end of the spout is drawn as a half-circle. The diameter (line B) is drawn as a line midway between the minor and major axes.

- Line C is an estimated angle.

- The aerator is a short cylinder and is drawn with a minor axis perpendicular to line C.

- The faucet handle is laid out in exactly the same way as the spout. A radius of an ellipse that vertically locates the handle is extended the estimated length of the handle (line DE).

- Note how the handle and spout are projected at different angles from the main cylindrical body of the faucet. If the process described with Figures 6.4.1–6.4.3 is not followed, the probability is high that the drawing will look wrong, as indicated in Figure 6.4.4.

- Figures 6.4.5–6.4.7 are examples of the 10- to 15-minute sketch exercise.

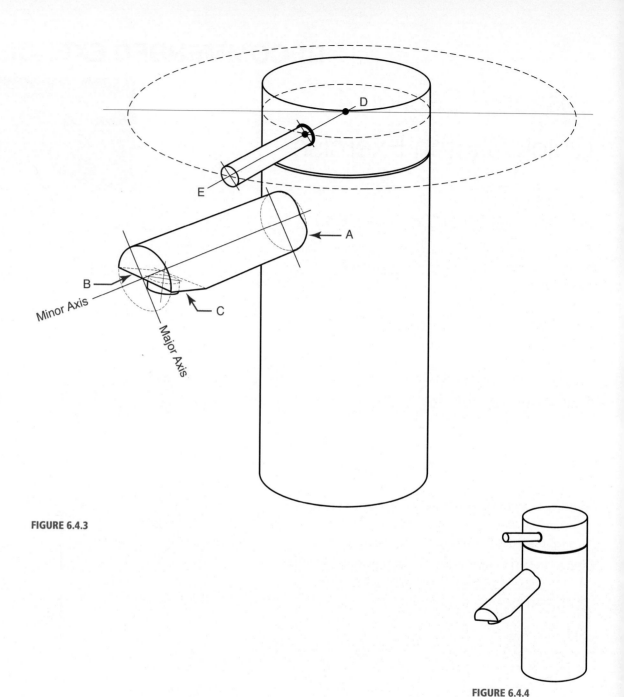

FIGURE 6.4.3

FIGURE 6.4.4

EXERCISE RESULTS—FIGURES 6.4.5–6.4.7

- Figure 6.4.5 is an instructor demonstration of the quick sketch exercise.
- Figures 6.4.6 and 6.4.7 are examples of student work.

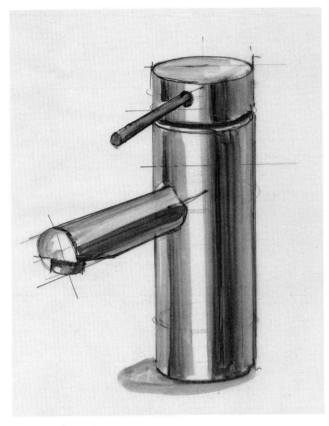

FIGURE 6.4.5

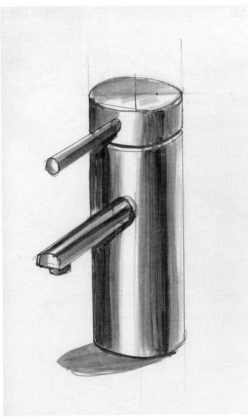

FIGURE 6.4.6

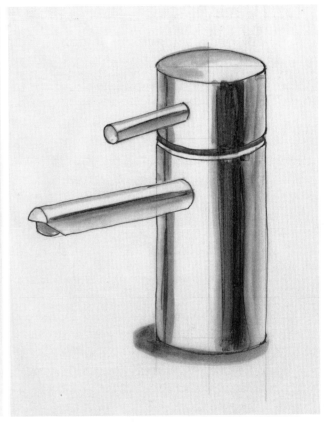

FIGURE 6.4.7

REQUIRED ASSIGNMENT

Lesson 6 Section 5
Homework

HOMEWORK ASSIGNMENT—FIGURES 6.5.1–6.5.4 (4 HOURS)

- Interior Designers: Use Figures 6.5.1–6.5.2 and Section 2 of this lesson as a reference to lay out an interior perspective with a beamed ceiling. Use auxiliary vanishing points to develop the ceiling perspective of your sketch.

 Be creative with your drawing. Do not just copy the photographs.

- Graphic Designers: Use Figure 6.5.3 and Section 2 of this lesson as a reference drawing to develop a print advertisement for an art supply store. Your drawing must include a drawing board and typography. Use an auxiliary vanishing point to develop the angled drawing-board top.

 Be creative with your drawing. You may scan your drawing and use a computer to add the typography.

- Game Artists and Animators: Use Figure 6.5.4 and Section 2 of this lesson as a reference to lay out a drawbridge scene. Your drawing must use an auxiliary vanishing point to develop the perspective of a partially open bridge.

 Be creative with your drawing. Do not just copy the reference photograph. You may add characters to your drawing.

FIGURE 6.5.1

Courtesy of Jupiterimages

FIGURE 6.5.3

Courtesy of Jack Beduhn

FIGURE 6.5.2

Courtesy of Jupiterimages

FIGURE 6.5.4

REQUIRED READING

Lesson 6 Section 6 Homework Examples

- Figures 6.6.1–6.6.9 are examples of Lesson 6 homework completed by students at the Art Institute of California–San Diego.
- Note: Homework at the Art Institute is often modified. Some of the examples in this section do not reflect the exact homework assignment as described in Section 5 of this lesson.

FIGURES 6.6.1–6.6.3

These sketches are examples of an interior design student's homework assignments. All effectively use an auxiliary vanishing point for the beamed ceiling. Marker application, scale, and proportion are representative of excellent work.

FIGURE 6.6.4

This is a nice example of a graphic design student's homework assignment. The drawing-board sketch effectively uses an auxiliary vanishing point for the inclined top surface. Typography was added after scanning the original sketch and importing it into Photoshop®.

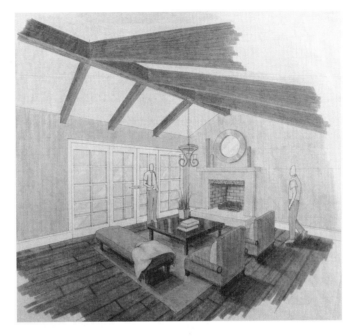

FIGURE 6.6.1

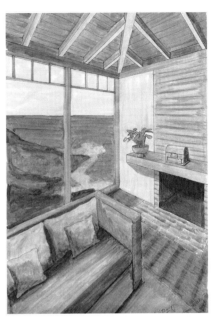

FIGURE 6.6.2

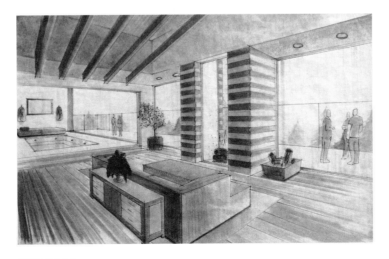

FIGURE 6.6.3

FIGURE 6.6.4

FIGURES 6.6.5–6.6.9

All five of these drawings effectively use an auxiliary vanishing point for an inclined plane and represent good examples of marker and layout technique.

FIGURE 6.6.5

This game art student's homework assignment from Section 5 of this lesson was creatively applied to this drawing. The use of white space enhances the sketch.

FIGURE 6.6.6

This game artist used an auxiliary vanishing point for the beamed ceiling. The beam layout was drawn with straight lines and then modified by estimating the curves. The student leveraged the interior design assignment consistent with his major.

FIGURE 6.6.7

An auxiliary vanishing point is used in this game art drawing to lay out the open bridge. There is a nice value range in this drawing

FIGURE 6.6.8

An animation student leveraged the graphic design drawing-board assignment in a creative way. The detail in this drawing is exceptional.

FIGURE 6.6.9

This is a nice sketch by a graphic design student.

NOTE
The interior design, graphic design, game art, and animation student work featured in the first nine lessons of this text is the work of first-year students.

FIGURE 6.6.5

FIGURE 6.6.7

FIGURE 6.6.8

FIGURE 6.6.6

FIGURE 6.6.9

Shadows and Reflections

Lesson Overview

Lesson 7 is written in four sections:

- Lesson 7, Section 1: Shadows.
- Lesson 7, Section 2: Reflections.
- Lesson 7, Section 3: Estimating Shadows and Reflections, with examples of student work.
- Lesson 7, Section 4: Homework exercise.

It is recommended that students follow the Sections 1 and 2 instruction by drawing freehand and estimating proportion and scale.

NOTE
Most design students are visual learners. MyKit instruction for this lesson includes:

- Section 1, Video 1 demonstrates plotting a shadow with a light source behind an object.
- Section 1, Video 2 demonstrates plotting a shadow with the light source in front of an object.
- Section 1, Video 3 demonstrates plotting shadows with an interior light source.

Lesson 7 Section 1
Shadows

PLOTTING SHADOWS—FIGURES 7.1.1–7.1.2

- Some professional illustrators use shadow-plotting techniques effectively. However, I have never met a designer who took the time to plot accurate shadows for a sketch. Plotting shadows can be both difficult and time consuming. In today's world, most designers would use a computer if shadows had to be highly accurate. A basic understanding of plotting shadows is important when learning to estimate shadows.

- Most perspective books give considerable attention to plotting shadows. In this text we will only cover the basics of sunlight and direct-light shadows. If the reader is interested in more detailed lessons, it is advised to use another reference, such as *Perspective Drawing Applications*, Third Edition, by Charles A. O'Connor, Jr., Thomas J. Kier, and David B. Burghy (ISBN 0-13-191466-9).

- When drawing shadows, one must consider both the angle of a light source and the direction of a light source. In a three-dimensional world, both the angle of the light and the direction of the light can be communicated by simply pointing. When drawing on a piece of paper, the direction of the light (DL) and the source of the light (SL) must be separated, as indicated in Figures 7.1.1 and 7.1.2.

- In Figure 7.1.2, the DL is projected from a point on the horizon and the SL is projected from a point directly above the DL. The intersections of the SL and DL define the shadow.

- We will explore the SL and DL locations in more detail as this section of Lesson 7 progresses.

Lesson 7

124

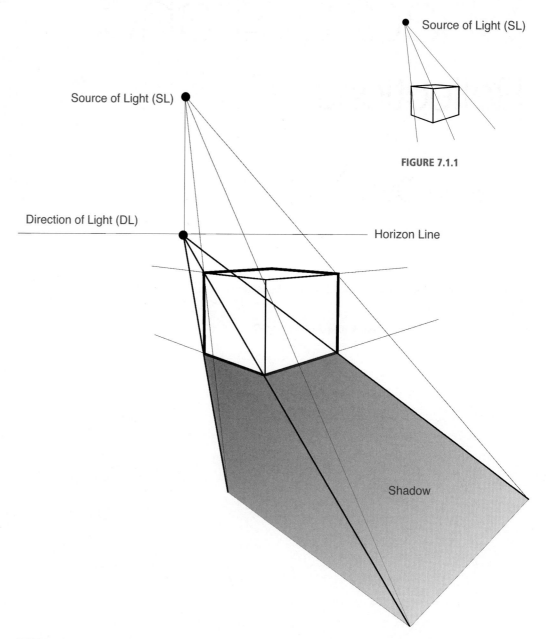

Source of Light (SL)

FIGURE 7.1.1

Source of Light (SL)

Direction of Light (DL)

Horizon Line

Shadow

FIGURE 7.1.2

PLOTTING SHADOWS PARALLEL WITH THE PICTURE PLANE—FIGURES 7.1.3–7.1.5

- Shadows parallel with the picture plane are the easiest to plot.

- When the DL is coming from the left or right edge of the sheet of paper you are using for your sketch, then the DL is parallel with the picture plane. Light rays coming from the left or right edge of the picture plane are drawn as parallel lines, as indicated in Figure 7.1.3. The parallel line rationale is the same as a one-point perspective drawing. Horizontal lines in a one-point perspective (Figure 7.1.4) are parallel with the picture plane and do not converge to a vanishing point.

- In Figure 7.1.5, the SL is drawn with parallel lines projected downward through the top corners of the object.

- The DL in Figure 7.1.5 is coming from the left. The parallel DL lines are projected through the base corners of the object.

- In Figure 7.1.5, the intersection of the SL lines and the DL lines defines the shadow.

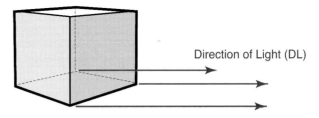

Direction of Light (DL)

FIGURE 7.1.3

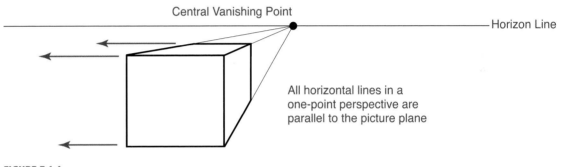

Central Vanishing Point

Horizon Line

All horizontal lines in a one-point perspective are parallel to the picture plane

FIGURE 7.1.4

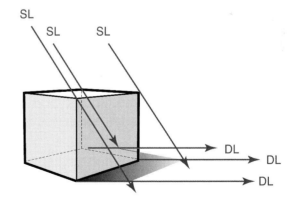

SL SL SL

DL
DL
DL

FIGURE 7.1.5

PLOTTING SHADOWS NOT PARALLEL WITH THE PICTURE PLANE WITH THE LIGHT SOURCE BEHIND THE OBJECT—FIGURE 7.1.6

- Shadows not parallel with the picture plane are more difficult to plot. The light rays appear to radiate from the SL and the shadow radiates from the point representing the DL. Shadows that are not parallel with the picture plane are drawn with both the DL and SL used as vanishing points.

- The DL is indicated as a point on the horizon, as illustrated in Figure 7.1.6. The DL is a location point selected by the artist.

- When the SL is from behind an object, the SL is positioned directly above the DL, as illustrated in Figure 7.1.6.

- The shadow is defined by the intersection of the DL lines and the SL lines.

- The DL is the vanishing point for the shadow. Remember not to confuse the vanishing point for the shadow with the vanishing points for the object (VPL and VPR).

- The SL rays cross the top corners of the object. Point A is an example. The DL rays cross the ground-level corners of the object directly below an SL ray. Point B is an example. The intersection of the DL and SL rays at point C defines a corner of the shadow. Identify the SL and DL intersections of the two remaining shadow corners in Figure 7.1.6.

- Notice that the SL determines the inside shadow of the open box illustrated in Figure 7.1.6.

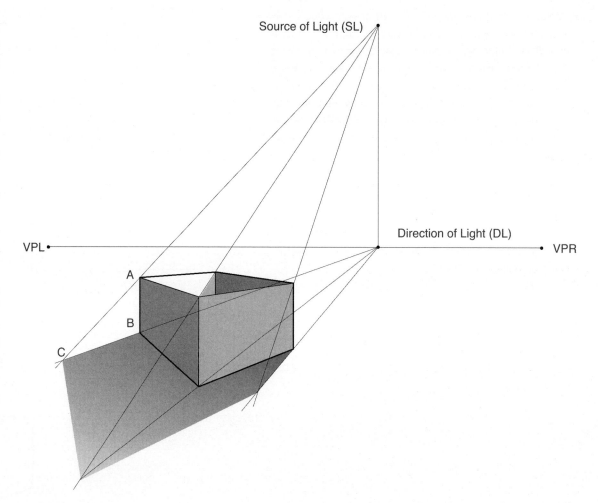

FIGURE 7.1.6

PLOTTING SHADOWS NOT PARALLEL WITH THE PICTURE PLANE WITH THE LIGHT SOURCE IN FRONT OF THE OBJECT—FIGURE 7.1.7

- Sunlight shadows from light in front of the object are more difficult to plot. The light rays converge from the actual source of light (SL) to the source of light convergence (SLC). The shadow converges from the actual direction of light (DL) to the direction of light convergence (DLC).

- Shadows from light in front of the object are drawn with both the DLC and SLC used as vanishing points.

- The DLC is indicated as a point on the horizon, as illustrated in Figure 7.1.7. The DLC is a location selected by the artist.

- When the SL is in front of an object, the SLC is positioned directly below the DLC, as illustrated in Figure 7.1.7. The closer the SLC is to the DLC, the longer the shadow.

- The shadow is defined by the intersection of the DL and the SL lines. For example, the intersections of SL1/DL1, SL2/DL2, and SL3/DL3 define the top of the shadow for object 1. DL1 and DL3 define the length of the shadow.

- The DLC is the vanishing point for the shadow. Remember not to confuse the vanishing point for the shadow with the vanishing point of the object. In Figure 7.1.7, the objects are drawn in a one-point perspective to the central vanishing point (CVP).

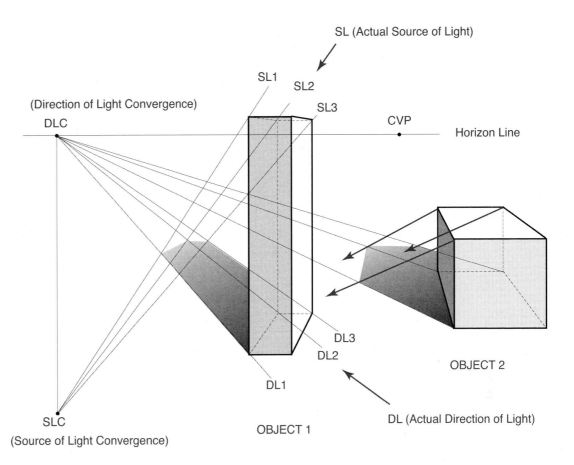

FIGURE 7.1.7

OPTIONAL READING

COMPARING SHADOW PROJECTIONS — FIGURES 7.1.8–7.1.9

- Sunlight behind the object—Figure 7.1.8

 - When sunlight is behind an object, the shadow RADIATES FROM the DL and the light RADIATES FROM the SL.

 - The DL is always on the horizon line at a point selected by the artist. The SL is always directly above the DL at a height selected by the artist.

- Sunlight in front of the object—Figure 7.1.9

 - When sunlight is in front of an object, the shadow CONVERGES TO the DLC and the light CONVERGES TO the SLC.

 - The DLC is always on the horizon line at a point selected by the artist. The SLC is always directly below the DLC at a distance selected by the artist.

 - In Figure 7.1.9, the actual SL and DL are labeled and indicated by ellipses.

- Note: It may be helpful to think of DL projections as LINES on the GROUND.

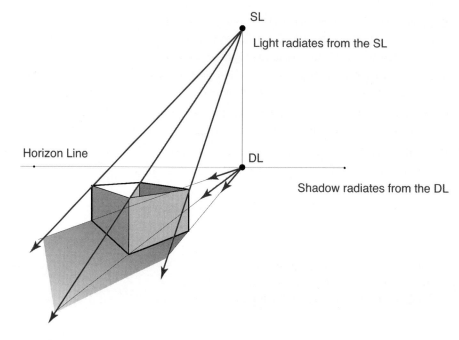

FIGURE 7.1.8

Direction of Light (DL) converges to the DLC

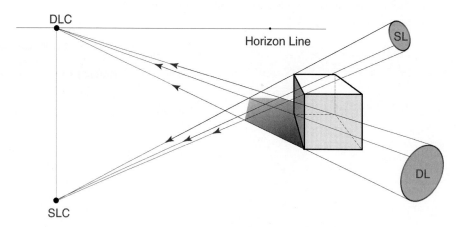

Source of Light (SL) converges to the SLC

FIGURE 7.1.9

RECOMMENDED EXERCISE

SHADOW PLOTTING EXERCISE—FIGURE 7.1.10

- Exercise 1. Select a DL location on the horizon line and an SL directly above the DL. Plot a shadow with the light source behind the object.

- Exercise 2. Select a DLC location on the Horizon Line with an SLC directly below. Plot a shadow with the light coming from in front of the object.

- If required, use Figure 7.1.8 and Figure 7.1.9 as reference for your shadows.

FIGURE 7.1.10

OPTIONAL READING

PLOTTING COMPLEX SHADOWS NOT PARALLEL WITH THE PICTURE PLANE—FIGURES 7.1.11–7.1.12

- As illustrated in Figure 7.1.11, a grid can be constructed using the SL and DL to plot a shadow of a complex object. This is a time-consuming process. It is generally more than adequate to plot, or even eyeball, a rough outline of the shadow boundaries, as illustrated in Figure 7.1.12, and then estimate the shadow shape.

- The DL is indicated as a point on the horizon, as illustrated in Figure 7.1.11. The DL is a location selected by the artist.

- When the SL is behind an object, the SL is positioned directly above the DL.

FIGURE 7.1.11

FIGURE 7.1.12

RECOMMENDED READING

PLOTTING ARTIFICIAL LIGHT SHADOWS—
FIGURES 7.1.13–7.1.14

- Artificial light shadows can be difficult and time consuming to plot. A basic understanding of plotting shadows from an artificial light source helps in your ability to estimate shadows.

- In Figure 7.1.13, the SL location is indicated on the ceiling of the one-point perspective. Lines are plotted to determine the DL location on the floor directly below the SL.

- Three flat rectangular objects are drawn on the floor of the one-point perspective.

- To plot the artificial shadows in Figure 7.1.14, follow this methodology:

 - Draw guidelines from the SL through the top corners of each object.

 - Draw guidelines from the DL through the bottom corners of each object.

 - Connect the intersections of the SL and DL guidelines to determine the shape of the shadows.

- In the real world, there is seldom a single light source. Plotting multiple light sources compounds the difficulty. The overlap area of multiple shadows is darker than the non-overlap areas.

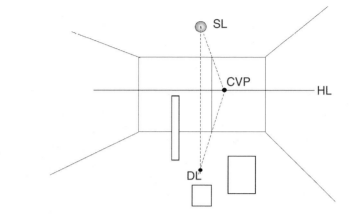

FIGURE 7.1.13

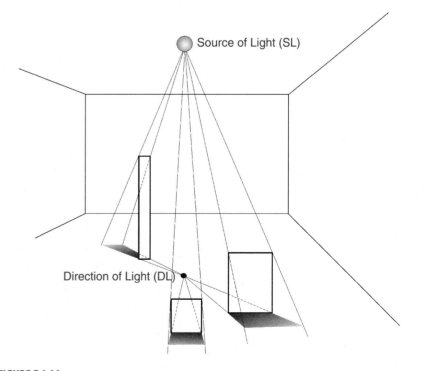

FIGURE 7.1.14

RECOMMENDED READING

Lesson 7 Section 2
Reflections

OVERVIEW OF REFLECTIONS—FIGURES 7.2.1–7.2.2

- Plotting reflections can be both difficult and time consuming. A basic understanding of plotting reflections is important when learning to estimate reflections.

- Most perspective books give considerable attention to reflections. In this text, we will only cover the basics of simple reflections, as illustrated in Figure 7.2.1. Simple reflections are the easiest both to estimate and to plot. If the reader is interested in more detail than provided in this book, it is advised to use another reference, such as *Perspective Drawing Applications*, Third Edition, by Charles A. O'Connor, Jr., Thomas J. Kier, and David B. Burghy (ISBN 0-13-191466-9).

- Complex reflections (Figure 7.2.2) can be plotted, but are most often estimated by designers.

- The complex reflection in Figure 7.2.2 is estimated using only a basic knowledge of reflections. In Figure 7.2.2, the reflective surface, the object, and the object's reflection all use vanishing points that are unique. The reflection in Figure 7.2.2 is NOT accurate, but it is believable.

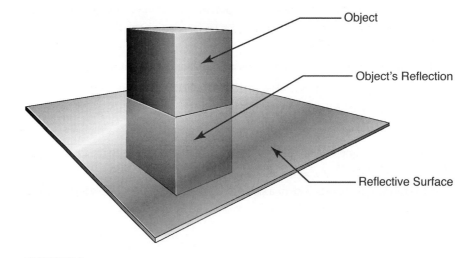

FIGURE 7.2.1

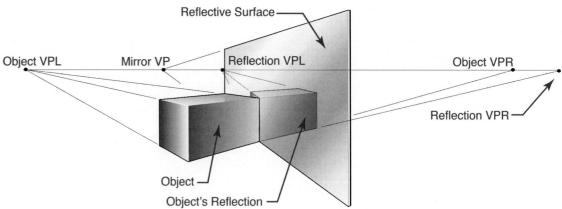

FIGURE 7.2.2

PLOTTING SIMPLE REFLECTIONS— FIGURES 7.2.3–7.2.5

- Reflections follow the rules of linear perspective. A duplicated object is foreshortened as it converges to a vanishing point.

- In Figure 7.2.3, diagonals are used to duplicate a square shape (1) three times. Note squares 1–4 in Figure 7.2.3. Each square appears foreshortened (or more rectangular) as it converges to the vanishing point. Square 4 is the reflection of square 1. The diagonal measurement methodology is fully discussed in Lesson 4, Section 1.

- In Figure 7.2.4, a measuring line and a measuring point are used to duplicate a square three times. Each square appears foreshortened (or more rectangular) as it converges to the vanishing point. The measuring line methodology is fully discussed in Lesson 5, Section 1.

- Figure 7.2.5 illustrates a rendered object reflected into a mirror. The object shadow is plotted using a point on the horizon as the DL and a point above the DL is used as the SL. The shadow reflection in the mirror is estimated.

- In Figure 7.2.5, a stylized diagonal reflection is added to the mirror. The reflection adds a surface to the mirror and makes the rendering appear more believable.

- Most designers simply estimate the reflected object's proportions and do not plot perspective. This takes an understanding of perspective and a good eye.

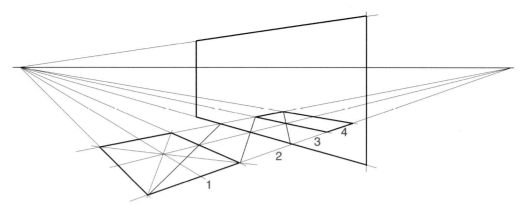

FIGURE 7.2.3

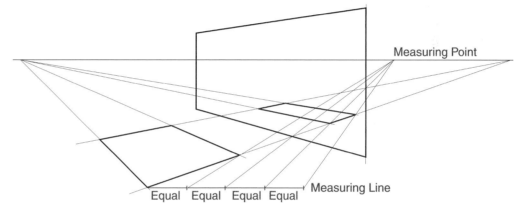

FIGURE 7.2.4

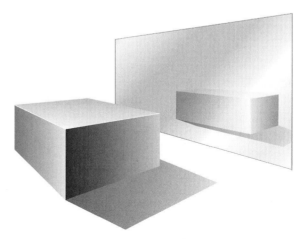

FIGURE 7.2.5

ESTIMATING SIMPLE REFLECTIONS—FIGURE 7.2.6

- The reflections in Figure 7.2.6 are, for the most part, estimated.

- Reflections follow the rules of linear perspective and appear to converge to vanishing points.

- An angled plane, as indicated with objects A and B, is reflected into the mirror at the same angle but in the opposite direction.

- The reflection of objects C, D, and E are cut by the edge of the mirror.

- Object D floats above the surface of the mirror and is reflected an equal distance into the mirror.

- Object E is located to the rear of the mirror and is reflected an equal distance into the mirror.

- A stylized reflection is added to the mirror in Figure 7.2.6. The reflective surface makes the mirror appear more believable.

- Most designers simply estimate the reflected object's proportions and do not plot foreshortening. This takes an understanding of perspective and a developed sense of scale and proportion.

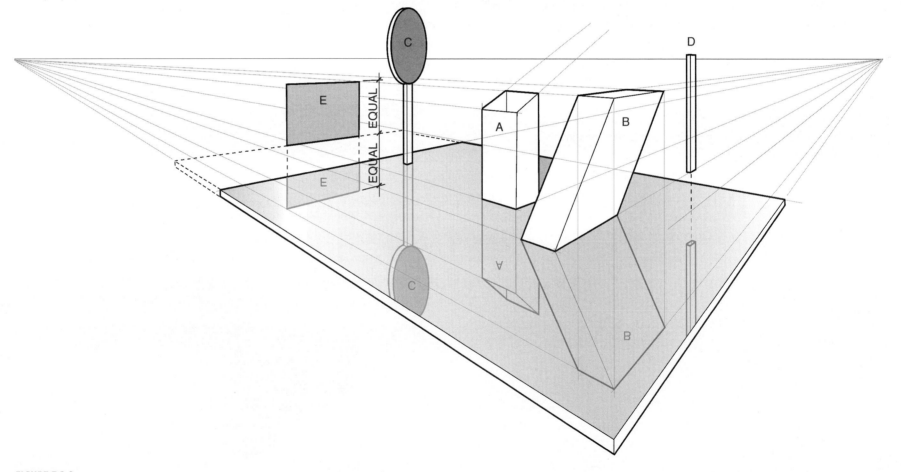

FIGURE 7.2.6

RECOMMENDED EXERCISE

REFLECTION EXERCISE—FIGURE 7.2.7

- Use your knowledge of perspective and reflection to estimate the reflection of the objects in Figure 7.2.7.
- As an added challenge, add shadows for each object in Figure 7.2.7. Estimate the SL and DL, and then estimate the shadows.
- Use a lead pencil to sketch the shadows and reflections.
- Compare your reflections with Figure 7.2.6.

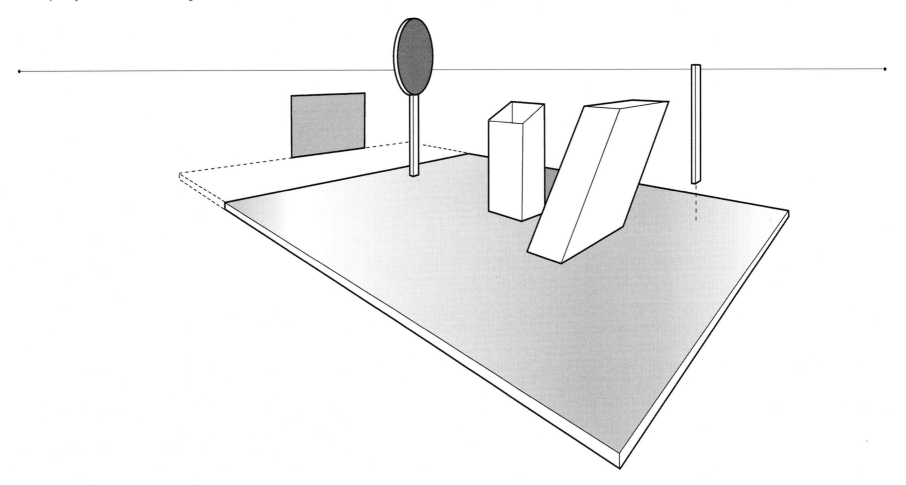

FIGURE 7.2.7

Lesson 7 Section 3
Estimating Shadows and Reflections

OVERVIEW OF ESTIMATING SHADOWS AND REFLECTIONS—FIGURES 7.3.1–7.3.13

- Use the following principles to estimate shadows:

 - Keep shadows close to the object.

 - Gradate shadows from darkest near the object to lighter further away.

 - Simplify shadows and abstract them whenever possible.

 - Estimate the DL and the SL when estimating shadows. Do not plot shadows when sketching.

 - Shadows from bright, direct light are drawn with hard edges. Soften the edges of indirect-light shadows.

 - Minimize shadow contrast with the surrounding area. Shadows are generally not the focal point of the drawing.

- Use the following principles when estimating reflections:

 - Keep reflections simple and abstract them whenever possible.

 - Add a stylized reflection to the surface of a reflective object. This includes, but is not limited to, floors, windows, and water.

 - Estimate rather than plot reflections.

 - A dull reflective surface results in a subtle reflection. Conversely, a highly reflective surface results in a more pronounced reflection.

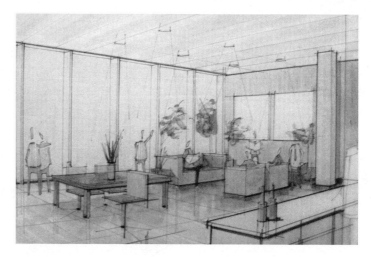

FIGURE 7.3.1

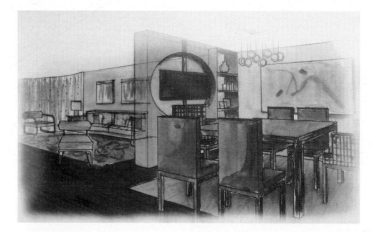

FIGURE 7.3.2

RECOMMENDED EXERCISE

ESTIMATING SHADOWS AND REFLECTIONS

Identify the following shadow and reflection principles in Student Work Figures 7.3.1–7.3.13:

- Keep shadows close to the object.
- Gradate shadows from darkest near the object to lighter further away.
- Simplify shadows and abstract them whenever possible.
- Estimate the DL and the SL when estimating shadows. Do not plot shadows when sketching.
- Shadows from bright, direct light are drawn with hard edges. Soften the edges of indirect, soft-light shadows.
- Minimize shadow contrast with the surrounding area. Shadows are generally not the focal point of the drawing.
- Keep reflections simple and abstract them whenever possible.
- Add a stylized reflection to the surface of a reflective object. This includes, but is not limited to, floors, windows, and water.
- Estimate rather than plot reflections.
- A dull reflective surface results in a subtle reflection. Conversely, a highly reflective surface results in a more pronounced reflection.

FIGURE 7.3.3

FIGURE 7.3.4

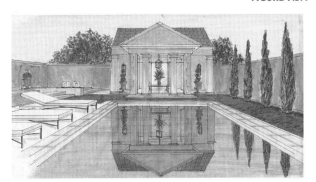

FIGURE 7.3.5

FIGURE 7.3.6

FIGURE 7.3.7

FIGURE 7.3.8

FIGURE 7.3.9

FIGURE 7.3.10

FIGURE 7.3.11

FIGURE 7.3.12

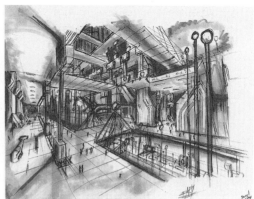

FIGURE 7.3.13

REQUIRED ASSIGNMENT

Lesson 7 Section 4
Homework

HOMEWORK ASSIGNMENT—FIGURES 7.4.1–7.4.2 (4 HOURS)

- Interior Designers, Graphic Designers, Game Artists, and Animators: Develop a finished grayscale drawing from your imagination. Your final drawing must include the following:
 - Estimated shadows
 - Estimated reflections
 - Value and contrast
 - One-point or two-point perspective
 - Believable scale and proportion
 - Use of line to communicate shape and form
 - Elements and principles of design
- The student drawings in Figures 7.3.1–7.3.13 and 7.4.1–7.4.2 Sections 3 and 4 of this lesson are all examples of "A" work and may be used as inspiration for your homework assignment.
- Your instructor may agree to the use of Photoshop® to enhance your final drawing. Figure 7.3.12, for example, uses Photoshop® for the shadows and the outdoor scene. The remainder of the drawings in Sections 3 and 4 are all done by hand.

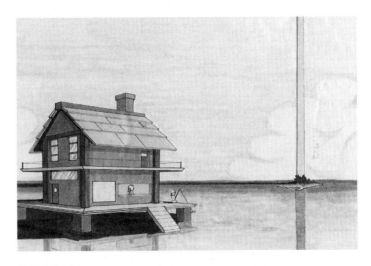

FIGURE 7.4.1

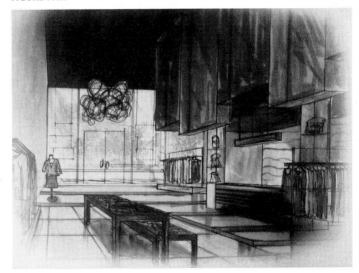

FIGURE 7.4.2

8 People, Lighting, Colorizing

Lesson Overview

Lesson 8 is written in five sections:

- Lesson 8, Section 1: Adding people to a perspective sketch.

- Lesson 8, Section 2: Adding luminaries to a sketch.

- Lesson 8, Section 3: Colorizing a grayscale sketch.

- Lesson 8, Section 4: Homework exercise.

- Lesson 8, Section 5: Samples of student work with instructor comments.

NOTE

Most design students are visual learners. MyKit instruction for this lesson includes:

- Section 1, Video 1 demonstrates adding and scaling people in a two-point perspective sketch.

- Section 3, Video 1 demonstrates the use of pastel sticks to colorize a grayscale marker sketch.

REQUIRED READING

Lesson 8 Section 1
People in Perspective

SCALING PEOPLE IN PERSPECTIVE—FIGURE 8.1.1

- When adding people to a perspective drawing, it is critical to get the scale of the people correct. As indicated in Figure 8.1.1, people are easy to scale when the horizon line is set at normal standing eye level, or between 5'-0" and 6'-0" above the ground. No matter where a standing figure is located in the perspective, his or her head will be near the horizon line.
- It gets more complicated with a combination of people both sitting and standing. The head of a seated figure would be approximately 4'-0" above the ground and must be plotted using a measuring line and vanishing point. In Figure 8.1.1, the measuring line is the rear corner of the room.

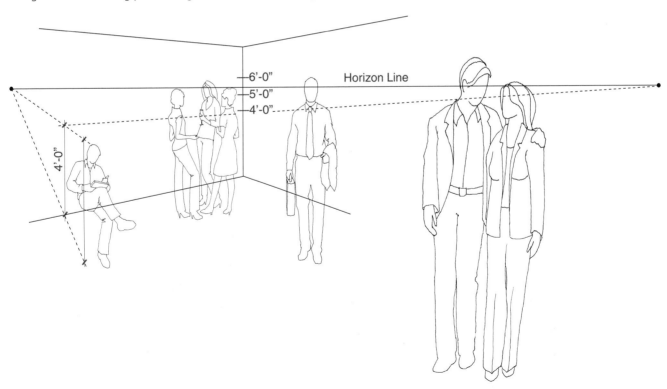

6'-0" Horizon Line
5'-0"
4'-0"

4'-0"

FIGURE 8.1.1

SCALING PEOPLE IN PERSPECTIVE—FIGURE 8.1.2

- When the horizon line is either higher or lower than normal standing eye level, it is important to plot the scale of people relative to their location in the perspective sketch. The measuring line in Figure 8.1.2 locates the horizon line approximately 7'-6" above the floor. The measuring line and vanishing points are used to plot the scale of the people in the drawing.

- Recommended exercise: Create a simple interior wall sketch with the horizon line located 3'-0" above the floor. Use a measuring line and vanishing points to scale people at three different locations in the room. Indicate people as stick figures.

- Now would be a good time to review the MyKit Video for Lesson 8, Section 1.

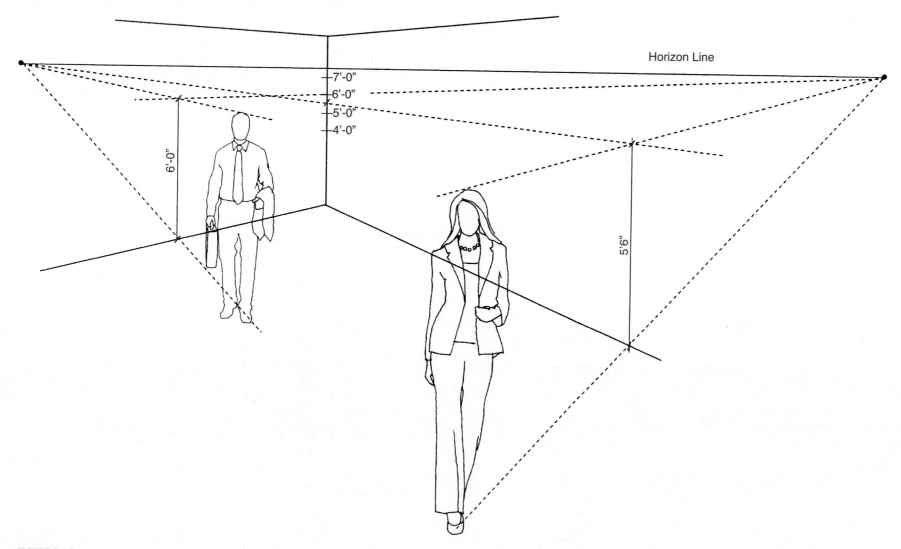

FIGURE 8.1.2

OPTIONAL READING

DRAWING PEOPLE—FIGURE 8.1.2

- It is beyond the scope of this text to teach readers how to draw or sketch people. Game artists and animators take courses in anatomy and life drawing to develop competent figure-drawing ability and probably do not need to read the remainder of this section. Interior designers and graphic designers seldom develop people-drawing skills and should read the remainder of this section.

- A simple way to add people to a drawing is to use a reference photo (Figure 8.1.3 for example) and trace it. The tracing (Figure 8.1.4) can then be scaled to a required size on a computer or a copy machine and used as an underlay to add people to a drawing.

- Many designers develop trace files with figures drawn at multiple sizes so they can be traced at a scale relative to their location in a drawing. Trace Files 1 through 15 have been developed for users of this text and are located in an appendix in the back of the book. The trace files are labeled A.1–A.15 and are printed on single perforated pages, which allows students to easily remove them from the book. MyKit also includes copies of the trace files.

- Note: It is usually best for interior and graphic designers to abstract the human figure. The trace files for this section use an outline for the hands and eliminate facial detail.

Courtesy of Jupiterimages

FIGURE 8.1.3

FIGURE 8.1.4

OPTIONAL READING

ADDING PEOPLE TO A LAYOUT SKETCH—FIGURE 8.1.5

- A layout sketch (Figure 8.1.5) with the horizon line set at approximately 5'-6" above the floor was generated on trace paper with a Sharpie Extra Fine Pen.

- Trace files similar to those in the appendix of this book and in MyKit were placed under the layout sketch. Appropriately scaled figures were positioned in desired locations and then traced on the overlay.

- With people added to the layout drawing, the sketch is ready for final tracing, refinement, and rendering. Alternatively, marker rendering can be applied directly to the layout sketch.

CREATING A TRACE FILE WITH ADOBE® PHOTOSHOP®

- Scan your **trace layout** of entourage (people, plants, trees, etc.) at 300 dpi and save as a jpg file.

- Open the jpg **trace layout** in Photoshop®.

- Click the File dropdown, click New, and create a blank 8 1/2 × 11" sheet with white background at 300 dpi. When the new sheet opens, click the Window dropdown, click Arrange, and then click Float all in Window.

- Use a selection tool to select the area on your **trace layout** that you want to move.

- Use the move tool to move the **trace layout** selection to the new blank sheet.

- Click the Edit dropdown, click Transform, and then click Scale.

- Depress the left mouse button and hold the Shift key to maintain proportions while scaling the **trace layout** on the new sheet.

- Repeat the move and scale process to duplicate the original trace at all desired scales. Make sure you are scaling the correct layer.

- Save the file and print.

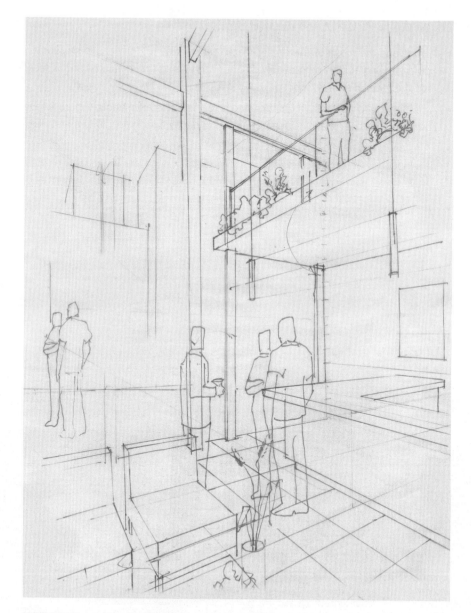

FIGURE 8.1.5

RECOMMENDED READING

Lesson 8 Section 2
Lighting

ADDING LUMINARIES TO A DRAWING—FIGURES 8.2.1–8.2.2

- Figure 8.2.1 is a typical small room layout drawing without lighting.
- Figure 8.2.2 adds luminaries. Many designers will finish a sketch and not indicate light projecting from the luminaries. Other designers will use one of the methods (Figures 8.2.3–8.2.4) on the following page to indicate light projection in their drawings.

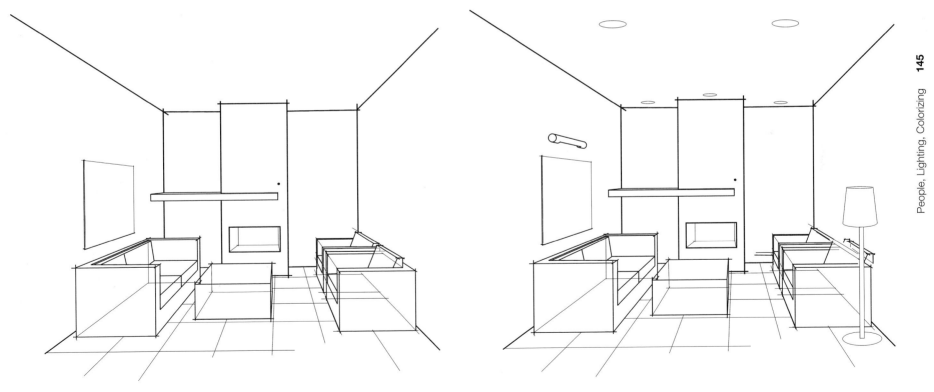

FIGURE 8.2.1

FIGURE 8.2.2

TWO METHODS TO INDICATE LIGHT—FIGURES 8.2.3–8.2.4

- Figure 8.2.3 indicates light using simple light rays radiating from the source of light. This is a typical method used by many designers when creating a quick sketch.

- Figure 8.2.4 illustrates another method of indicating light. This method is more realistic and is often used when creating a more detailed drawing. It does take more time to render.

- Use the method you find most appropriate. The following drawings (Figures 8.2.5–8.2.7) illustrate the application of both approaches.

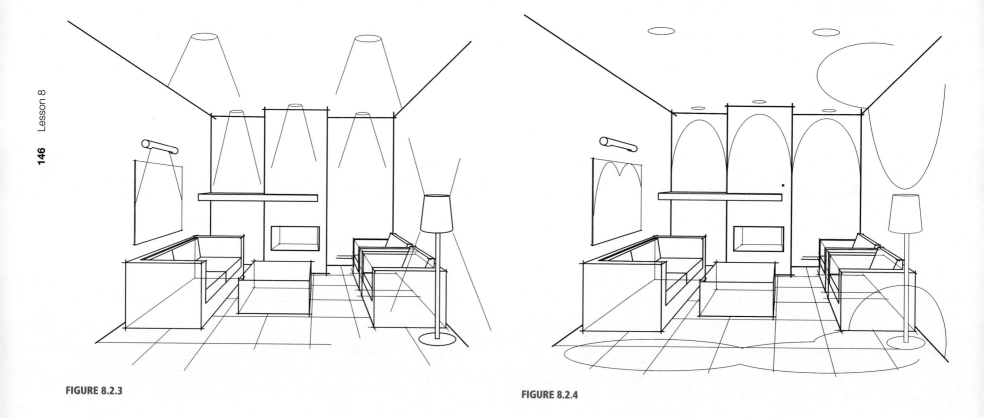

FIGURE 8.2.3 **FIGURE 8.2.4**

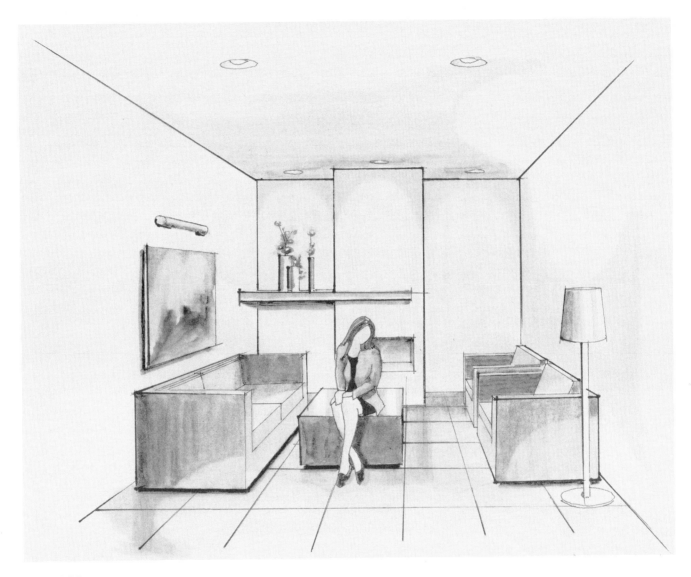

FIGURE 8.2.5

FIGURE 8.2.6

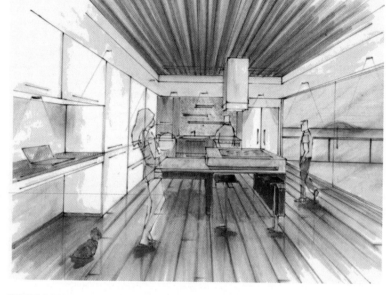

FIGURE 8.2.7

RECOMMENDED READING

Lesson 8 Section 3
Colorizing

COLORIZING A GRAYSCALE MARKER DRAWING—FIGURES 8.3.1–8.3.6

- Up until this section, we have concentrated on grayscale marker application, perspective, line, proportion, value, and light. We will now learn a simple method of adding color to a grayscale marker drawing with pastel sticks. Be sure to try this technique before purchasing pastels. Many students prefer rendering color with markers. Color marker rendering will be discussed in Lesson 10 and beyond.

- As indicated in Figure 8.3.1, the tools required to add color to a grayscale marker drawing include pastel color sticks, an eraser, tissues, Q-tips, and an X-ACTO blade. An erasing shield may come in handy.

- Begin colorizing your grayscale drawing by selecting a color stick and then shaving off pastel dust with an X-ACTO blade on a piece of paper separate from your drawing (Figure 8.3.2).

- Note: The recommended pastels are Prismacolor NUPASTEL Firm Pastel Color Sticks. Other pastels will work well. However, Nupastels are harder and are slightly less messy. Nupastels are relatively inexpensive and can be purchased in different size sets. The 96-color set is recommended and will last a lifetime. Some students share a set by breaking the pastel sticks in half.

FIGURE 8.3.1

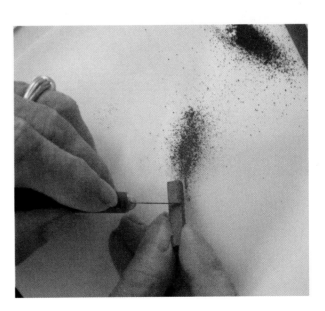

FIGURE 8.3.2

COLORIZING A GRAYSCALE MARKER DRAWING (CONTINUED)

- In Figure 8.3.3, a Q-tip is used to pick up a small amount of pastel dust and apply it lightly to the grayscale marker drawing. It is important to remember not to apply too much pastel dust. If you apply the pastel too heavily, the drawing will look muddy and compromise the final result. The colorization process works best when the pastel simply suggests color. It may take several attempts to get the application process right. Experiment with a Xerox copy of your drawing.

- It is best to apply the pastel dust with a Q-tip or a tissue. Direct application of the pastel stick makes it difficult to blend, smooth, and erase.

- Pastel dust can easily be erased to keep your drawing clean. An eraser can also be used to add highlights to an area covered with pastel. If the highlight is a narrow line, an eraser can be cut to a fine edge with an X-ACTO blade. In Figure 8.3.4, an eraser shield is used to keep a highlight straight and narrow.

- A piece of paper can be used as a mask to keep the application of pastel dust to a selected area.

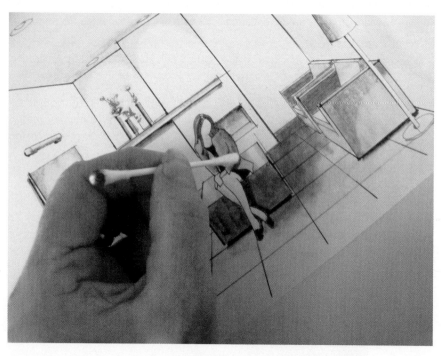

FIGURE 8.3.3

FIGURE 8.3.4

COLORIZATION OF A GRAYSCALE MARKER DRAWING—FIGURES 8.3.5–8.3.6

- Figure 8.3.5 illustrates the finished pastel colorization process described with Figures 8.3.1–8.3.4. The instructor took less than 10 minutes to complete the pastel application. Again, it is important to apply pastels lightly to add a subtle suggestion of color.

- Figure 8.3.6 is a student colorization sketch.

- Students will often use pastels in a color marker sketch for large areas such as walls and floors. This results in a smoother application of color or value than is typical with markers.

- Lesson 10 and beyond will go into more detail regarding color.

- Now would be a good time to review the MyKit Video for Lesson 8, Section 3 demonstrating pastel colorization of a student sketch.

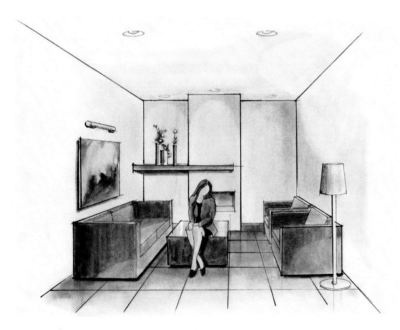

FIGURE 8.3.5

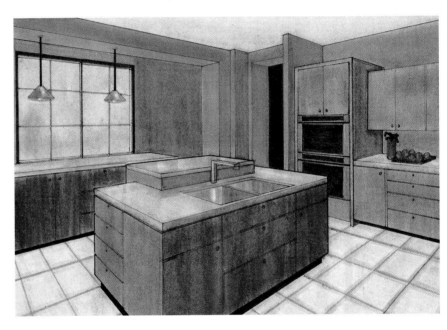

FIGURE 8.3.6

REQUIRED ASSIGNMENT

Lesson 8 Section 4
Homework

HOMEWORK ASSIGNMENT

This lesson's homework is a visualization exercise based on a written paragraph. You may modify the assignment, but the modifications must be described in writing before starting the sketch. This assignment is a design opportunity. Be creative. Color is optional for your finished sketch.

- Interior Designers: Use your creativity to develop a design concept for a two-story commercial interior. The interior drawing must include a reception desk on the north wall with a balcony above it. The west wall will include large windows looking out to a cityscape or landscape. The interior will include casual seating in front of the reception desk. People must be included in your finished sketch.

 The sketch may be of any type of commercial space. For example, the reception desk just described may be a bar in a pub. Think about the architecture of the space. Do not just draw walls and a ceiling.

 It is recommended you start the drawing by laying out a floor plan and use it to determine proportions and sightlines. The floor plan does not necessarily have to be scaled.

- Graphic Designers: Use your graphic design and sketch ability to design a book cover concept. The book cover must include a perspective element and typography. You may use this text as a basis for your design. People are optional in your finished sketch.

 Your sketch may be scanned and imported into a computer program to add the typography.

- Game Artists and Animators: Use your imagination to create a single storyboard marker sketch of a wooden ship interior. The view is from a ship's hold below a main deck. A seven-step wooden staircase to the ship's main deck dominates the middle ground of your sketch. The ceiling height of the hold is approximately 5 feet. Large wooden storage crates can be seen behind the staircase. Heavy wood beams support the hull and ceiling of the hold.

 Your sketch must include people, characters, creatures, or animals. You may add other elements, such as portholes, cannons, wine barrels, and so forth to reinforce your story.

REQUIRED READING

Lesson 8 Section 5 Homework Examples

Figures 8.5.1–8.5.15 are examples of homework completed by students at the Art Institute of California-San Diego.

- By Lesson 8, students typically have competent marker skills and are concentrating on the development of a personal drawing style and the visual communication of their ideas.

- The work featured in Lessons 1–9 of this text is from students in their first year of design school. Most of the students have not completed major-specific design courses when taking this course. It is important to keep in mind that although some of the projects in this text have a design component, this is not a design text.

- Students whose work is featured in this text had the opportunity to view finished drawings from other students who had completed the course. The authors believe the ability to view completed drawings from peers is a motivation to produce higher-quality work. Study and learn from the drawings in this section.

- All student sketches featured in Lesson 8 are examples of "A" grades.

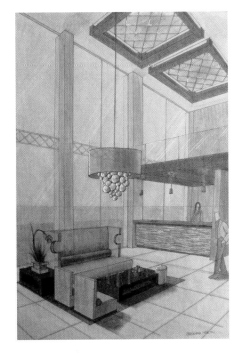

FIGURE 8.5.1

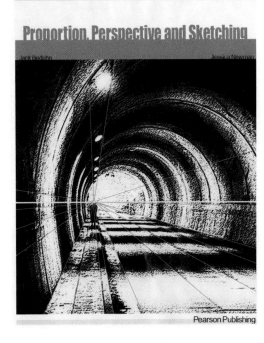

Pearson Publishing

FIGURE 8.5.2

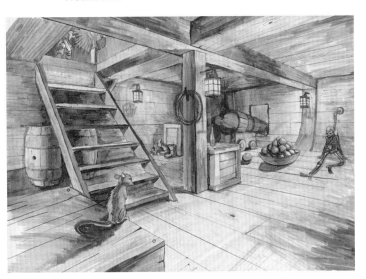

FIGURE 8.5.3

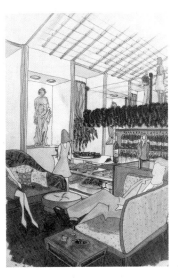

FIGURE 8.5.4

FIGURE 8.5.5

FIGURE 8.5.6

FIGURE 8.5.7

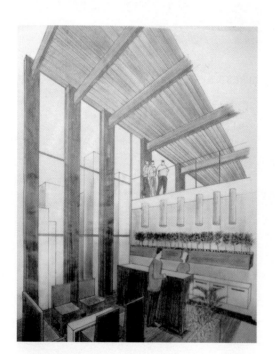

FIGURE 8.5.8

FIGURE 8.5.9

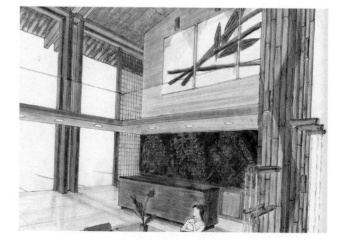

FIGURE 8.5.10

FIGURES 8.5.11–8.5.15

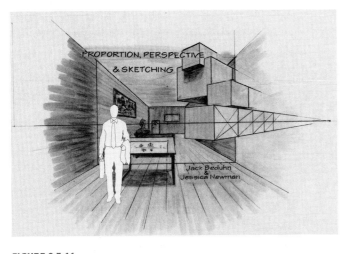

FIGURE 8.5.11

FIGURE 8.5.12

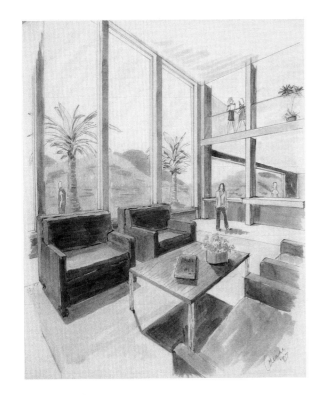

FIGURE 8.5.13

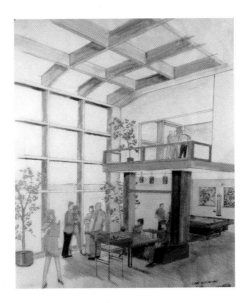

FIGURE 8.5.14

FIGURE 8.5.15

9

Three-Point
Perspective and Horizon Line Tricks

Lesson Overview

Lesson 9 is written in four sections:

- Lesson 9, Section 1: Three-point perspective techniques.

- Lesson 9, Section 2: Horizon line tricks.

- Lesson 9, Section 3: Homework assignment.

- Lesson 9, Section 4: Samples of student work with instructor comments.

NOTE
Most design students are visual learners. MyKit instruction for this lesson includes:

- Section 1, Video 1 demonstrates a three-point perspective layout technique.

- Section 1, Video 2 demonstrates another three-point perspective layout technique.

- Section 2, Video 1 demonstrates a horizon line trick to simulate a three-point perspective.

- Section 4, Video 1 demonstrates an interior design/graphic design layout technique for a homework assignment.

REQUIRED READING FOR GAME ARTISTS AND ANIMATORS
OPTIONAL FOR INTERIOR DESIGNERS AND GRAPHIC DESIGNERS

Lesson 9 Section 1
Three-Point Perspective

THREE-POINT PERSPECTIVE BACKGROUND—
FIGURES 9.1.1–9.1.2

- Interior designers and graphic designers seldom, if ever, use three-point perspective. Interior designers and graphic designers may want to skip this section and proceed to the Lesson 9, Section 3 homework assignment.

- Animators and game artists will have occasion to use three-point perspective for added drama. Three-point perspective is typically used when the observer or station point is very close to the object or the object is very large.

- Figures 9.1.1 and 9.1.2 illustrate a basic problem in laying out a three-point perspective:

 - In Figure 9.1.1, the vanishing points are located off of the paper. This makes the three-point perspective layout difficult.

 - In Figure 9.1.2, the building is drawn to the same height as the building in Figure 9.1.1. Figure 9.1.2 looks distorted because vanishing point 3 (VP3) is closer to the horizon line, resulting in a reduced cone of vision.

 - Of course the building in Figure 9.1.2 could have been drawn smaller, but that would make adding detail difficult.

- The following pages discuss techniques to lay out a three-point perspective with VP3 off of the page.

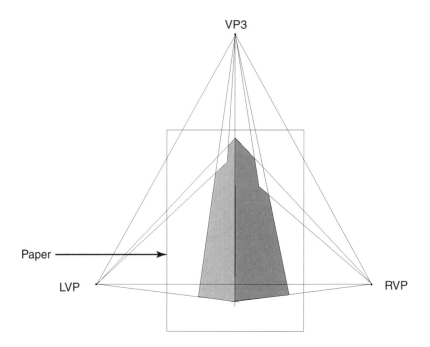

FIGURE 9.1.1

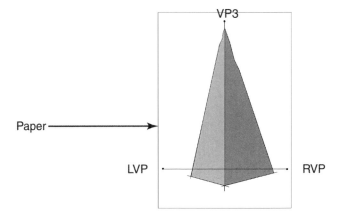

FIGURE 9.1.2

- When drawing a large object such as the building in Figure 9.1.3, keep the horizon line (HL) near the bottom of the paper approximately at normal standing eye level, or between 5 and 6 feet above the ground.

- To emphasize height, it is recommended that the left and right vanishing points (LVP and RVP) be located relatively close together. In Figure 9.1.3, the LVP and RVP are near the edges of the paper.

- In Figure 9.1.3, vanishing point 3 (VP3) is located off of the top of the paper, perhaps above the top edge of a drawing board.

- To facilitate vertical convergence to VP3, follow these simple steps:

 - Scale the horizon line to the left and right of the leading edge of the object. Any scale will work. If preferred, simply estimate equal increments on the HL. The increments are marked 1 through 5 to both the left and right of the leading edge of the building in Figure 9.1.3.

 - To facilitate convergence of the building's vertical lines to VP3, a horizontal line is drawn near the top of the paper.

 - Use a smaller scale than used on the HL to divide the top horizontal line into equal increments. These increments are marked 1 through 5 to the left and right of the leading edge of the building. It is critical that this scale be less than the scale used on the horizon line.

 - In Figure 9.1.3, note the scale difference on the two horizontal lines.

 - Align the vertical edges of the building with the HL scale and the horizontal scale at the top of the page. This will ensure that all vertical lines converge to VP3. Note how the back edges of the building align with tick mark 5 on both the HL and the horizontal line at the top of the page.

- The scale of the top horizontal line will determine the amount of convergence to VP3. If the scale is close to the scale used on the HL, then the convergence will be minimal. Conversely, the smaller the scale on the top line, the greater the angle of convergence.

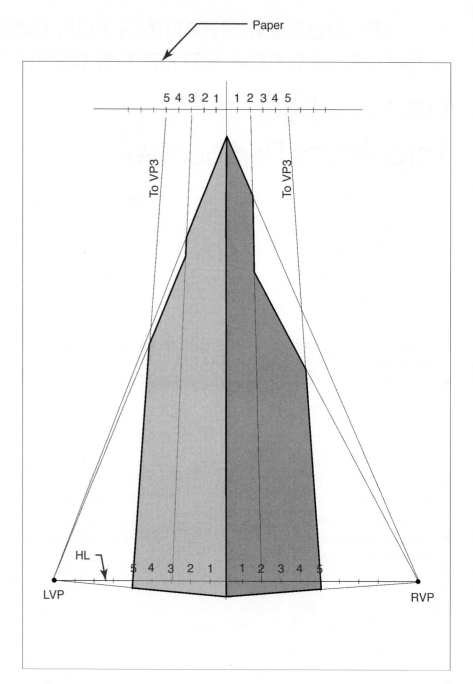

FIGURE 9.1.3

THREE-POINT PERSPECTIVE, TECHNIQUE 1—FIGURE 9.1.4

- There is a complex method of dividing the height of the building into visually equal perspective increments. It is obviously not as simple as measuring the leading edge of the building and subdividing it into equal increments. Each story of the building will appear smaller in height as it gets further from the horizon line and closer to VP3.

- The method to proportionally subdivide the height of a three-point perspective building is so complex it will not be reviewed in this text. It is the author's experience that students do not see value in the methodology.

- It is easiest and quickest to **estimate** each horizontal story of the building by keeping in mind that each story will appear to converge, or get closer together, as it gets closer to VP3.

- The author used his sense of scale and proportion to subdivide the building in Figure 9.1.4 into eight stories. The perspective is believable but not necessarily accurate.

- Use Figure 9.1.5 to estimate the vertical proportioning of a three-point perspective.

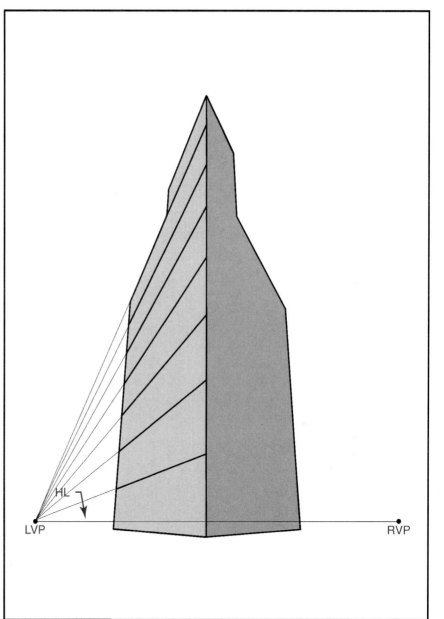

FIGURE 9.1.4

OPTIONAL EXERCISE

THREE-POINT PERSPECTIVE EXERCISE—FIGURE 9.1.5

Use your sense of scale and proportion to estimate the vertical proportioning of the building in Figure 9.1.5. Assume the HL is located approximately 5'-0" above the ground and each story of the building is approximately 15'-0" in height.

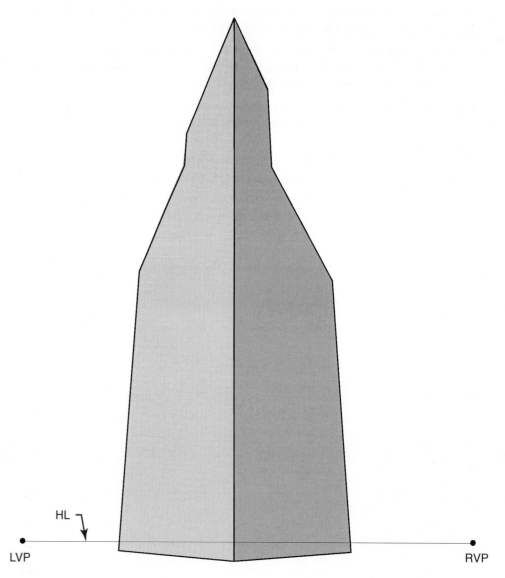

FIGURE 9.1.5

THREE-POINT PERSPECTIVE, TECHNIQUE 1—FIGURE 9.1.6

- The same technique used to lay out a three-point perspective looking up at an object can be used for a perspective looking down at an object.

- Simply move the HL to near the top of the page and follow the same steps outlined with Figures 9.1.1–9.1.5.

- The base of the block in Figure 9.1.6 looks distorted because it is too far outside the cone of vision. How might you correct the problem?

- Now would be a good time to review the first MyKit video for Lesson 9, Section 1.

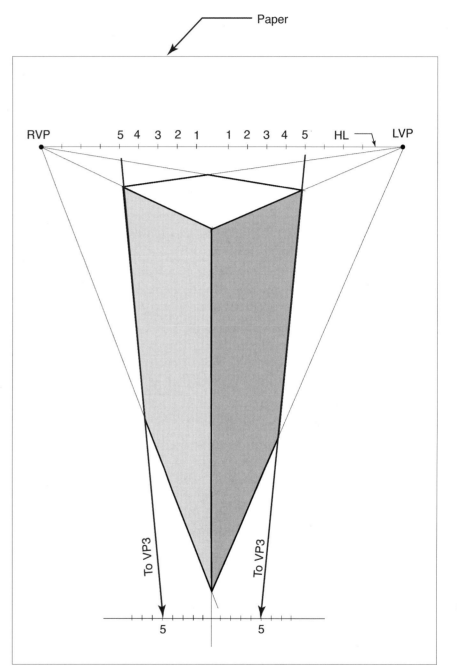

FIGURE 9.1.6

THREE-POINT PERSPECTIVE, TECHNIQUE 2—FIGURES 9.1.7A–9.1.7F

- Figure 9.1.7a: Use a compass to draw two concentric circles.

- Figure 9.1.7b–9.1.7c: Use the radius of the outer circle to subdivide the circle into six equal sections:

 - Figure 9.1.7b: Begin construction with the point of the compass on point A as illustrated in Figure 9.1.7b. Strike an arc crossing the outer circle at points B and C.

 - Figure 9.1.7b: Strike arcs using intersections B and C for the point of the compass.

 - Figure 9.1.7c: Continue striking arcs using intersections D and E for the point of the compass. This completes the geometry and subdivides the original circle into six equal sections.

- Figure 9.1.7d: Draw six radii from the center to the outside of the original circles. Each radius will intersect the crossing points of two arcs. Line X is a heavier line weight to reference one of the six radii.

- Figure 9.1.7e: Starting at point A on the outer circle, draw a line to point B on the inner circle. From point B on the inner circle, draw a line to point C on the outer circle. Continue drawing lines from outer circle C to inner circle D, inner circle D to outer circle E, and so forth until you are back to point A.

- Figure 9.1.7f: Strike lines from points A, C, and E to the center of the original circles. This completes a perfect three-point perspective without using vanishing points.

- This technique may come in handy when drawing a large three-point perspective where all the vanishing points are far off of the paper. It gives you a three-point perspective guide to **estimate** lines converging to unseen vanishing points. Figure 9.1.8 on the next page is an example.

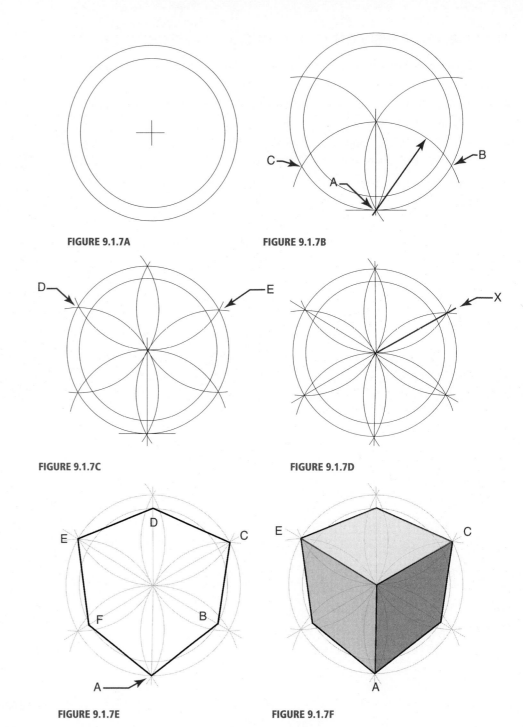

FIGURE 9.1.7A FIGURE 9.1.7B

FIGURE 9.1.7C FIGURE 9.1.7D

FIGURE 9.1.7E FIGURE 9.1.7F

THREE-POINT PERSPECTIVE, TECHNIQUE 2—FIGURE 9.1.8

- The blocks in Figure 9.1.8 were all estimated using a cube generated with concentric circles and arcs.

- Notice that the LVP, RVP, and VP3 are all off of the page. The vanishing points would all be off of a drawing board if Figure 9.1.8 were laid out using normal-size sketch paper.

- This methodology makes it difficult, if not impossible, to converge all the lines exactly to the vanishing points. The lack of precise convergence is not a significant visual problem. The vanishing points are so far away that your eye does not perceive the minimal misalignment.

- If you have completed all the assignments up to this point, it should be relatively easy to believably estimate convergence. This method works especially well for concept drawings and quick layouts.

- Note: The distance between the two concentric layout circles impacts the location of the vanishing points. As the distance between the concentric circles is increased, the distance of the vanishing points is decreased.

- Now would be a good time to review the second MyKit video for Lesson 9, Section 1.

FIGURE 9.1.8

Lesson 9 Section 2

Horizon Line Tricks

HORIZON LINE ROTATION—FIGURES 9.2.1–9.2.2

There is no rule that an HL must be horizontal. Rotating the HL can give the artist another way to add drama to a drawing.

- Figure 9.2.1 is a one-point perspective with a rotated HL. This drawing effectively communicates a sinking or rocking ship. The rotated HL adds interest to the drawing.

- Figure 9.2.2 is simply a two-point perspective with a vertical HL. It effectively simulates a three-point perspective to the casual observer. This is a nice trick when time is a critical factor.

- Now would be a good time to review the MyKit video for Lesson 9, Section 2.

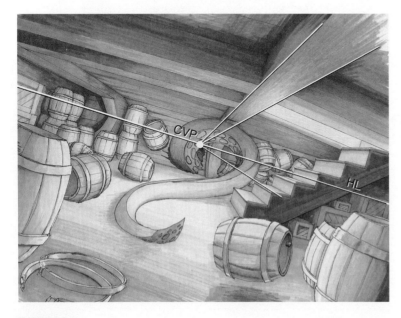

FIGURE 9.2.1

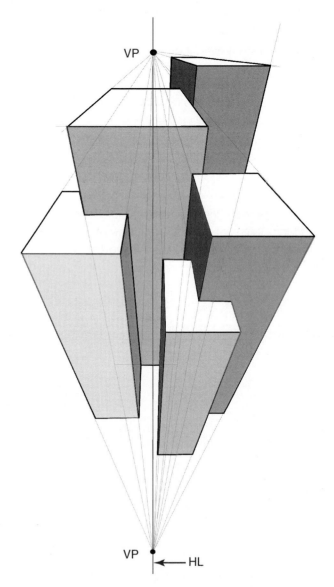

FIGURE 9.2.2

REQUIRED ASSIGNMENT

Lesson 9 Section 3
Homework

HOMEWORK ASSIGNMENT

This lesson's homework is an exercise on drawing from plans and elevations for graphic design and interior design students. It is a visualization exercise for game art and animation students based on a written scenario.

- Interior Designers and Graphic Designers: Imagine you are a ninth-quarter student intern and your supervisor asks you to provide a finished sketch based on floor plans and elevations. The floor plans and elevations in Figure 9.3.1 were presented to the client, but the client did not understand or could not visualize the design intent. Your supervisor wants you to complete a finished sketch in no more than 4 hours.

 - You may modify the style of the kitchen cabinetry, but you must maintain the layout and dimensions of the space. People may be added to the sketch to communicate scale and proportion. Color is optional. A vent hood over the island cook top is also optional.

 - It is recommended you start the drawing by proportioning the walls in one-point or two-point perspective. After the walls are roughed in, start laying out the kitchen cabinetry, appliances, and island as a perspective floor plan. Use your sense of scale to refine the floor plan proportions before adding vertical dimension and detail to the cabinetry and appliances.

 - If you have difficulty with the kitchen layout, please review the MyKit instruction video for Lesson 9, Section 4.

- Game Artists and Animators: Use your imagination to create a storyboard marker sketch of one of the following scenes:

 - Develop a three-point perspective drawing of large-scale buildings. Use one of the three-point perspective techniques learned in this lesson to lay out your drawing. Your drawing may include characters, animals, or creatures. Color is optional. Be creative.

 - Develop a one-point or two-point perspective of a park scene. The park is conceptually similar to Central Park in New York City. Your drawing should include large-scale buildings in the background and a path with water on one or both sides. Include a couple walking on the path. Include trees and shrubbery in the scene. Be creative and tell a story with your drawing. You may substitute animals, creatures, or characters for the couple in the scene.

 - Develop a one-point or two-point perspective of a large tree with a platform or tree house in the branches. Include people, characters, animals, or creatures in the scene. Be creative and tell a story with your drawing.

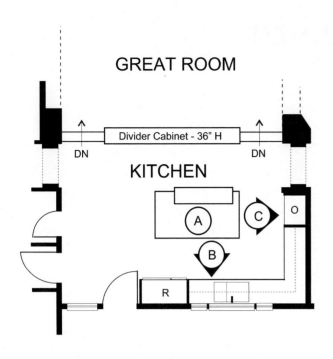

GREAT ROOM

Divider Cabinet - 36" H

DN DN

KITCHEN

A C O

B

R

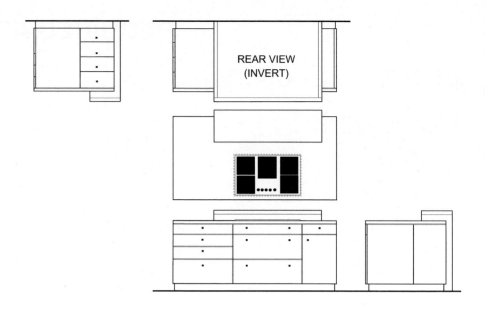

REAR VIEW
(INVERT)

KITCHEN FLOOR PLAN
1/8" = 1'-0"

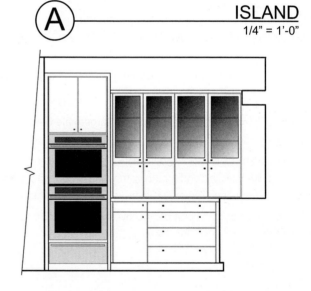

A ISLAND
1/4" = 1'-0"

B CABINETS / APPLIANCES
1/4" = 1'-0"

C CABINETS / APPLIANCES
1/4" = 1'-0"

FIGURE 9.3.1

REQUIRED READING

Lesson 9 Section 4
Homework Examples

Congratulations, you have finished the first half of the text.

By now you should be able to lay out perspective drawings that are believable in scale and proportion. You should be competent using markers and working on the development of a personal drawing style. Perhaps you are not yet laying out your drawings without a lot of effort, but you soon will be if you keep practicing. When you reach that plateau you can concentrate more on using perspective as a design tool. It is your authors' experience that great conceptual design is generated three-dimensionally, not just in plan and elevation.

The second half of the text will continue development of your perspective-drawing ability and amplify your use of color and value. You will develop rapid visualization skills and practice using different rendering materials. You will continue to improve with markers and learn how to use computer applications for efficiency and fine tuning your drawings.

A final thought about computers: It is critical that students integrate the use of a computer into their design competencies. It is doubtful that a graduating student would be hired in today's marketplace without competent computer skills. The computer, however, does not replace hand drawings for conceptual development and design ideation. Learn to draw well and learn to draw quickly. Integrate high-level drawing and computer skills into your portfolio and you will more likely succeed in today's highly competitive job market.

Jack K. Beduhn, FIDSA

NOTE
If you have not already reviewed the MyKit video instruction for the Lesson 9, Section 4 Interior Design and Graphic Design homework assignment, now would be a good time to do it.

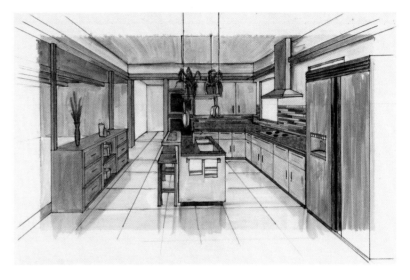

FIGURE 9.4.1

FIGURE 9.4.2

FIGURE 9.4.3

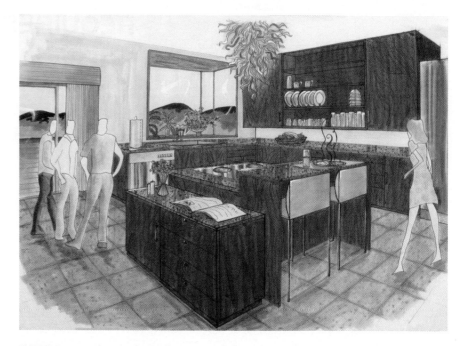

FIGURE 9.4.4

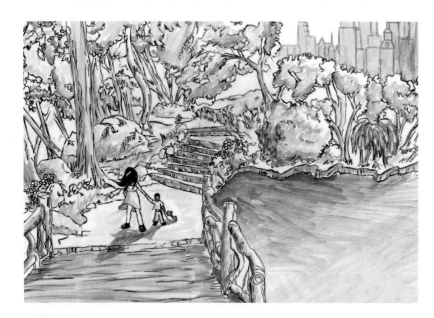

FIGURE 9.4.5

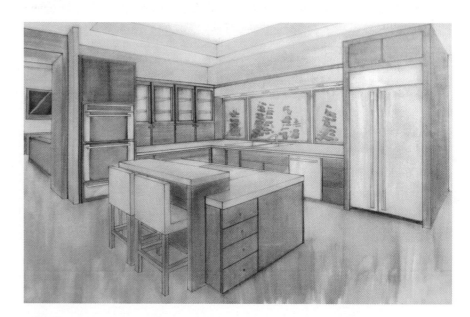

FIGURE 9.4.6

FIGURE 9.4.7

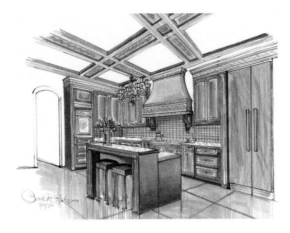

FIGURE 9.4.8

FIGURE 9.4.9

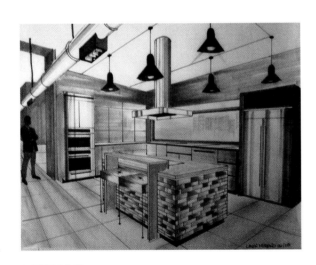

FIGURE 9.4.10

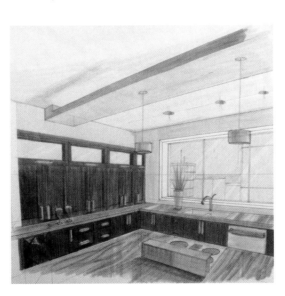

FIGURE 9.4.11

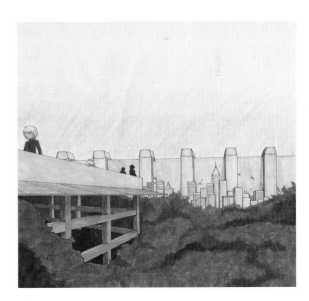

FIGURE 9.4.12

10

Chiaroscuro

Lesson Overview

Lesson 10 is written in five sections:

- Lesson 10, Section 1: Chiaroscuro and Pencil.

- Lesson 10, Section 2: Pen and Ink.

- Lesson 10, Section 3: Grayscale Markers.

- Lesson 10, Section 4: Homework.

- Lesson 10, Section 5: Student Work.

NOTE
Most design students are visual learners. MyKit instruction for this lesson includes:

- Section 1, Video 1 demonstrates the pencil exercises.

- Section 2, Video 1 demonstrates the pen-and-ink exercises.

- Section 3, Video 1 demonstrates the use of grayscale markers.

REQUIRED READING

Lesson 10 Section 1
Chiaroscuro and Pencil

It is important to realize that everything in the world is made up of four shapes—that's it, just four! With architectural and interior design drawings, we are usually drawing things that haven't been built yet. This is completely different from looking at something and drawing it. If you can commit these four shapes to memory (and you can), then you can draw anything realistically, whether it's in front of you or not.

CHIAROSCURO—VALUE

Chiaroscuro is a method of applying value to a two-dimensional piece of artwork to create the illusion of three dimensions. This way of working was devised during the Renaissance and was used by artists such as Leonardo da Vinci and Raphael. Chiaroscuro is an Italian word combining the word *chiaro* (light) and *oscuro* (dark). In this system, if light is coming from one direction, then light and shadow will conform to a set of rules that you will learn about in this lesson.

PENCIL—FIGURES 10.1.1–10.1.12

We are going to start learning about value by using pencil as our medium. Pencil is a great place to start because you already feel comfortable using pencils, even if you've never done much drawing. We will begin by making a value scale. We want six separate tones; the first one is the white of your paper, and the sixth one is pressing as hard as you can with your pencil. The other four tones will be equally spaced in value. To create light tones with pencil, hold your pencil far away from the point, and use little pressure. For dark tones, hold your pencil up near the point and press hard. Try to match these tones:

(Watch Section 1, Video 1 in MyKit for a demonstration.)

FIGURE 10.1.1

How can you tell if your value scale is correct? Squint your eyes! You should see a smooth gradation from dark to light. If there is a noticeable jump in tones, adjust your scale by erasing or darkening. It's important that you have a good value scale to work with, as we'll be referring to it many times throughout the book.

When you are happy with your scale, add the names of each value:

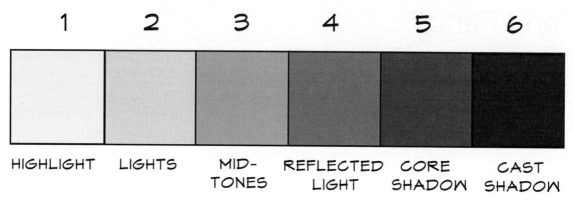

1	2	3	4	5	6
HIGHLIGHT	LIGHTS	MID-TONES	REFLECTED LIGHT	CORE SHADOW	CAST SHADOW

FIGURE 10.1.2

On the following pages are the four shapes, and how to render them in pencil. I have used a technique called mapping to break down dark and light into shapes similar to countries on a map. Copy these shapes first, then fill them in. This method makes shading as easy as color-by-number.

Cube: On EVERYTHING that is rectangular in shape, there is a **light side, a dark side, and a medium side.** Below is a map of where to use your tones, which correspond with the value scale, and below that, how they look rendered in pencil. There is a one-point perspective cube and a two-point perspective cube. Practice them both!

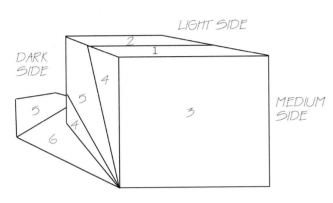

FIGURE 10.1.3

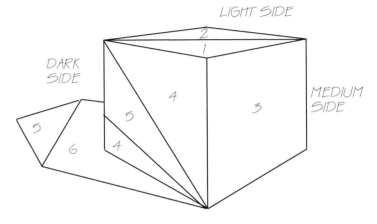

FIGURE 10.1.4

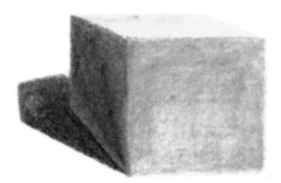

FIGURE 10.1.5

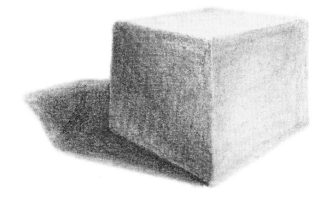

FIGURE 10.1.6

Sphere: The brightest spot on the sphere, or the highlight, is a SMALL point where the light is being reflected most directly. As you move away from the highlight, the sphere gets darker in concentric circles (like a target symbol).

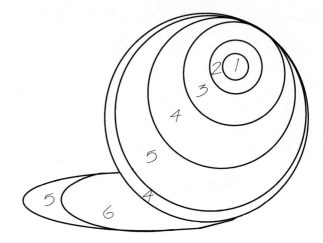

FIGURE 10.1.7

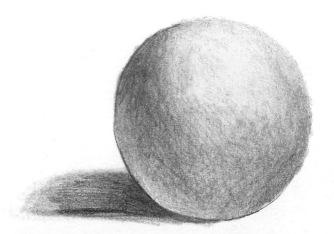

FIGURE 10.1.8

Cylinder: **Lighter closer to you, darker farther away.** The middle of your cylinder should be lighter than the sides of your cylinder. Remember this whenever you are shading columns.

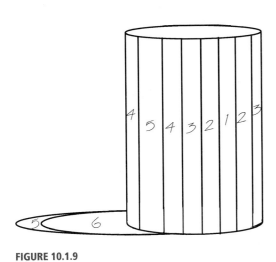

FIGURE 10.1.9

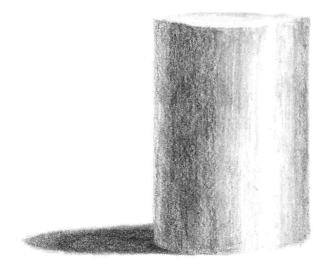

FIGURE 10.1.10

Cone/Pyramid: This is the same as a cylinder, but pinched at the end.

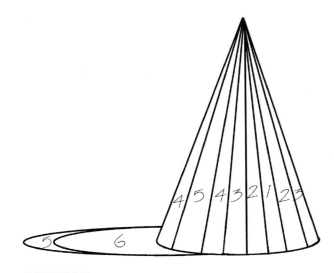

FIGURE 10.1.11

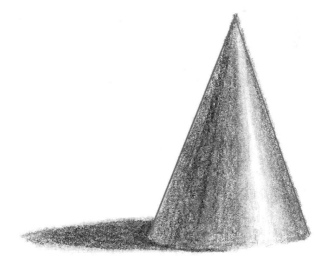

FIGURE 10.1.12

Lesson 10 Section 2
Pen and Ink

PEN AND INK—FIGURES 10.2.1–10.2.15

Pen and ink may seem similar to pencil, but it is actually very different. For one, you can't erase. It's important to plan out your drawing before you start, as you have to leave your white space—you can always go darker, but unfortunately, you cannot go lighter. Another big difference between pencil and pen and ink is the way that we achieve change in value. With pencil, you press hard for a dark line, and softly for a light line. With pen and ink, whether you press hard or soft, the result will be a black ink line. So how do we achieve change in value? With pen and ink it is the space between your marks that creates value change. Lines close together will read as dark, and lines with space between them will read as a lighter tone. Just as with pencil we'll start out with a value scale. One of the great things about pen and ink is that there is great opportunity for your personal style to emerge due to the kind of marks that you make. Just as everyone's signature is different, everyone's pen-and-ink marks will be different. Here are three different styles that are good to try: crosshatching, stipple, and vertical lines.

(Watch Section 2, Video 1 in MyKit for a demonstration.)

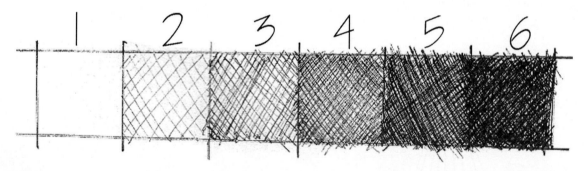

FIGURE 10.2.1

Above is a pen-and-ink value scale. The closer the lines are to each other, the darker the tone.

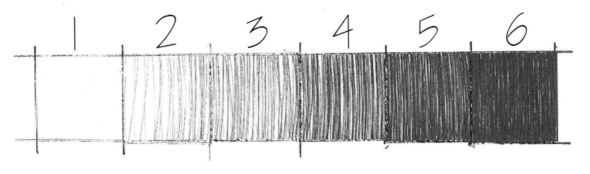

FIGURE 10.2.2

The above scale was created with vertical lines.

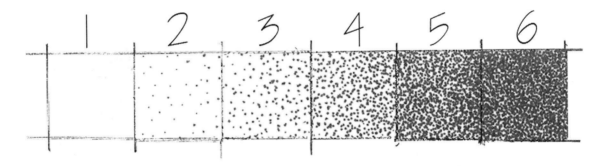

FIGURE 10.2.3

The final value scale was created with stipple.

Here is how each shape looks rendered in each style:

FIGURE.10.2.4

FIGURE 10.2.5

FIGURE 10.2.6

FIGURE 10.2.7

FIGURE 10.2.8

FIGURE 10.2.9

FIGURE 10.2.10

FIGURE 10.2.11

FIGURE 10.2.12

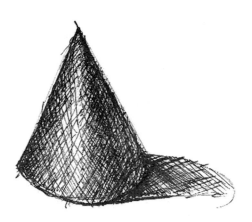

FIGURE 10.2.13

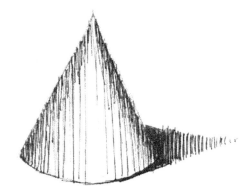

FIGURE 10.2.14

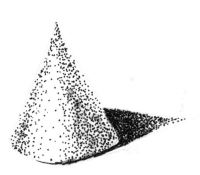

FIGURE 10.2.15

Chiaroscuro **179**

Lesson 10 Section 3
Grayscale Markers

GRAYSCALE MARKERS—FIGURES 10.3.1–10.3.6

Form is expressed by value. We will continue to use a six-value system to render forms. This is extremely easy with grayscale markers, as they are already separated in value and labeled with numbers. How they are labeled depends on the manufacturer, for example, gray #7, or 70% gray.

Name of value	What marker to use
Highlight	Gray marker #1 or #2 /10% or 20% gray
Lights	Gray marker #3 or #4/30% or 40% gray
Midtones	gray #5/50% gray
Reflected light	**gray #7/70% gray**
Core shadow	**gray #9 or 10/90% gray**
Cast shadow	**Black**

As you can see, you only need six gray markers to create the illusion of form.

The last three are in bold type because they should only be used on the dark side of the object.

The first two should only be used on the light side.

The third is the midtone between light and dark, and will be used on the medium side.

Your value scale will look different depending on which type of paper you choose to use. I'll talk more about paper in the next lesson, which focuses solely on markers. Here are two value scales, the first is on tracing paper (Figure 10.3.1) and the second is on marker paper (Figure 10.3.2).

(Watch Section 3, Video 1 in MyKit for a demonstration.)

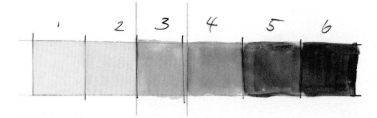
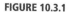

FIGURE 10.3.1

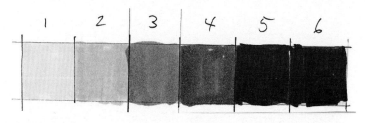

FIGURE 10.3.2

Below are the four shapes in marker grayscale.

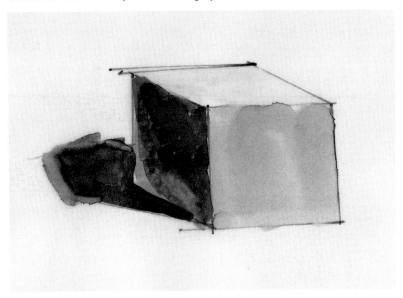

FIGURE 10.3.3

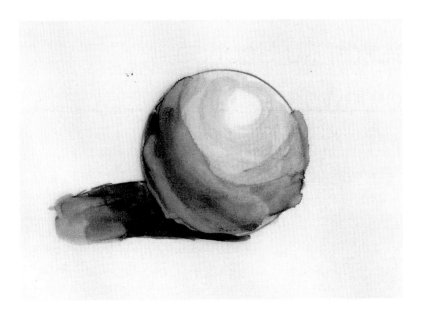

FIGURE 10.3.4

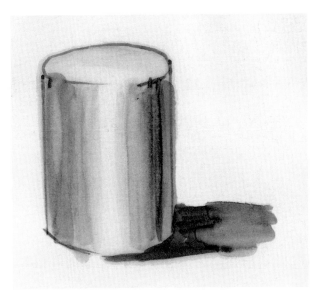

FIGURE 10.3.5

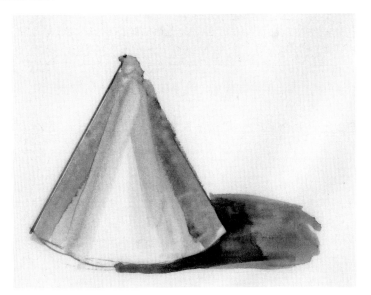

FIGURE 10.3.6

DO NOT MOVE ON TO THE NEXT LESSON UNTIL YOU CAN RENDER EACH OF THESE SHAPES IN GRAYSCALE IN PENCIL, PEN, AND MARKER! Colors can be off, but if the values are correct, then your work will always look good.

REQUIRED READING

Lesson 10 Section 4
Homework

HOMEWORK ASSIGNMENT

Find an image of an interior from a magazine or online. Photocopy the image, or print it in black and white on 8½" × 11" paper. Redraw the room the same size on another piece of paper. Draw, do not trace. Render the image in grayscale in pencil, pen, or marker. Look for the shapes that you practiced, and squint your eyes to really see the changes in value.

REQUIRED READING

Lesson 10 Section 5
Homework Examples

PENCIL—FIGURES 10.5.1–10.5.2

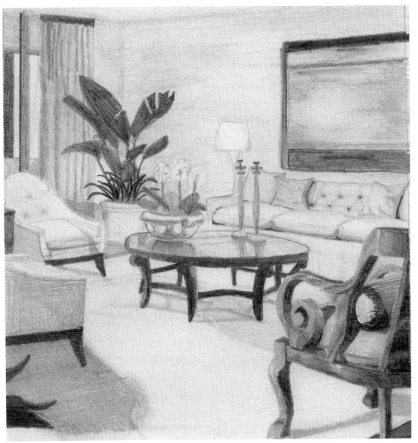

FIGURE 10.5.1

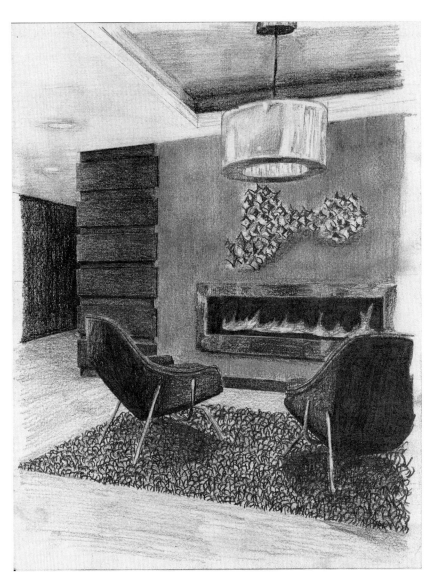

FIGURE 10.5.2

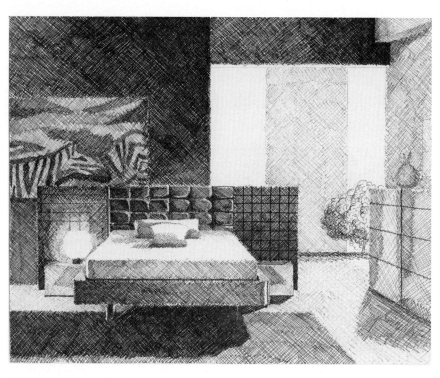

FIGURE 10.5.3

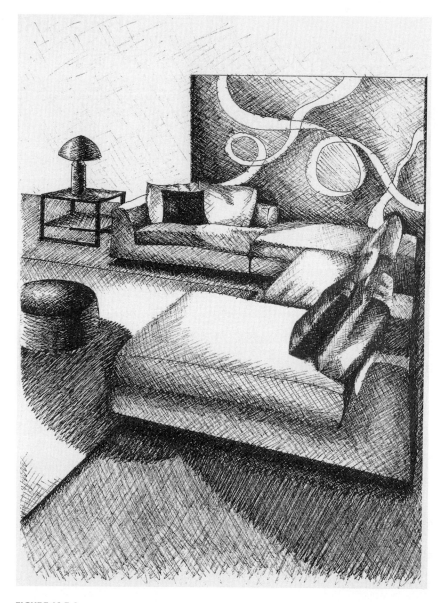

FIGURE 10.5.4

Markers and Color

Lesson Overview

Lesson 11 is written in five sections:

- Lesson 11, Section 1: Background information and techniques.
- Lesson 11, Section 2: How to achieve value change using color.
- Lesson 11, Section 3: Color marker exercises.
- Lesson 11, Section 4: Homework assignment.
- Lesson 11, Section 5: Student examples.

NOTE
Most design students are visual learners. MyKit instruction for this lesson includes:

- Section 3, Video 1 demonstrates the color marker exercises.

Lesson 11 Section 1
Introduction to Markers

WORKING WITH COLOR

The media that we will be working with the most is marker. Before we begin, you must understand that a marker is just ink and a medium to make it flow. Knowing which type of marker you're using is very important. There are basically two types of markers—alcohol based and xylene based. One of these is toxic and one is not, and it is very easy to tell them apart. If you take the cap off of an alcohol-based marker and smell it, there is no strong smell. If you take the cap off of a xylene-based marker and smell it, you will notice immediately that there is a very strong smell! Strong-smelling or xylene-based markers should only be used in a well-ventilated area. Due to the toxicity, xylene-based markers are more rare. AD chartpack markers are xylene based. They are also juicy and saturated, painterly, and come in beautiful colors; for a long time, these were my favorites.

Some of the alcohol-based markers are Prismacolor and Copic. Alcohol-based markers can be used together, regardless of brand—they will blend with each other. A xylene-based marker and an alcohol-based marker will not blend very well.

Another reason that you must know which type of marker you are using is because if you add more of that medium to the marker, you can actually paint with it! For alcohol-based markers, the medium is 97% alcohol, which you can buy from any drugstore for around 99 cents. For xylene-based markers, the medium is lighter fluid (obviously don't smoke or light candles while you are using this method, as the fumes can be flammable).

REQUIRED READING

Lesson 11 Section 2
Color Relationships

You simply cannot move on to using color until you understand value. By now, I trust that you have followed the exercises in this book, and that you have an understanding of chiaroscuro.

It is possible to create all of your value changes using grays, and then add color; however, I think you will find that this does not give you an optimal result. For a truly beautiful color drawing, use your grays sparingly, and create value change using COLOR! I have spent many years as a painter, and have translated oil painting techniques to marker to help you create rich, beautiful marker renderings.

Everything has a local color, the overall color of an object. For example, an apple is red. The apple has other colors in it, but, basically, it's red. Once you know the local color of something, you can create value change by following this chart:

Lighter	⬅	Local color	➡	Darker
Orange		Red		Violet
Yellow		Orange		Red
White		Yellow		Orange
Yellow		Green		Blue
Green		Blue		Violet
Blue/or Red		Violet		Black

You should notice a pattern in the above chart. You can create value change by using the colors that lie on either side of your local color on the color wheel (Figure 11.2.1). For example, if your local color is green, look to the colors that are next to green on the color wheel—yellow and blue. Use blue in the shadow, or darker tone areas (values 5 and 6 on our value scale) and use yellow for the lighter tone areas (values 1 and 2 on our value scale).

FIGURE 11.2.1

On the following pages are the six colors with a value scale and four shapes rendered using this method. Practice these until they look realistic!

REQUIRED READING

Lesson 11 Section 3
Color Marker Exercises

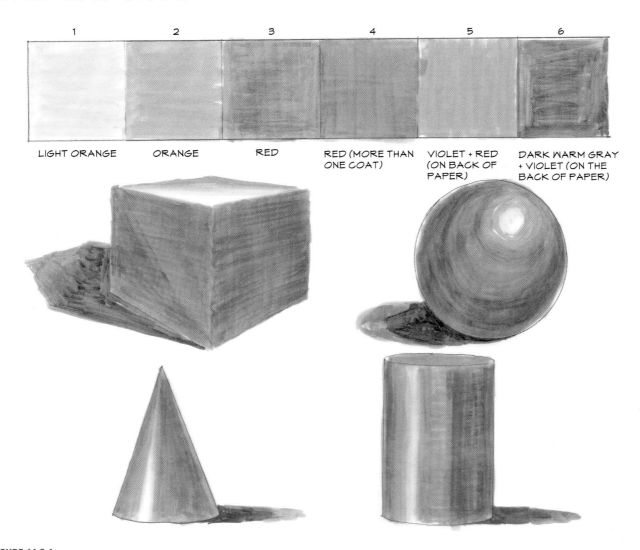

1	2	3	4	5	6
LIGHT ORANGE	ORANGE	RED	RED (MORE THAN ONE COAT)	VIOLET + RED (ON BACK OF PAPER)	DARK WARM GRAY + VIOLET (ON THE BACK OF PAPER)

FIGURE 11.3.1

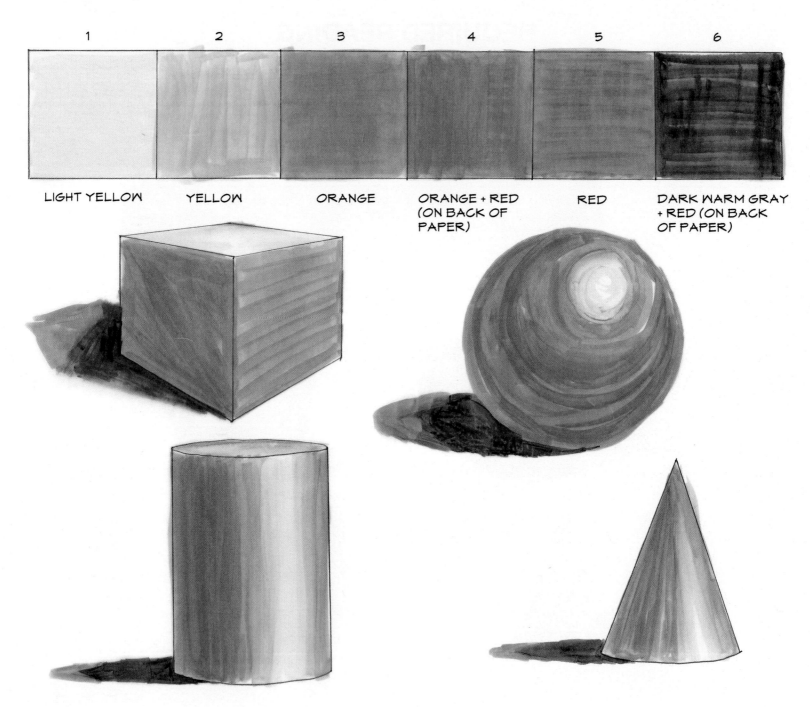

1 2 3 4 5 6

LIGHT YELLOW YELLOW ORANGE ORANGE + RED (ON BACK OF PAPER) RED DARK WARM GRAY + RED (ON BACK OF PAPER)

FIGURE 11.3.2

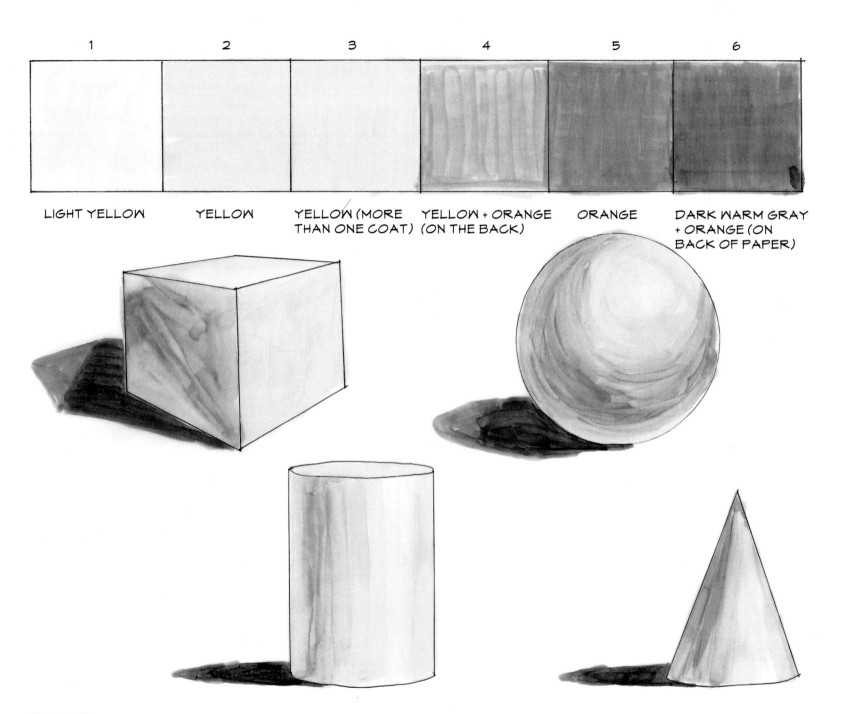

1 2 3 4 5 6

LIGHT YELLOW YELLOW YELLOW (MORE THAN ONE COAT) YELLOW + ORANGE (ON THE BACK) ORANGE DARK WARM GRAY + ORANGE (ON BACK OF PAPER)

FIGURE 11.3.3

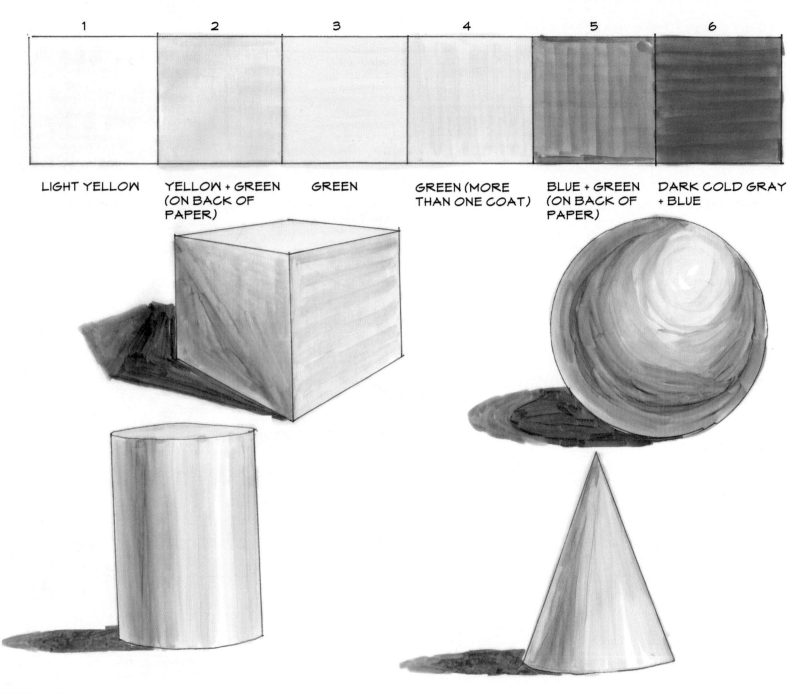

1	2	3	4	5	6
LIGHT YELLOW	YELLOW + GREEN (ON BACK OF PAPER)	GREEN	GREEN (MORE THAN ONE COAT)	BLUE + GREEN (ON BACK OF PAPER)	DARK COLD GRAY + BLUE

FIGURE 11.3.4

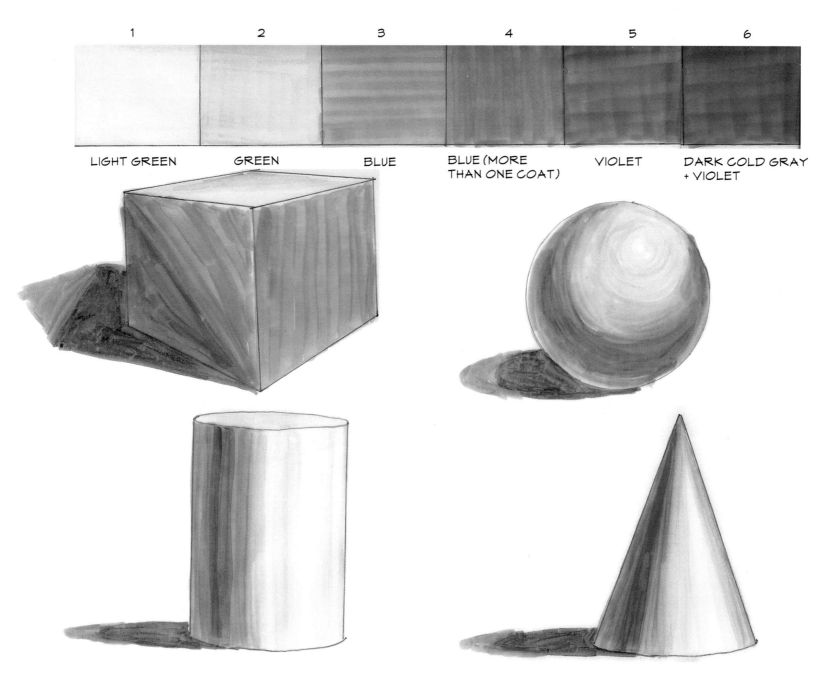

1	2	3	4	5	6
LIGHT GREEN	GREEN	BLUE	BLUE (MORE THAN ONE COAT)	VIOLET	DARK COLD GRAY + VIOLET

FIGURE 11.3.5

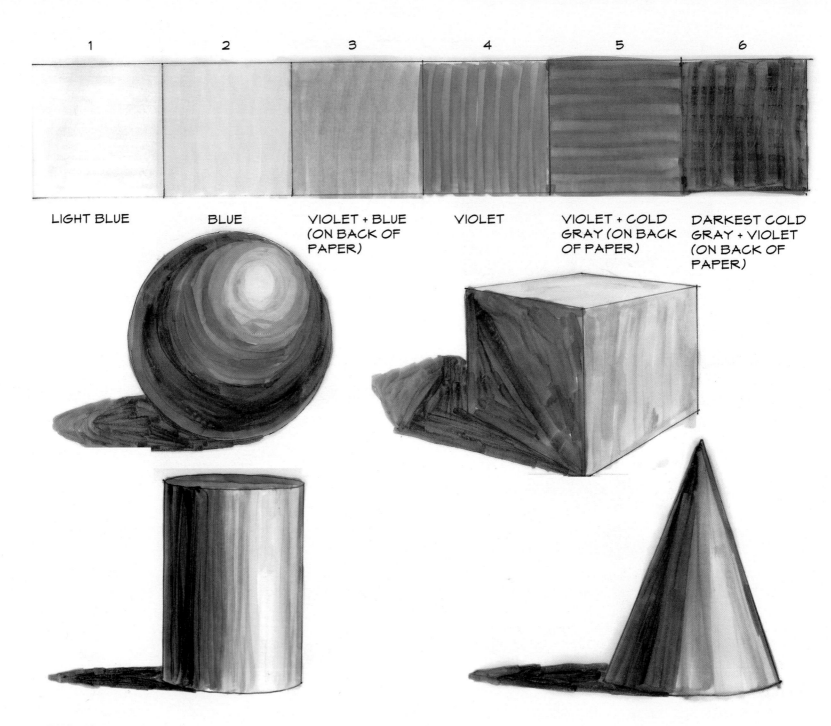

1 2 3 4 5 6

LIGHT BLUE BLUE VIOLET + BLUE (ON BACK OF PAPER) VIOLET VIOLET + COLD GRAY (ON BACK OF PAPER) DARKEST COLD GRAY + VIOLET (ON BACK OF PAPER)

FIGURE 11.3.6

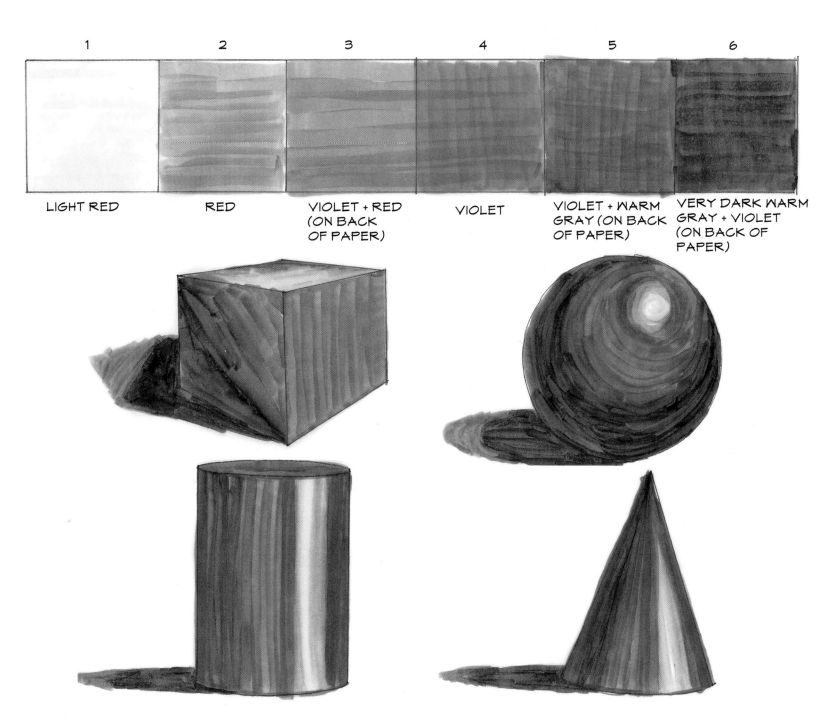

1	2	3	4	5	6
LIGHT RED	RED	VIOLET + RED (ON BACK OF PAPER)	VIOLET	VIOLET + WARM GRAY (ON BACK OF PAPER)	VERY DARK WARM GRAY + VIOLET (ON BACK OF PAPER)

FIGURE 11.3.7

Lesson 11 Section 4
Homework

HOMEWORK ASSIGNMENT

Create and render an interior space with brightly colored objects. These objects could be furniture, materials, and so on. USE GRAY SPARINGLY! Inject as much color as you can with the colored objects by using the methods explained in this lesson.

REQUIRED READING

Lesson 11 Section 5
Homework Examples

STUDENT WORK—FIGURES 11.5.1–11.5.4

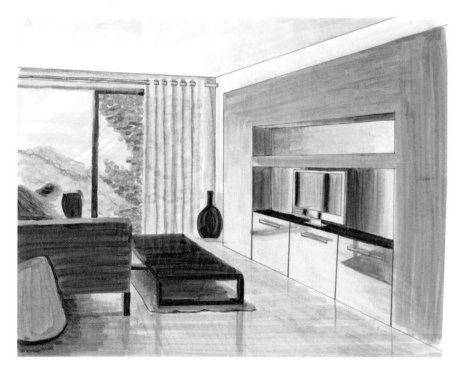

FIGURE 11.5.1

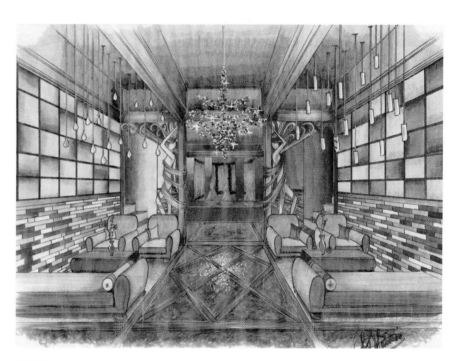

FIGURE 11.5.2

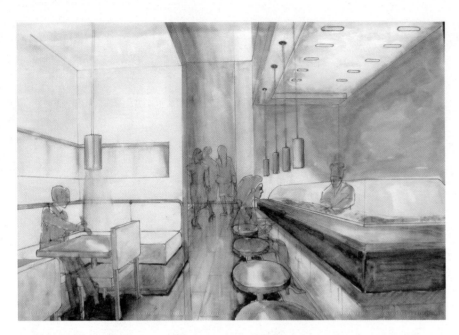

FIGURE 11.5.3

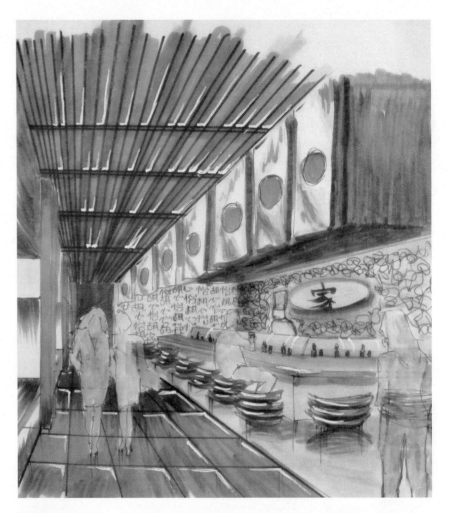

FIGURE 11.5.4

Color Pencils

Lesson Overview

Lesson 12 is written in five sections:

- Lesson 12, Section 1: Background information and techniques.
- Lesson 12, Section 2: How to achieve value change.
- Lesson 12, Section 3: Burnishing.
- Lesson 12, Section 4: Color pencil on black or toned paper.
- Lesson 12, Section 5: Homework exercise.
- Lesson 12, Section 6: Samples of student work.

NOTE
Most design students are visual learners. MyKit instruction for this lesson includes:

- Section 3, Video 1 demonstrates burnishing technique.
- Section 4, Video 1 demonstrates color pencil on black paper.

Lesson 12 Section 1
Color Pencils

Color pencils are often used in conjunction with markers, but they warrant their own chapter because they have special, unique applications all their own.

COLOR PENCILS WITH MARKERS

Do not fall into the trap of relying on color pencil to render materials, especially on elevations and floor plans. Color pencils are a wonderful supplement to markers, and you will see me use them often, but in today's fast-paced design world, it takes far too much time to complete a drawing with color pencils to be worth it. Use markers for the majority of your renderings, and use color pencils for details like highlights and wood grain. You should be 90% done with your rendering when you reach for the color pencils. Keep it painterly; keep it loose. Remember, if you wanted a tight rendering, you would have used a computer 3D rendering program.

There is an exception—a technique that is so interesting and dramatic that it is worth your time to use color pencils. We will cover that technique in Section 4.

The first thing you must know about color pencils is that they are fragile—don't drop them! Although it is difficult to break the entire pencil, the color pigment "lead" inside is very breakable. Did you ever have a color pencil that you sharpen, and the inside color piece falls out, so you sharpen again, and the color falls out again? That's because the color pigment is broken inside the pencil.

There are two types of paper made specifically for color pencil: hot press and cold press. Cold press has a rough texture, and hot press is smooth (imagine an iron smoothing out the wrinkles to remember which is which). Cold-press paper will hold more pencil. If you intend to do a lot of layering, cold press would be a good choice. It is extremely important that you keep your pencil sharp when using this type of paper, as a dull pencil will not get into the ridges in the paper, and the white of the paper will show through. This will give your drawing a strange and unwanted texture. If you will be working primarily in marker, use whatever paper you prefer for markers, as markers are extremely affected by the paper, but color pencils can be used with any type of paper. You will see me use them on tracing paper all of the time in the demonstration videos.

REQUIRED READING

Lesson 12 Section 2
Achieving Value Change

Each color pencil was created with a specific value (lightness/darkness). For example, the pigment in a red pencil will always be darker than the pigment in a yellow pencil, no matter how hard you press with the yellow pencil. So how do we achieve change in value with color pencils? There are actually four ways:

1. Change in pressure: This works better with darker pencils, because you can hold them lightly at the end of the pencil, and let some of the paper show through, but a light pencil will never get very dark; instead, you will have to employ technique 2 or 4 to get a full range of values.

2. Overlay any color with black.

3. Overlay any color with white.

4. Overlay any color with another color. This method will not only change the value (lightness/darkness), it also changes the hue (color) and intensity (saturation). One particularly good color to choose is the complementary color.

To practice these techniques, choose one of the following colors: red, orange, yellow, or green. You will also need the complementary color to your chosen color (it will be green, blue, purple, or red). A hint on choosing the colors for this exercise: For a color that is a primary color, you want it to be a pure color without any other colors mixed in. (For example: cadmium red = good choice, teal = bad choice). For a secondary color, you want it to be an exact mix of its adjacent primary colors. (For example: parrot green = good choice, teal = still a bad choice).

Draw three value scales with six squares each. Don't make them too big, because it takes a long time to fill an area with color pencil. For your first value scale, use your chosen color and change in pressure to create a value scale. Depending on your color, you may not get very dark; for example, yellow will never really achieve a dark value, but you can definitely get six separate values. For the second value scale, overlay the color with black; and for the last value scale, overlay the color with its complement.

Figure 12.2.1 shows the value scale using one color and change in pressure.

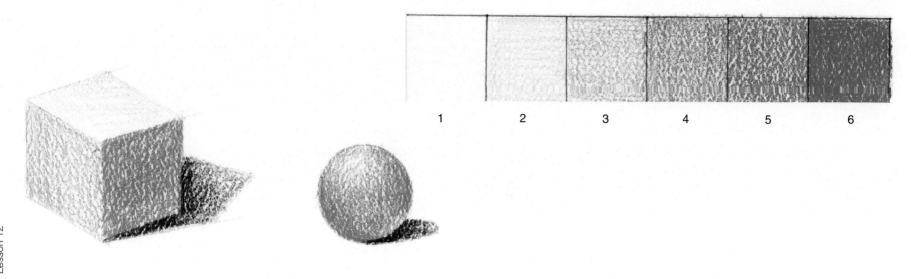

Lesson 12

FIGURE 12.2.1

Figure 12.2.2 shows the value scale using one color plus black.

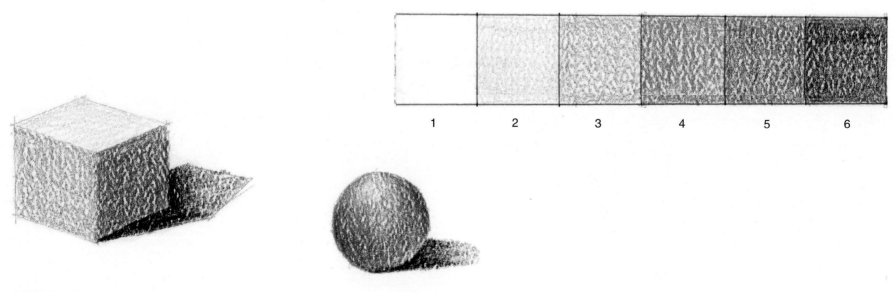

FIGURE 12.2.2

Figure 12.2.3 shows the value scale using one color plus its complementary color.

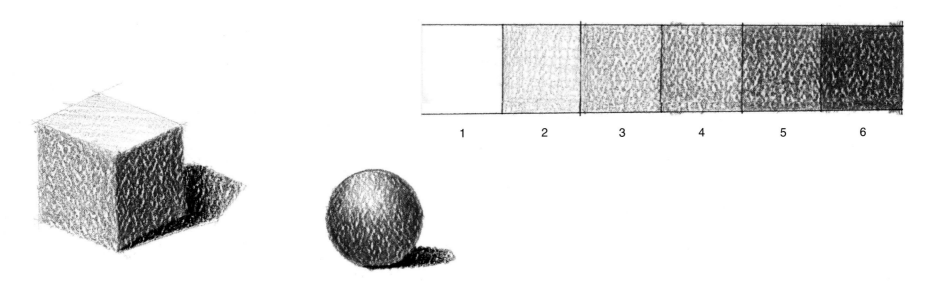

1 2 3 4 5 6

FIGURE 12.2.3

So when would you choose one method over the others? Previously in this book, we talked about using value to create the illusion of three dimensions on a two-dimensional surface (your paper), and I said that one of the tricks is to make things LIGHTER CLOSER TO YOU, AND DARKER FARTHER AWAY. Another trick is that things are MORE COLORFUL CLOSER TO YOU, AND GRAYER FARTHER AWAY. Therefore, if you have a room filled with red chairs, render the ones in front using the complement (green) to create the dark side, light side, and medium side, and use black and gray to render the chairs in the back of the room. Your result will be more 3D than if you use the same markers/pencils for all of the chairs.

Lesson 12 Section 3
Burnishing

Burnishing is a special technique that can only be achieved using Prismacolor brand pencils. Prismacolor pencils are very waxy, and that wax can be used as a medium to blend the colors. Burnishing is a beautiful technique that tends to look more like a painting when finished than a color pencil drawing. However, it does take some time, and you will have to apply significant pressure to the entire drawing, so if you choose this technique, keep your drawings on the small size to avoid carpel tunnel syndrome!

For burnishing you will apply your colors just as you would regularly; the burnishing only comes in at the last step to blend your colors.

Figure 12.3.1 shows a chair that I rendered with color pencils. The local color is red, so I used red, violet, and orange pencils (as explained in Lesson 11).

I could leave it like this, or I could burnish the drawing. I used a light color pencil with a dull point to apply even pressure and blend the colors together (Figure 12.3.2). (See Section 3, Video 1.)

In this image, the back of the seat has been burnished, but the seat has not.

FIGURE 12.3.1

FIGURE 12.3.2

Lesson 12 Section 4
Color Pencil on Black
or Toned Paper

When you draw on white paper, the paper is your lightest value. When you draw on toned paper, the paper becomes a middle value, meaning you must use lighter and darker pencils for value change, as shown in Figure 12.4.1.

REVERSE GRISAILLE—FIGURE 12.4.2

The technique I mentioned at the beginning of this lesson, the one that is so interesting and dramatic, is called reverse grisaille. *Gris* means gray in French, and reverse grisaille uses a black background and a process of lightening rather than darkening. It is the opposite of working with graphite pencils on white paper, because with black paper, the paper is the darkest tone (value #6), and the pencils are your lighter tones. Use change in pressure to go lighter. Press hard with a white pencil for your lightest tone. If you decrease your pressure, and hold your pencil farther from the point, the dark paper will show through your paper, resulting in a medium tone, as in Figure 12.4.2.

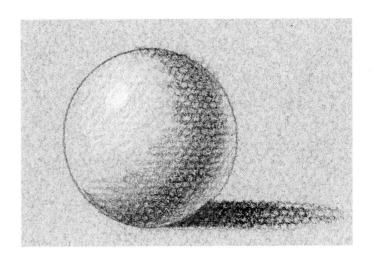

FIGURE 12.4.1

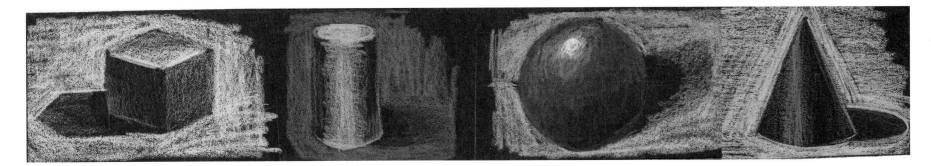

FIGURE 12.4.2

Lesson 12 Section 5
Homework

HOMEWORK ASSIGNMENT

Using a photo for reference, or your own design, render a drawing in color pencils using one of the techniques from this lesson.

Lesson 12 Section 6
Homework Examples

COLOR PENCIL ON WHITE PAPER—FIGURE 12.5.1

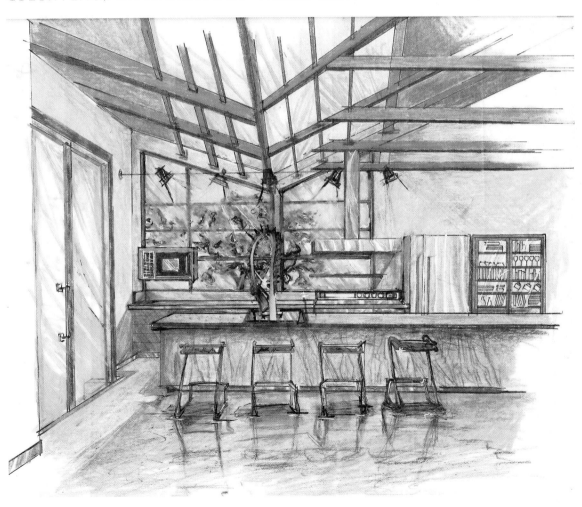

FIGURE 12.5.1

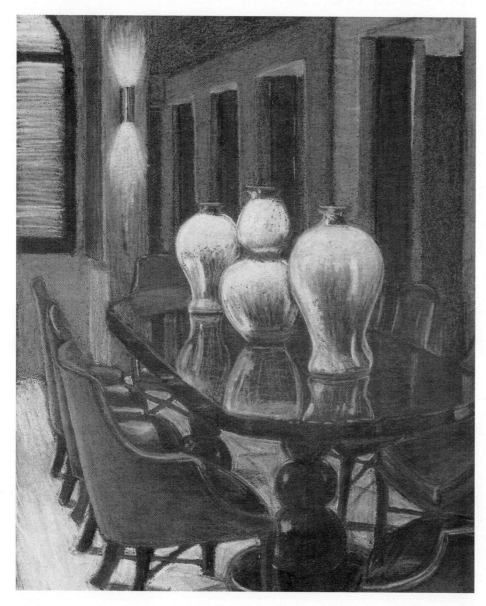

FIGURE 12.5.2

FIGURE 12.5.3

13 Metallic Surfaces

Lesson Overview

Lesson 13 is written in five sections:

- Lesson 13, Section 1: Values, reflections, and highlights.
- Lesson 13, Section 2: Stainless steel.
- Lesson 13, Section 3: Copper.
- Lesson 13, Section 4: Homework exercise.
- Lesson 13, Section 5: Student work.

NOTE
Most design students are visual learners. MyKit instruction for this lesson includes:

- Section 4, Video 1 demonstrates the homework exercise.
- Section 4, Video 2 demonstrates adding highlights to the homework exercise.

Marker colors used (Copic brand):

- C3 Cold gray 3
- C5 Cold gray 5
- C7 Cold gray 7
- C10 Cold gray 10
- B91 Light grayish blue
- E19 Redwood
- E59 Walnut

YR24 Pale sienna
E97 Deep orange
B29 Burnt umber

Lesson 13 Section 1
Metallic Surfaces

Rendering metallic surfaces can be challenging. Students often make the mistake of using solid medium gray to represent metal, which ends up looking more like painted wood than metal. Three things define reflective surfaces: a separation of values, strong highlights, and reflections.

SEPARATION OF VALUES

If you look at something metal, you'll see that there is a lot of black and white, and some gray, but these tones are very separate from each other. There is a striped effect as the values separate into very dark and very light. You will need DARK COLD grays and LIGHT COLD grays for the exercises that follow.

REFLECTIONS

All metallic surfaces are reflective, but to varying degrees. Some metallic surfaces are extremely reflective and give a mirrored effect. Other metallic surfaces are finished to a duller sheen, so that the reflections are much less pronounced. Always give some thought to how reflective the metal is that you are trying to render.

HIGHLIGHTS

Strong highlights are very important for metallic surfaces. Sometimes we leave the white of our paper to represent highlights, but when creating highlights on reflective surfaces, we want a more prominent white than the white of the paper. A sharp white color pencil or white paint is a much better way to achieve the dramatic sparkle of reflective materials. White paint could be gouache applied with a brush, or a white-out pen. I once had a student who used white nail polish, with excellent results!

Undertones are extremely important in rendering reflective surfaces. Stainless steel and silver have light cold blue undertones, copper has warm orange undertones, and gold has warm yellow and brown undertones. For stainless steel, choose a color like light cerulean blue. In the homework example, which is demonstrated in Section 1, Video 1, I used Copic markers; Cold grays C3, C5, C7, and C10, and B91 Light grayish blue for the stainless steel.

The most important thing to remember about color is that it doesn't exist in a vacuum. Color is totally affected by the colors that surround it. This is especially true of reflective surfaces, as they will reflect whatever surrounds them. Therefore, if a silver object is next to a red object, you will see red in the silver object. Noticing the nuances of how colors interact with each other is the key to understanding color as an artist and a designer.

Lesson 13 Section 2
Stainless Steel

STAINLESS STEEL EXERCISE—
FIGURES 13.2.1–13.2.5, LINE DRAWING
IN THE APPENDIX

The bathtub image in Figure 13.2.1 is a good example of stainless steel.

Use the line drawing of the bathtub in Figure 13.2.1 found in the Appendix, and overlay with your choice of paper (tracing, vellum, or marker). I used the following Copic markers to render the bathtub: C9 Cool gray 9, C5 Cool gray 5, C3 Cool gray 3, and B91 Pale grayish blue. Additionally, I used a liquid paper correction pen for the highlights. I used the wedge side of the marker instead of the brush side, because I want a streaky look. Use the photograph in Figure 13.2.1 for reference, but don't try to copy it exactly. Use your knowledge of value and color to render what you think will look best, which is not necessarily the same as the photograph.

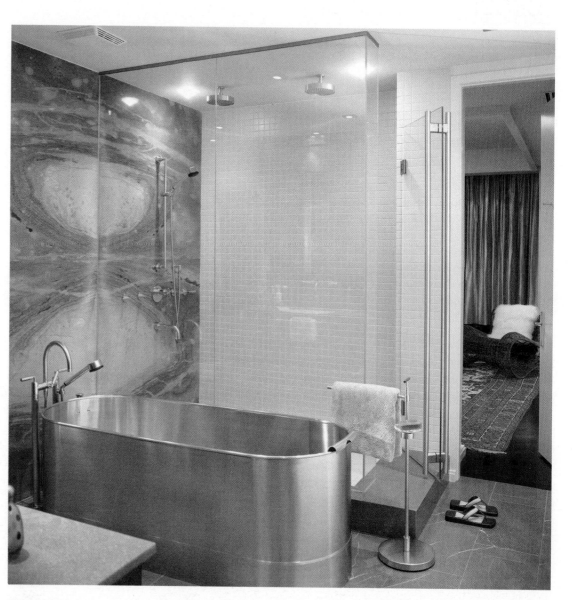

FIGURE 13.2.1

Begin with the dark tones using the C9 (or similar) marker. It is always a good idea to put darks at the sides of an object. This goes back to the principle discussed in Lesson 10, "Lighter closer to you, darker further away." It is always good to have a dark line along the bottom of objects as well, because it will create an illusion of shadow (Figure 13.2.2).

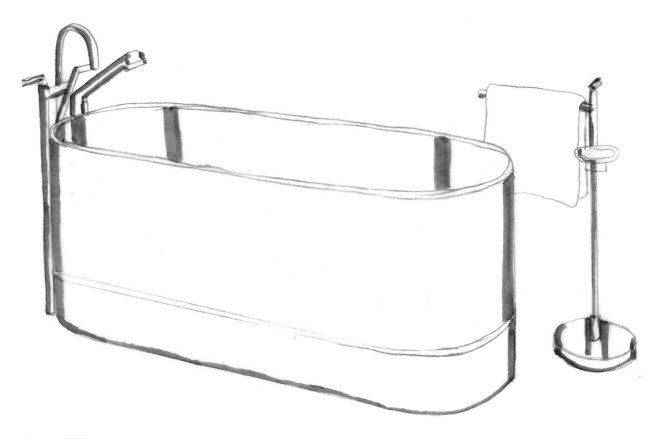

FIGURE 13.2.2

Now add some C5 on either side of the dark lines, overlapping your strokes a little so there is some blending of tones (Figure 13.2.3).

FIGURE 13.2.3

Now fill in the rest of the bathtub with C3, adding some B91 for undertones and visual interest (Figure 13.2.4).

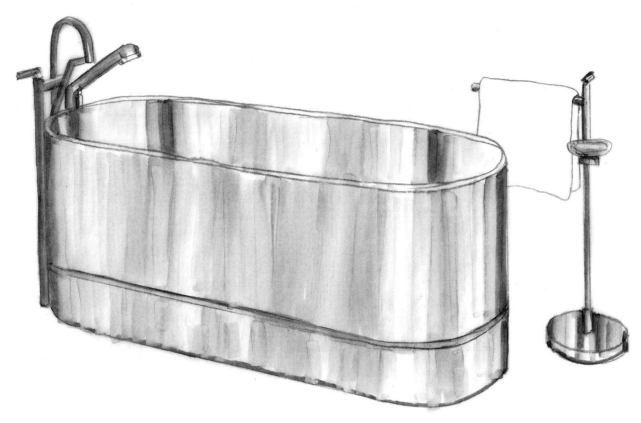

FIGURE 13.2.4

Add a few more darks back in, looking for opportunities where there would naturally be a shadow, such as along the reveal at the bottom of the tub and the lip of the tub along the top. Now is the fun part! Add some highlights with the white pen. Highlights should go wherever the light would hit the objects directly, such as along the top of the tub, and anywhere else you think looks good (Figure 13.2.5).

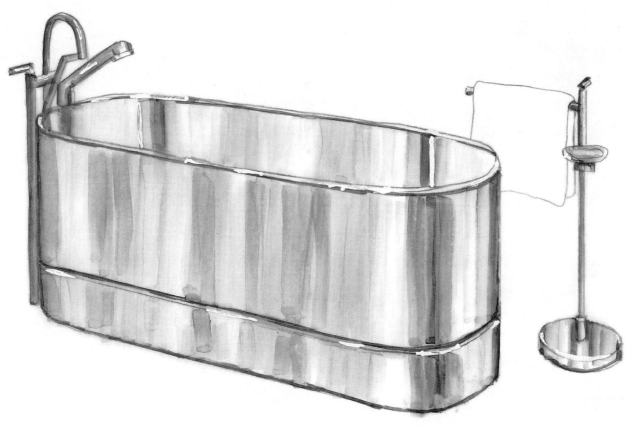

FIGURE 13.2.5

Lesson 13 Section 3
Copper

COPPER BREWERY TANKS EXERCISE—
FIGURES 13.3.1–13.3.5, LINE DRAWING IN THE APPENDIX

Use the line drawing of the brewery tank in Figure 13.3.1 found in the Appendix, and overlay with your choice of paper (tracing, vellum, or marker). I used the following Copic marker colors: E59 Walnut, E29 Burnt umber, E19 Redwood, E97 Deep orange, and YR24 Pale sienna.

FIGURE 13.3.1

Begin with the dark browns, E59 and E29 (Figure 13.3.2).

Then add some orange, E97 and E19 (Figure 13.3.3).

FIGURE 13.3.2

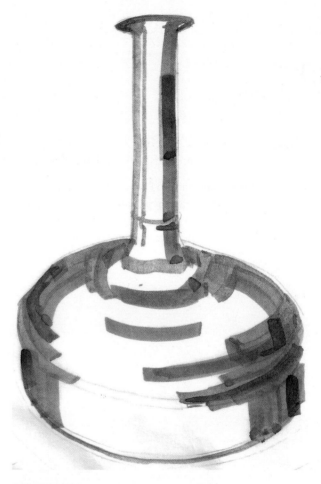

FIGURE 13.3.3

Fill in with the yellow tones, YR24 and YR65 (Figure 13.3.4).

Add highlights with the white-out pen (Figure 13.3.5).

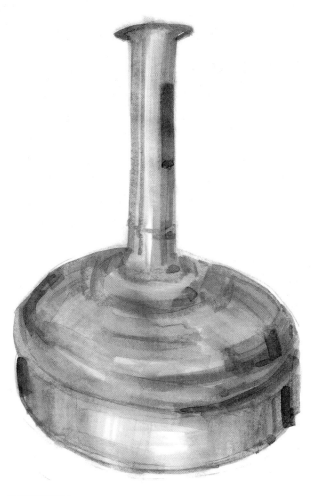

FIGURE 13.3.4

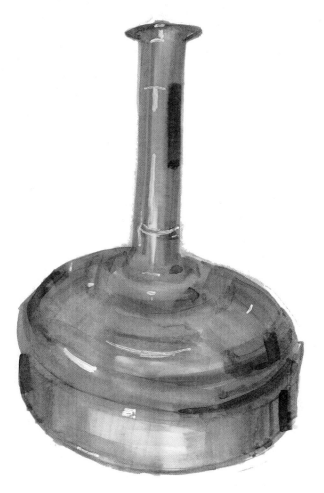

FIGURE 13.3.5

REQUIRED ASSIGNMENT

Lesson 13 Section 4
Homework

HOMEWORK ASSIGNMENT—FIGURE 13.4.1, LINE DRAWING IN THE APPENDIX

Render the kitchen shown in Figure 13.4.1 (line drawing can be found in the Appendix) with stainless-steel cabinets and countertops. Use the techniques you learned in the earlier exercise. One of the most important parts of this drawing will be the reflections in the countertops. This is the easiest type of reflection to draw—a vertical object reflected in a horizontal surface. The key is that the vertical measurements are not foreshortened, so the object and its reflection measure the same height and distance from the reflective surface. If this is confusing to you, revisit Chapter 7, which covers reflections in depth.

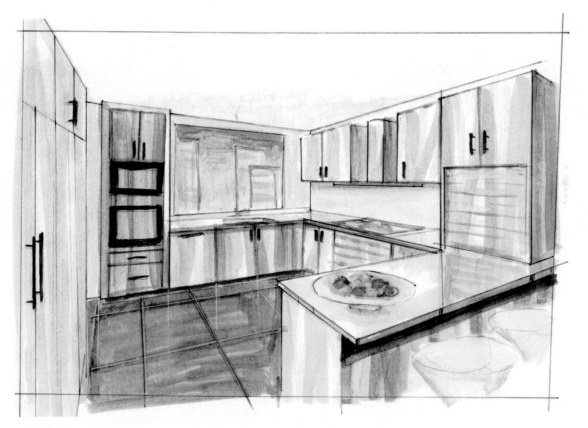

FIGURE 13.4.1

REQUIRED READING

Lesson 13 Section 5
Homework Examples

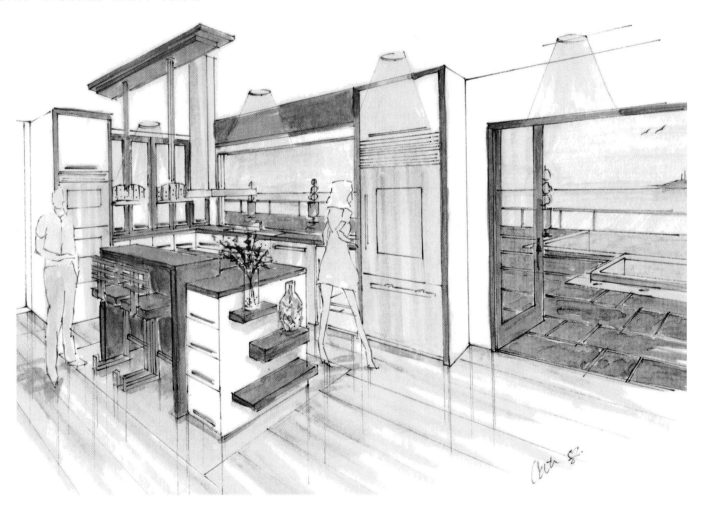

FIGURE 13.5.1

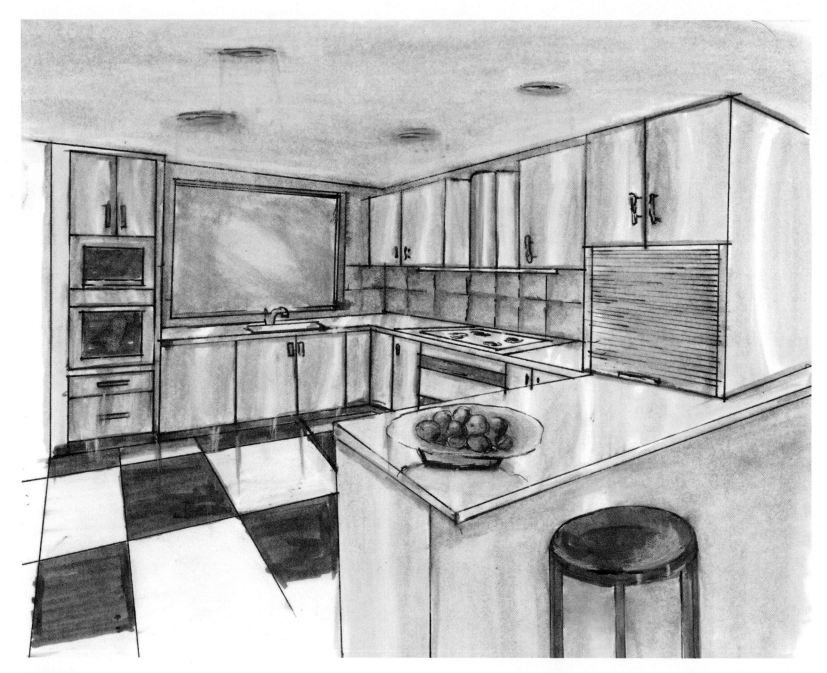

FIGURE 13.5.2

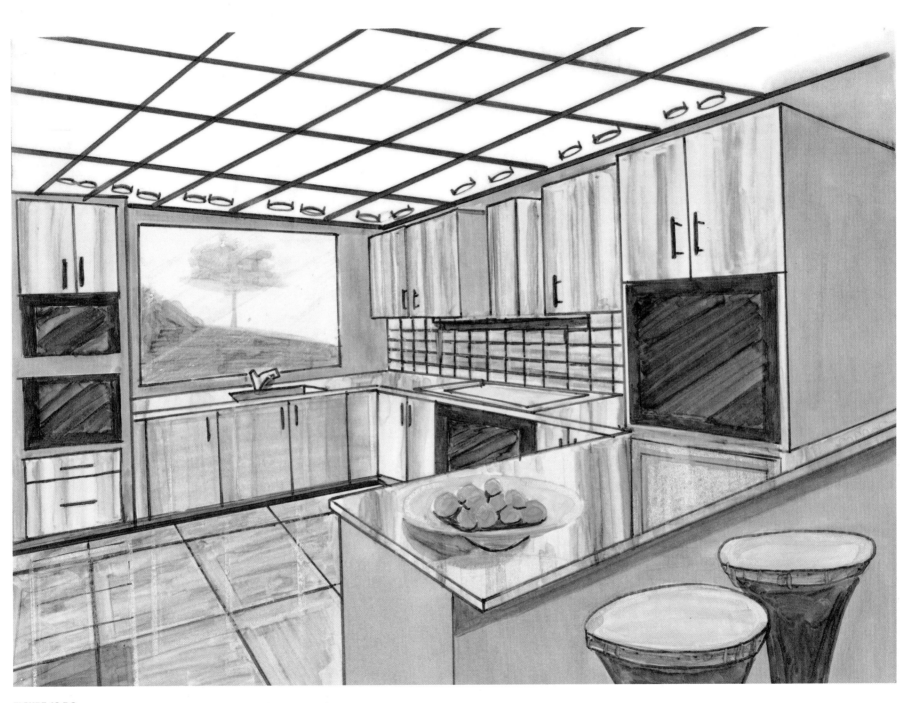

FIGURE 13.5.3

14

Wood Surfaces

Lesson Overview

Lesson 14 is written in five sections:

- Lesson 14, Section 1: Wood grain.
- Lesson 14, Section 2: Exercise with student examples.
- Lesson 14, Section 3: Wood walls, floor, and cabinet.
- Lesson 14, Section 4: Homework exercise.
- Lesson 14, Section 5: Student work.

NOTE

Most design students are visual learners. MyKit instruction for this lesson includes:

- Section 3, Video 1 exercise.
- Section 4, Video 1 homework exercise.

Marker colors used (Copic brand):

- E19 Redwood
- E59 Walnut
- B34 Manganese blue
- E29 Burnt Umber
- E55 Light Camel

Lesson 14 Section 1
Wood Grain

WOOD GRAIN—FIGURE 14.1.1

The most important element of rendering wood is the grain. It is absolutely essential that you understand wood grain and be able to replicate it convincingly. Your actual color choices are less important because wood comes in so many different colors, and can be stained, painted, or otherwise finished with an infinite number of applied colors.

Wood grain is concentric! Look closely at a piece of wood, and you will see that the grain is actually organic concentric rings. Each ring is different from the last, but the lines do follow each other. Often, you can only see part of the rings, so they look like vertical lines, but even then they are never straight. Figure 14.1.1 provides an example.

FIGURE 14.1.1

Lesson 14 Section 2

EXERCISE—FIGURES 14.2.1–14.2.2

Find a piece of wood, or an image of a piece of wood, and copy it at the same scale.

1. Match the colors; choose two or three markers to match the colors in your wood.

2. Use these colors to create the background of the wood, meaning the wood without the grain.

3. Examine the grain of the wood. Choose a color marker or color pencil for the grain.

4. Don't just draw a line to represent the grain. The grain is often best represented by short vertical strokes that, upon completion, read as a thick, wavy, organic line.

5. Don't spend more than 20 minutes on this exercise.

STUDENT WORK EXAMPLES

Figures 14.2.1 and 14.2.2 are examples of student work.

FIGURE 14.2.1

FIGURE 14.2.2

REQUIRED READING

Lesson 14 Section 3
Wood Walls, Floor, and Cabinet

WOOD WALLS, FLOOR, AND CABINET EXERCISE—
FIGURES 14.3.1–14.3.6

Render the bathroom shown in Figure 14.3.1 (line drawing can be found in the Appendix) with wood cabinet, walls, and floor. Use the same wood, or use different woods. Use your design sense to create a color scheme and mood before you begin.

FIGURE 14.3.1

The first step is to add in the reflections with pencil. There are vertical reflections in the floor, and horizontal reflections in the mirror. You will need to find your vanishing point to add in these reflections by hand. Line up your triangle with the angle lines in the drawing, and see where they cross; that is the vanishing point (labeled vp on my drawing). It's important that the mirror looks like a mirror and not a window. One way to show that it's a mirror is to put something right in front of the mirror and reflect it. I added a plant on the countertop and its reflection in the mirror (Figure 14.3.2).

FIGURE 14.3.2

Let's begin the color with the wood walls. Choose two or three markers to represent the background color of the wood without the grain. I used E59 Walnut and E19 Redwood to color the walls and their reflection in the floor.

In this image, the light source is the light fixtures attached to the mirror, therefore the lightest side of each object will be the side closest to the lights. For the walls, the side closest to the light source is the angled side of each wall. Use the back of the paper to make the front of your walls darker, as they are the medium side value. Add in a dark line with your marker where there are reveals between the wood panels, and use the same marker to add a shadow from the towel (Figure 14.3.3).

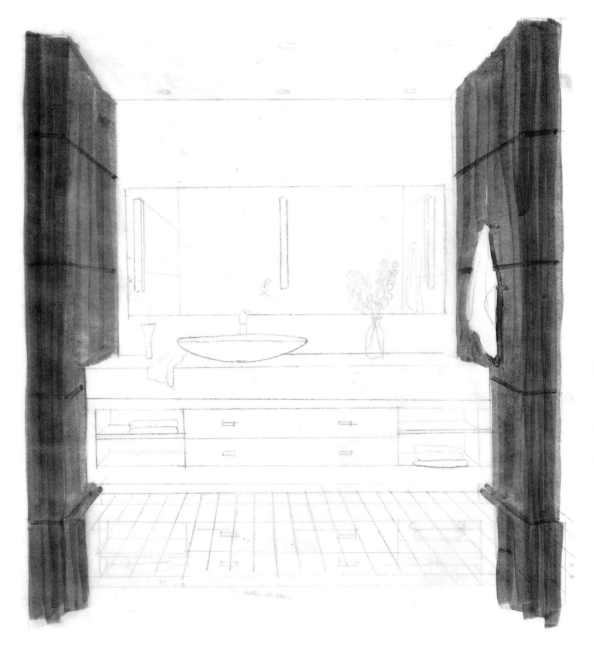

FIGURE 14.3.3

Render the wood cabinet, countertop, and their reflections in the floor, keeping in mind LIGHT SIDE, DARK SIDE, MEDIUM SIDE. In this case, the side of the object that is closest to the light source is the top surface; this will be your light side. The front of the cabinet will be medium, and the dark side will be seen on the inside of the shelves, which are blocked from the light. I used E29 Burnt umber and E55 Light camel. Don't forget to add a shadow at the toe kick, the overlap of the countertop (Figure 14.3.4).

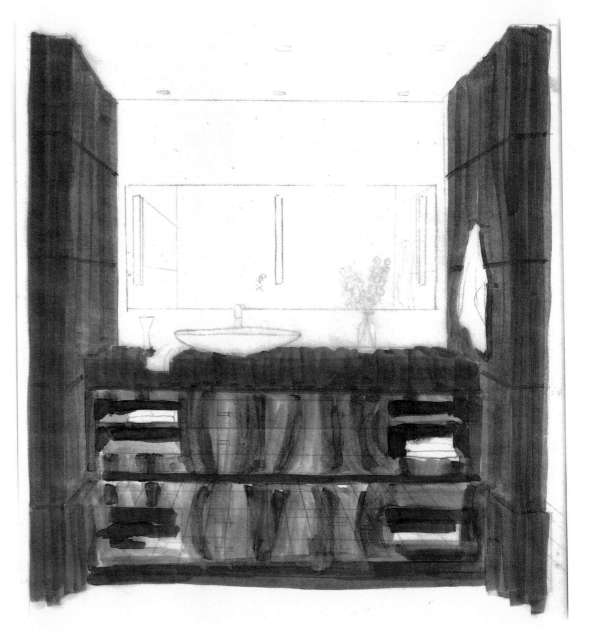

FIGURE 14.3.4

Now fill in everything else. For the wood floor, choose two or three colors and, on the back (so you don't mess up the reflection you just did), apply the marker in the direction of the wood planks. For the mirror, start with the reflection of the walls. Scribble some of the wall color on a piece of tracing paper, then use a blender or light color to pick up some of that color, and apply it to the walls in the mirror. It will give you a lighter version of your wall color. Apply some neutral colors to the rest of the reflection, and add a little light blue with diagonal strokes; I used B34 Manganese blue. Use a colorless blender to keep the area around the light fixtures light. The reflection should be obscured by the brightness of the light (Figure 14.3.5).

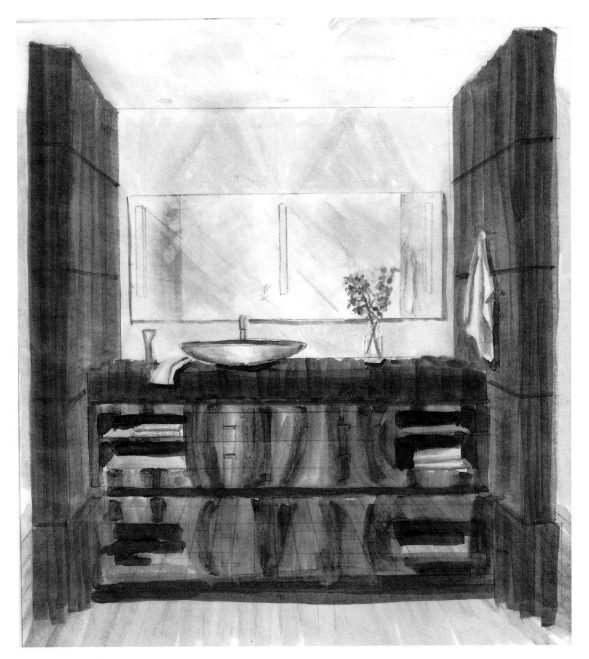

FIGURE 14.3.5

Use a thin black pen to trace the important lines. Make any other last-minute changes. I darkened my shadows and added some blue to them because I thought the drawing needed more color. I also used a sharp white Prismacolor pencil and a liquid paper correction pen for highlights. **A tip to remember: white vertical lines in the floor always look good!** Bring down the vertical lines of everything above the floor with a sharp white pencil, regardless of the color of the walls, furniture, or floor (Figure 14.3.6).

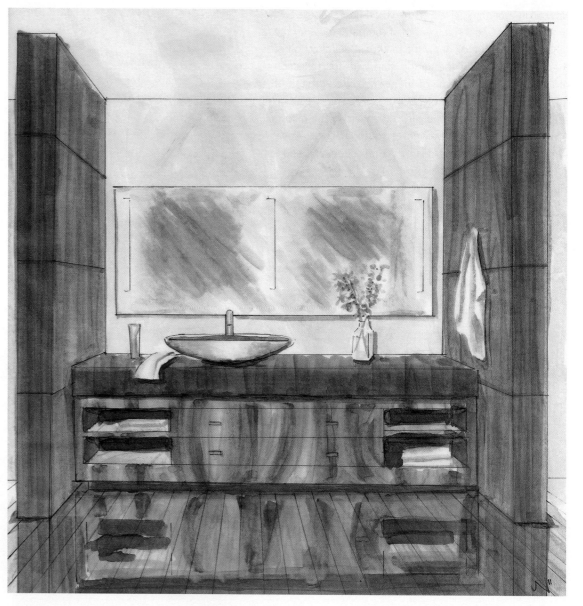

FIGURE 14.3.6

REQUIRED ASSIGNMENT

Lesson 14 Section 4
Homework

HOMEWORK ASSIGNMENT—FIGURES 14.4.1–14.4.7

Render the room shown in Figure 14.4.1 (line drawing can be found in the Appendix) with wood floors and wood panels.

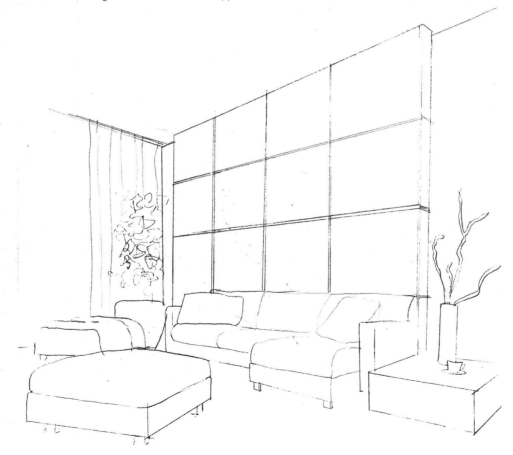

FIGURE 14.4.1

To create lines in the wood floor representing the separate planks of wood, you have to find the vanishing points of the drawing. Do this by following two lines until they converge. That spot is the vanishing point. Connect your two points to create a horizon line (Figure 14.4.2).

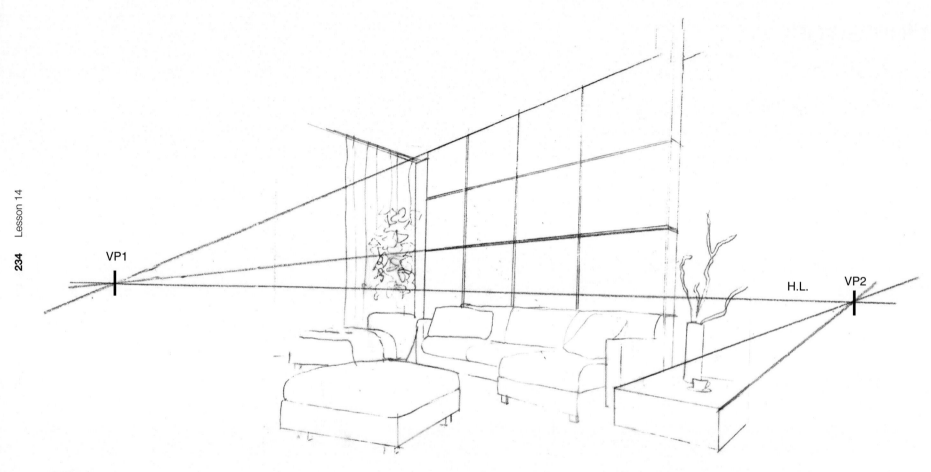

VP1

H.L. VP2

FIGURE 14.4.2

Draw a horizontal line from the corner and mark off tick marks in even increments either with a scale or using your internal sense of scale. Draw a line from the vanishing point through each tick mark to create the lines in the floor (Figure 14.4.3). Watch Section 4, Video 1 for a demonstration of this technique.

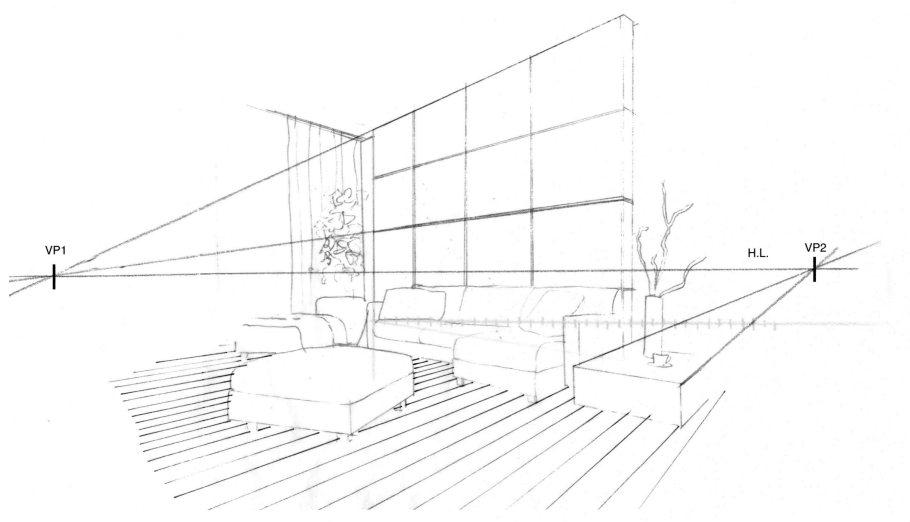

FIGURE 14.4.3

Before you begin adding color, consider the light source and determine the **light side, dark side, and medium side** of your objects. Begin with everything that is not wood. Fabric and plants will be discussed in the next lesson, but essentially, fabric is just cylinders and cones, exactly like the ones you created in Lesson 11. Plants are best represented by using a stipple motion rather than trying to draw the leaves individually. You are trying to capture the spirit of the plant, not an exact likeness. Make the pillows lighter in the center and darker on the edges to create an illusion of softness (Figure 14.4.4).

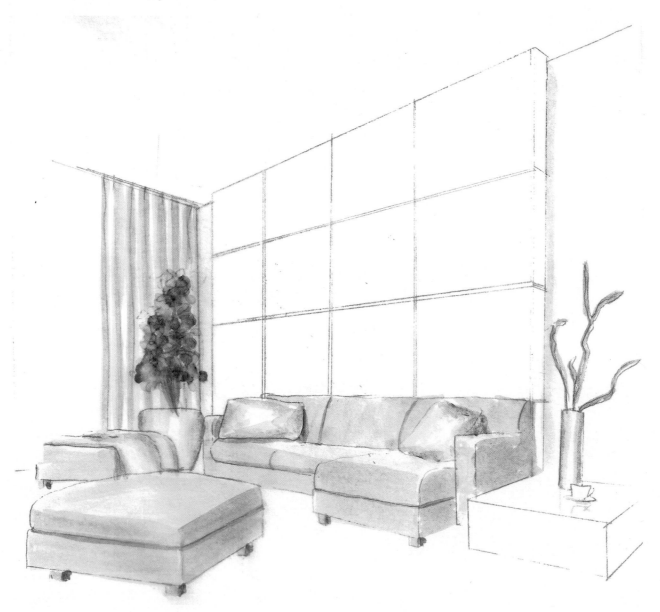

FIGURE 14.4.4

Now flip over the page, and create the reflections in the floor (Figure 14.4.5). In the last exercise, I drew them in pencil first. This time I "eyeballed" the reflections. Draw them first in pencil if you must, but the goal is to eventually be able to draw them in as you go with marker.

FIGURE 14.4.5

Add the wood color in streaks in the direction of the wood grain (Figure 14.4.6).

FIGURE 14.4.6

Finish off the drawing by tracing the floor lines, creating something outside the window (this will be covered in depth in the next lesson). Add white pencil and white-out pen for reflections (Figure 14.4.7).

FIGURE 14.4.7

REQUIRED READING

Lesson 14 Section 5
Homework Examples

STUDENT WORK—FIGURES 14.5.1–14.5.3

FIGURE 14.5.1

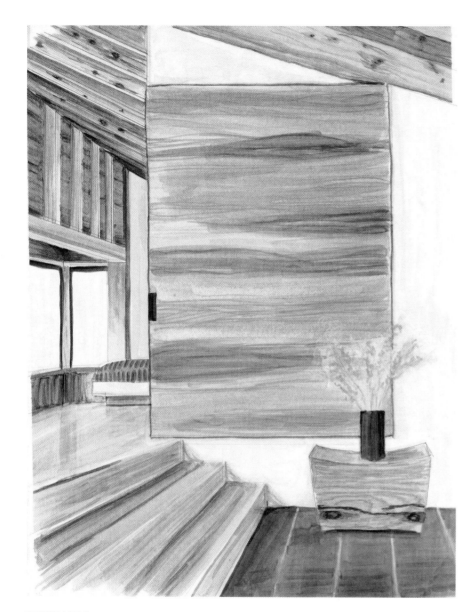

FIGURE 14.5.2

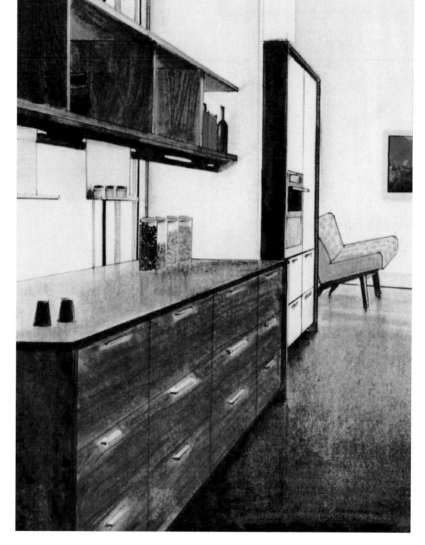

FIGURE 14.5.3

Wood Surfaces **241**

15

Floor Plans

Lesson Overview

Lesson 15 is written in six sections:

- Lesson 15, Section 1: Design drawings versus construction drawings.
- Lesson 15, Section 2: Shadows.
- Lesson 15, Section 3: Floor plans by hand.
- Lesson 15, Section 4: Floor plans by computer.
- Lesson 15, Section 5: Homework exercise.
- Lesson 15, Section 6: Student work.

NOTE

Most design students are visual learners. MyKit instruction for this lesson includes:

- Section 3, Video 1 demonstrates floor plans by hand.
- The Section 4 Video Lessons demonstrate floor plans by computer:
 - 15.4.1: wood floor
 - 15.4.2: rug
 - 15.4.3: pattern fill
 - 15.4.4: defining patterns
 - 15.4.5: glass
 - 15.4.6: stainless steel
 - 15.4.7: shadows
 - 15.4.8: filters

REQUIRED READING

Lesson 15 Section 1
Floor Plans

In architecture, interior design, industrial design, and any other type of design where the subject matter is something that will be built, there are two kinds of drawings: construction drawings and design drawings. Construction drawings will be given to a fabricator such as a general contractor, cabinet maker, mold maker, and so on. The fabricator will use those drawings to build from. Construction documents are not rendered, and have information such as dimensions and call-outs to help communicate construction information to the person who will be building the items.

Design drawings are shown to the client, investors, and anyone else who wants to see what the design will look like. Design drawings are generally construction documents that are altered to show design intent. A rendered floor plan is a design drawing that is created for almost every architectural, industrial, exhibit, and interior design project. It not only helps communicate your vision to the client, it helps you, as a designer, focus on the juxtaposition of colors and materials that you have chosen.

For small floor plans, you can work on whichever type of paper you like. Vellum and marker paper can be cut or bought to fit in a printer. You can print directly from AutoCAD, Revit, and other programs onto vellum and marker paper using any ink-jet or laser printer. You cannot put tracing paper in the printer because it's too thin, and will jam up your printer. You can, however, print your plan on bond paper and do an overlay of tracing paper. Of course, you can always draft the floor plan directly on your paper of choice. I prefer to use tracing paper for rendering floor plans for the same reasons that I choose to use it with marker perspectives: the blending ability. Often, large floor plans will be plotted on a large piece of bond paper at a specific scale, in which case you will have to render directly onto the bond paper. Luckily, blending is not as important in floor plans, as they are graphic representations that do not rely heavily on realism and gradation of tones, as perspective drawings do.

Most non-designers have trouble reading a floor plan because it is a contrived view. Have you ever floated above a building where someone has cut through everything 4' above the ground? Of course not! The other reason it is a contrived view is because there is no perspective. Everything is flat and two-dimensional, which never happens in real life. Because they are not used to seeing it, this perspective can be hard for clients to understand. Rendering the floor plan helps in two ways:

1. Shadows create the illusion of three dimensions. This is the most important part of rendering the floor plan. Furniture casting shadows onto the floor is immediately recognizable to everyone.

2. Realistic colors and materials make things recognizable, and add a sense of scale.

REQUIRED READING

Lesson 15 Section 2
Shadows

SHADOWS—FIGURES 15.2.1–15.2.8

You might think that the way to begin adding shadows to the floor plan would be to use each window or opening as a light source, and create cast shadows on the opposite side of that light source. However, this would be confusing to the viewer and time consuming for the designer. It is a common convention in architecture and design to choose one corner of the paper to act as the light source (most commonly the upper-left corner of the paper), and have all shadows cast from there, regardless of the room, or the actual openings in the building shell. Draw a line at a 45-degree angle from each corner of the object to determine the shadow edges (Figures 15.2.1 and 15.2.2).

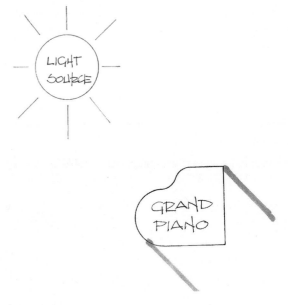

FIGURE 15.2.1 **FIGURE 15.2.2**

The edge of the shadow is determined by the edge of the object. If the object is all one height, you can just copy the edge on the floor plan. For example, see Figure 15.2.3.

In Lesson 10 we talked about shadows, and that a cast shadow is DARKER and SHARPER close to the object, but dissipates (becomes lighter and fuzzier) as it moves away from the object. This is still true in plan drawings, and Figure 15.2.4 provides an example of what that looks like.

FIGURE 15.2.3

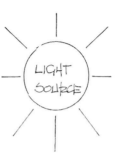

FIGURE 15.2.4

THE LENGTH OF THE SHADOW = THE HEIGHT OF THE OBJECT. Tall objects have soft, long shadows, whereas short objects have short, sharper shadows. The length of the shadow is one way to communicate information about the object doing the casting. For example, Figure 15.2.5 shows the difference between a 20"-high round coffee table and an 8'-high round column.

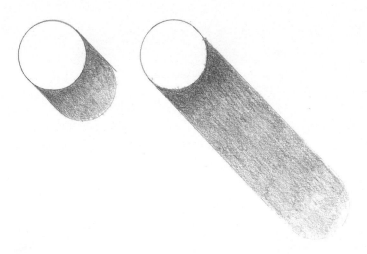

FIGURE 15.2.5

Not all objects are all one height—for example, a chair usually has a higher back than seat. It is not necessary to figure out all of the height changes and technically cast the shadows using the 45-degree-angle light source. That would be unnecessarily time consuming. An indication of the change in height is good, but don't get caught up in unimportant details (Figure 15.2.6).

FIGURE 15.2.6

Sometimes you don't know what all of the materials are in a floor plan. Sometimes you don't have time to render all the materials and colors, even when you know what they are. In either case, it is perfectly acceptable to render a floor plan in grayscale. It is also common to render a floor plan in grayscale with a few focus areas in color (Figure 15.2.7).

FIGURE 15.2.7

Don't forget to poche (color in) your walls with black, so that they don't blend into the flooring!

Although we don't usually render light entering the building, sometimes the light, window placement, and/or cast shadows are an extremely important part of the design concept. Remember that the main objective of doing a rendered floor plan is to communicate your design vision. Figure 15.2.8 provides an example where the student's clerestory windows on an interior wall were an important element of the design, so she highlighted them with light rays.

FIGURE 15.2.8

Lesson 15 Section 3
Floor Plans Rendered by Hand

(These techniques are demonstrated in Section 3, Video 1 in MyKit.)

 Indicating materials and colors by hand in floor plan view is very similar to rendering by hand in perspective view. If you are drawing the same space in perspective and plan views, use the same markers to create continuity and to make it obvious to viewers what space they are looking at. In this section we will cover some common materials that are seen in a floor plan.

WOOD FLOORING

Use three colors—light, medium, and dark—and apply in the direction of the wood planks. Optional: Add the wood plank lines with a thin black pen or a dark-brown pencil.

CARPET

Dab with your marker, rather than making broad strokes. If you have a carpet with a pattern, indicate the pattern, but don't get too caught up in the details! If you have something very important and intricate to render, such as the company's logo in the floor, or a mosaic medallion in a round space, print it out in the correct scale and trace it (or consider rendering the floor plan in Adobe Photoshop).

GLASS

Use a light-blue marker in diagonal strokes. Leave three stripes of varying widths of the white paper to look like highlights. You can also add the highlights in later with a white pencil or a white-out pen. Subtly add some of the colors of what is beneath the glass—for example, a chair seat or carpet visible under a glass table. Use the back of the paper or your colorless blender to keep it from obscuring the glass effect.

STAINLESS STEEL AND OTHER REFLECTIVE SURFACES

In Lesson 13 we discussed that reflective materials separate into light and dark tones. Use a light- to dark-gray gradient for the background. Add a few stripes of the white at a 45-degree angle with the brush tool to represent highlights.

TILE AND NATURAL STONE

Dab colors randomly to represent natural stone. You can add "L" shapes to one corner of each tile (in the same location on each tile) to create a 3-D effect. Always draw the grid at the end with a thin black pen or a white or black pencil.

REQUIRED READING

Lesson 15 Section 4
Photoshop

(These techniques are demonstrated in the Section 4 Video Lessons in MyKit.)

I am going to assume that you have some very basic knowledge of Photoshop, but don't know how to use the tools for rendering floor plans. To render a floor plan in Photoshop, you can scan it in and open it in Photoshop. Or, you can open an AutoCAD file in Photoshop by following these directions: In AutoCAD, go to Layout in Paper space and zoom extents. Open file/plot and click on the arrow in the bottom-right corner of the dialog box. Change the plot style table to Grayscale. Click apply to layout. Change printer/plotter to pdf. Save as pdf on desktop. Open Photoshop. Click File/open and open the pdf file on your desktop. Save as psd, jpg, or whatever type of file you prefer to work with.

Visually, rendering a floor plan in Photoshop is the same as doing it by hand. We are just using a different type of media to obtain a similar result.

HOW TO CREATE A WHITE BACKGROUND BEHIND YOUR DRAWING

If you print a cad file to a pdf and open it in Photoshop, often you will see a checkerboard background behind your floor plan. Unlock the background layer by double-clicking on the layer name, then rename it "drawing." Create a new layer—it will ask for a name; name this one "white." Drag the "white" layer below the "drawing" layer so that "drawing" is above "white." Turn off the "drawing" layer, select the "white" layer, and fill with the white paint bucket.

TO POCHE WALLS

Use the paint bucket tool. Make your foreground color black. Click the paint bucket inside each wall to poche. (Click with the tip of the paint spilling out of the bucket on the object that you intend to fill.)

The most exciting thing about rendering a floor plan with Photoshop is that you can scan in real materials, or find images of them online, and use them in your floor plan for an extremely realistic result. The best way to do that is to select an object or area and fill it with a pattern. The pattern is your jpg image of your exact material.

TO DEFINE AN IMAGE AS A PATTERN

Import or scan your image, such as a wood sample, stone tile, or piece of fabric. Save it as a jpg (e.g., bamboo.jpg). Choose Edit⇒Define pattern to open up the Pattern Name dialog box. Name the pattern (e.g., bamboo). Click OK. The pattern is added to the current pattern library.

TO APPLY A PATTERN TO AN OBJECT/AREA

Choose the object/area with the magic wand tool, or a similar selection tool. With your object/area still selected on the plan, create a new layer and name it. Choose the paint bucket tool. Choose Pattern from the Fill dropdown menu. Click the arrow next to the pattern swatch to open the pattern picker dropdown. Double click a pattern to make it active. Click inside the object or area to be filled with your paint bucket.

Warning: Sometimes fill (paint bucket) spills out of what looked like an enclosed area and floods a larger space. If this happens, you can undo this, or any, command with Edit-Undo. The reason the fill escapes the enclosure is usually as simple as a missing pixel in the boundary. The fix is easy: Zoom in to find the break in the boundary and repair it with pixels using the line or pencil tool. Be careful to repair a broken boundary on the same layer as the boundary line work.

TO SCALE A PATTERN

Double-click next to the layer name, which will bring up the FX dialog box. On the left side, click on Pattern Overlay, and change your pattern back to the one you want; directly underneath it is a slider for adjusting the scale.

WOOD FLOORS

Sometimes the piece that you have defined for your pattern will repeat over and over, creating a tiled effect. The best way to avoid this is to create a wood floor without using a pattern. Instead fill your floor area with a gradient of two brown colors, a light one and a dark one. Use the fiber filter and adjust the sliders to your liking.

TO APPLY A COLOR TO A PATTERN

Using color overlays over grayscale patterns already included in Photoshop greatly increases your pattern library. Double-click next to the layer name containing the object or area that you filled with a pattern to open the FX dialog box, and then click color overlay on the left. If you just check it, the controls don't change. You must click on the name "color overlay" to highlight it, and then the controls will change. You must also change the blend mode (at the top of the dialog box) to "overlay" so that the pattern will show through the color that you are applying. Click the color swatch to open the color picker. Choose a color, and tone down the saturation with the opacity slider.

CARPET

Fill an area on your floor plan with the overall color, then from the Filter menu (top of the screen) choose Add Noise. You can control the noise with a slider; lots of noise = commercial carpet, a little noise = residential carpet.

GLASS

Create a separate layer for your glass so that you can control the opacity (usually 50%), so the background under the glass is still visible (for example, a chair seat or carpet visible under a glass table). Fill the area with a subtle gradient of light blue to even lighter blue. Change the foreground color to white and add three stripes of varying widths with the airbrush tool to look like highlights.

STAINLESS STEEL AND OTHER REFLECTIVE SURFACES

In Lesson 13 we discussed that reflective materials separate into light and dark tones. Use dark and light grays in diagonal strokes. Leave a few stripes of the white of the paper to represent strong highlights. You can add some in later as well with a white pencil or a white-out pen.

DROP SHADOWS

Drop shadows add the illusion of depth to an otherwise two-dimensional floor plan. The principles of shadows covered earlier in this lesson still apply: a cast shadow is DARKER and SHARPER close to the object, but dissipates (becomes lighter and fuzzier) as it moves away from the object.

In the FX dialog box, click Drop Shadow in the left panel to display new controls on the right side. Change the angle to 45°. To add depth to the shadow, move the spread and distance sliders. You can also control the darkness of the shadow with the opacity slider.

Warning: Your drop shadows WILL interfere with your boundaries, so add them last, or you can toggle off the visibility of the drop-shadow effect in the layer menu to fix this problem. For example, say you put a lovely drop shadow on a sofa, and now you want to add a bamboo floor under the sofa. If you use the magic wand tool on the white floor, it will not include the area under the drop shadow.

SHADOWS

To create shadows without the automatic drop shadow tool, select an area for the shadow. Use a 45-degree angle from the object's corners, just like in the beginning of this lesson. I like to use the lasso tool with the alt/option key to make straight lines (see the video for a demonstration). Then go to View-Show-Selection Edges to turn off the selection edges ("marching ants") temporarily. Go to Image-Adjustments-Brightness/Contrast and use the sliders to create a shadow that you are happy with (usually 50% brightness); remember the number that you choose so that you can keep all of your shadows consistent.

REQUIRED ASSIGNMENT

Lesson 15 Section 5
Homework

HOMEWORK ASSIGNMENT

Render a floor plan either by hand or in Photoshop. You can use one of the floor plans provided earlier, in the Appendix, or create your own.

REQUIRED READING

Lesson 15 Section 6
Homework Examples

STUDENT WORK—FIGURES 15.6.1–15.6.2

FIGURE 15.6.1

FIGURE 15.6.2

16

Elevations
and Windows

Lesson Overview

Lesson 16 is written in eight sections:

- Lesson 16, Section 1: Design drawings versus construction drawings.

- Lesson 16, Section 2: Shadows.

- Lesson 16, Section 3: Windows, exterior views, and window treatments.

- Lesson 16, Section 4: Elevations by hand.

- Lesson 16, Section 5: Elevations by computer.

- Lesson 16, Section 6: People.

- Lesson 16, Section 7: Homework exercise.

- Lesson 16, Section 8: Student work.

NOTE
Most design students are visual learners. MyKit instruction for this lesson includes:

- Section 4, Video 1 demonstrates elevations by hand.

- The Section 5 Video Lessons demonstrate elevations by computer:

 - 16.5.1: windows
 - 16.5.2: lights
 - 16.5.3: shadows

- Section 6, Video 1 demonstrates adding people to elevations by computer.

REQUIRED READING

Lesson 16 Section 1
Elevations

As with floor plans, elevations generally fall into one of two categories: construction drawings or design drawings. Construction drawings will be given to a fabricator such as a general contractor, cabinet maker, mold maker, and so on. The fabricator will use those drawings to build from. Construction drawings are not rendered, and have information such as dimensions and call-outs to help communicate construction information to the person who will be building the items.

Design drawings are shown to the client, investors, and anyone else who wants to see what the design will look like. Design drawings are generally construction documents that are altered to show design intent. Sketching in color during the design process phase helps you, as a designer, focus on the juxtaposition of colors and materials.

You can work on whichever type of paper you like. Vellum and marker paper can be cut or bought to fit in a printer. You can print directly from AutoCAD, Revit, or another program onto vellum and marker paper using any ink-jet or laser printer. You cannot put tracing paper in the printer because it's too thin, and will jam up your printer. You can, however, print your plan on bond paper and do an overlay of tracing paper. Of course, you can always draft the elevation directly on your paper of choice. I prefer to use tracing paper for rendering elevations for the same reasons that I choose to use it with marker perspectives: the blending ability. Just like floor plans, often elevations will be plotted on a large piece of bond paper at a specific scale, in which case you will have to render directly onto the bond paper. Luckily, blending is not as important in floor plans and elevations, as they are graphic representations that do not rely heavily on realism and gradation of tones, as perspective drawings do.

Most non-designers have trouble reading an elevation because it is a contrived view. In reality, it is impossible to see a wall completely flat, without any perspective. Because they are not used to seeing it, this perspective can be hard for clients to understand. Rendering the floor elevation helps in two ways:

1. Shadows create the illusion of three dimensions by separating objects from the wall and each other.

2. Realistic colors and materials make things immediately recognizable: "I see the slate, so that must be the backsplash."

REQUIRED READING

Lesson 16 Section 2
Shadows

SHADOWS—FIGURE 16.2.1

Just like with a floor plan, with an elevation you choose one corner of the paper to act as the light source (most commonly the upper-left corner of the paper), and have all shadows cast from there, regardless of the room, or the actual openings in the building shell. Draw a line at a 45-degree angle from each corner of the object to determine the shadow edges, and shade in a gradation, with the shadow darkest next to the object, getting lighter and softer as it moves away (just like with the floor plan and perspective drawings). You should also shade objects that are rounded, cylindrical, or rectangular shapes that are showing multiple sides. The more shade and shadow you add, the more realistic your objects will appear. Look for common recessed areas, such as toekicks, and common overhangs, such as counterops, as opportunities to add shadow, and therefore realism, to your elevation. For example, Figure 16.2.1 shows how to shade a rectangular sink cabinet with a rounded vessel sink.

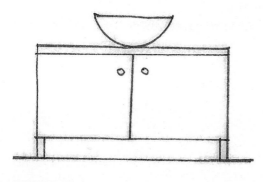 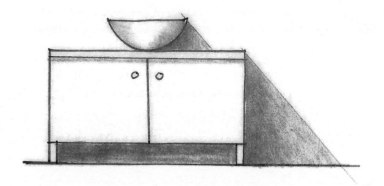

FIGURE 16.2.1

REQUIRED READING

Lesson 16 Section 3
Windows and Exteriors

OUTSIDE THE WINDOW—FIGURES 16.3.1–16.3.7

Most elevations and interior perspective drawings have windows that look outside. It is a huge mistake to leave the windows blank, or color them a solid blue to represent glass. The exterior is a great opportunity to reinforce your concept and the overall feel of the space! Use the same colors in the exterior that you used in your interior to create a harmonious drawing. For example, if you have a purple wall, the tree across the street visible through the window could have purple flowers (Figure 16.3.1).

FIGURE 16.3.1

It is important to have a few exterior scenes that you can use in your drawings. Find an example of a cityscape and a rural landscape that you like online. Print these out and practice rendering them. The exterior scene is not the focal point of your elevation, or any interior perspective drawing, so keep it subtle. When using Adobe Photoshop, this is easy to do by putting the exterior on a separate layer and lightening the opacity, as in Figure 16.3.2; this also has the added benefit of appearing as though you are seeing it through glass. In hand renderings, render exteriors on the back of the paper, or use lighter colors and your colorless blender to create a soft exterior.

In Figure 16.3.2, you can see that the student used a soft, dabbing technique for the exterior, but used sharper lines and bolder colors for the interior. This is a very effective way to separate the interior and exterior, while keeping the focus on the interior.

FIGURE 16.3.2

GLASS EFFECT

To represent the glass of the window, you can use a very-light-blue marker on the front of your drawing (remember to use the back of the paper for the exterior scene; you will not mess it up by applying light blue on the front). Apply the marker in diagonal strokes. Remember that the magic number for reflections is three! Leave three stripes of paper with no marker to act as reflections in the glass. Make these stripes different thicknesses with different intervals in between them. You want it to appear organic and uneven, not at all like a striped pattern. Another technique is to add the highlights in later with a white pencil.

The most important part of the glass effect is the shadow on the glass. This is the difference between your exterior scene looking like a painting on the wall or a window looking outside. A piece of glass is not nearly as thick as a wall, especially an exterior wall. Therefore, the glass is always recessed inside the wall. If the wall is a window wall, there is a frame holding it in place, which is also thicker than the glass, and therefore will also cast a shadow onto the glass. Use a medium dark gray or medium dark blue (don't use a bright or saturated blue—this is a cast shadow, and it must be a dull color) to draw an L-shaped shadow.

CITYSCAPE

On the back of your paper, draw a series of grayish boxes. Add windows and shading to the boxes to create buildings (Figure 16.3.3). Use an image reference for realism, but don't spend too much time rendering these buildings, as they are meant to be in the background. If you have a specific view that is a focal point of the design, you can print out the view and trace it.

For the sky, add a gradient rather than a solid color (Figure 16.3.4). Usually the sky is lighter at the horizon and darker (or more blue) above. This is especially true at night, because of the glow from the buildings' lights.

FIGURE 16.3.3

FIGURE 16.3.4

Next, flip over the drawing and add the frame and the blue glass. I used Copic marker B95 Light bluish cobalt, for the glass. Apply the marker in diagonal strokes. Leave three stripes of paper with no marker to act as reflections in the glass. Make these stripes different thicknesses with different intervals in between them (Figure 16.3.5).

FIGURE 16.3.5

Add the shadow onto the glass with a medium dark-gray or medium dark-blue marker—I used Copic marker B99 Agate—and you're done (Figure 16.3.6).

FIGURE 16.3.6

WINDOW TREATMENTS

Fabric is very easy to render; it is simply cylinders and cones (Figure 16.3.7). In Lesson 11, we practiced rendering both in a variety of colors using analogous colors to shade with for visual interest.

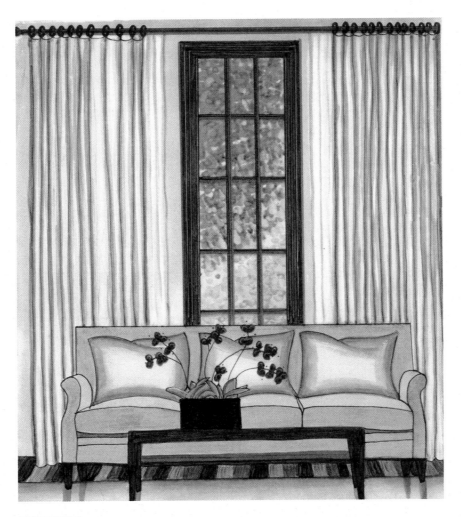

FIGURE 16.3.7

REQUIRED READING

Lesson 16 Section 4
Elevations by Hand

ELEVATIONS BY HAND—FIGURE 16.4.1

Indicating materials and colors by hand in elevation view is very similar to rendering by hand in perspective view. In this section we will cover some common materials that are seen in elevations. (These techniques are demonstrated in Section 4, Video 1 in MyKit.)

WOOD CABINETS

Use three colors—light, medium, and dark—and apply in the direction of the wood planks (Figure 16.4.1). Optional: Add the wood plank lines with a thin black pen or a dark-brown pencil. Remember to add a shadow every time there is a recess to indicate three dimensions.

FIGURE 16.4.1

PATTERNED FABRIC

Indicate the pattern, but don't get too caught up in the details! If you have something very important and intricate to render, such as the company's logo, print it out in the correct scale and trace it (or consider rendering the floor plan in Photoshop).

STAINLESS STEEL AND OTHER REFLECTIVE SURFACES

In Lesson 13 we discussed that reflective materials separate into light and dark tones. Use dark and light grays in diagonal strokes. Leave a few stripes of the white of the paper to represent strong highlights. You can add some in later as well with a white pencil or a white-out pen.

TILE AND NATURAL STONE

Dab colors randomly to represent natural stone. You can add "L" shapes to one corner of each tile (in the same location on each tile) to create a 3-D effect. Always draw the grid at the end with a thin black pen or a white or black pencil.

REQUIRED READING

Lesson 16 Section 5
Photoshop

(These techniques are demonstrated in the Section 5 Video Lessons in MyKit.)

I am going to assume that you have some very basic knowledge of Photoshop, but don't know how to use the tools for rendering elevations. To render an elevation in Photoshop, you can scan it in and open it in Photoshop. Or, you can open an AutoCAD file in Photoshop by following these directions: In AutoCAD, go to Layout in Paper space and zoom extents. Open file/plot/ and click on the arrow in the bottom-right corner of the dialog box. Change the plot style table to Grayscale. Click apply to layout. Change printer/plotter to pdf. Save as pdf on desktop. Open Photoshop. Click File/open and open the pdf file on your desktop. Save as psd, jpg, or whatever type of file you prefer to work with.

Visually, rendering an elevation in Photoshop is the same as doing it by hand. We are just using a different type of media to obtain a similar result. Make sure you name your layers as you go; it takes very little effort but will save you so much time in the end!

HOW TO CREATE A WHITE BACKGROUND BEHIND YOUR DRAWING

If you print a cad file to a pdf and open it in Photoshop, often you will see a checkerboard background behind your elevation. Unlock the background layer by double-clicking on the layer name, then rename it "drawing." Create a new layer—it will ask for a name; name this one "white." Drag the "white" layer below the "drawing" layer so that "drawing" is above "white." Turn off the "drawing" layer, select the "white" layer, and fill with the white paint bucket.

The most exciting thing about rendering an elevation with Photoshop is that you can scan in real materials, or find images of them online, for an extremely realistic result. The best way to do that is to select an object or area and fill it with a pattern. The pattern is your jpg image of your exact material.

TO DEFINE AN IMAGE AS A PATTERN

Import or scan your image, such as a wood sample, stone tile, or piece of fabric. Save it as a jpg (e.g., bamboo.jpg). Choose Edit⇒Define pattern to open up the Pattern Name dialog box. Name the pattern (e.g., bamboo). Click OK. The pattern is added to the current pattern library.

TO APPLY A PATTERN TO AN OBJECT/AREA

Choose the object/area with the magic wand tool, or a similar selection tool. With your object/area still selected on the plan, create a new layer and name it. Choose the paint bucket tool. Choose Pattern from the Fill dropdown menu. Click the arrow next to the pattern swatch to open the pattern picker dropdown. Double-click a pattern to make it active. Click inside the object or area to be filled with your paint bucket.

Warning: Sometimes fill (paint bucket) spills out of what looked like an enclosed area and floods a larger space. If this happens, you can undo this, or any, command with Edit-Undo. The reason the fill escapes the enclosure is usually as simple as a missing pixel in the boundary. The fix is easy: Zoom in to find the break in the boundary and repair it with pixels using the line or pencil tool. Be careful to repair a broken boundary on the same layer as the boundary line work.

TO SCALE A PATTERN

Double-click next to the layer name, which will bring up the FX dialog box. On the left side, click on Pattern Overlay, and change your pattern back to the one you want; directly underneath is a slider for adjusting the scale.

WOOD CABINETS, PANELS, AND OTHER ELEMENTS

Sometimes the piece that you have defined for your pattern will repeat over and over, creating a tiled effect. The best way to avoid this is to create wood without using a pattern. Instead, fill your area that you want to read as wood with a gradient of two brown colors, a light one and a dark one. Use the fibers filter (under Filter-Render) and adjust the sliders to your liking.

TO APPLY A COLOR TO A PATTERN

Using color overlays over grayscale patterns already included in Photoshop greatly increases your pattern library. Double-click next to the layer name containing the object or area that you filled with a pattern to open the FX dialog box, and then click color overlay on the left. If you just check it, the controls don't change—you must click on the name "color overlay" to highlight it, and then the controls will change. You must also change the blend mode (at the top of the dialog box) to "overlay" so that the pattern will show through the color that you are applying. Click the color swatch to open the color picker. Choose a color, and tone down the saturation with the opacity slider.

WINDOWS

Choose the area of the elevation that will be open to the outside with a selection tool. Delete it. Find an exterior scene that you like from an image search or your own photo. Open the exterior scene in Photoshop, and drag and drop it into your drawing. It will come in as its own layer. Click on the layer name and drag it beneath the drawing layer so that the only part visible is through the window area that you just deleted. Use Transform-scale to scale to the correct size (hold down the shift key to constrain proportions). You can make the drawing layer translucent to help you adjust the scale of the exterior scene correctly. Add glass on top.

GLASS

Create a separate layer for your glass so that you can control the opacity (usually 50%), so the background under the glass is still visible (for example, an exterior scene outside of a window). Fill the area with a subtle gradient of light blue to even lighter blue. Change the foreground color to white and add three stripes of varying widths with the airbrush tool to look like highlights.

STAINLESS STEEL AND OTHER REFLECTIVE SURFACES

In Lesson 13 we discussed that reflective materials separate into light and dark tones. Use a light- to dark-gray gradient for the background. Add a few stripes of the white at a 45-degree angle with the brush tool to represent highlights. The stripes should have varying levels of opacity.

DROP SHADOWS

Drop shadows add the illusion of depth to an otherwise two-dimensional elevation. The principles of shadows covered earlier in this lesson still apply: a cast shadow is DARKER and SHARPER close to the object, but dissipates (becomes lighter and fuzzier) as it moves away from the object.

 In the FX dialog box, click Drop Shadow in the left panel to display new controls on the right side. Change the angle to 45°. To add depth to the shadow, move the spread and distance sliders. You can also control the darkness of the shadow with the opacity slider.

SHADOWS

To create shadows without the automatic drop shadow tool, select an area for the shadow. Use a 45-degree angle from the object's corners, just like in the beginning of this lesson. I like to use the lasso tool with the alt/option key to make straight lines (see the video for a demonstration). Then go to View-Show-Selection edges to turn off the selection edges ("marching ants") temporarily. Go to Image-Adjustments-Brightness/Contrast and use the sliders to create a shadow that you are happy with (usually 50% brightness); remember the number that you choose so that you can keep all of your shadows consistent.

PEOPLE

It is extremely important to put people in your elevations for the same reasons that it is important to put people in your perspective drawings, as discussed next.

Lesson 16 Section 6
People

People are an important part of your elevations and perspective drawings. It may seem like they are merely a detail, and they are often referred to as "entourage," in the same category as trees and cars; however, people are much more than simply entourage.

It is human nature to seek out, and look at, the people in any drawing or work of art. It is as natural and inexplicable as our eyes being drawn to the center of a page, or our eyes being drawn to contrast in a piece of art. People will always look at people, so CHOOSE YOUR PEOPLE CAREFULLY.

You will need to create a drawing file of people. There are many websites with royalty-free images of people that you can use. Create a folder on your computer of images of people.

What to look for:

- Full-length people—head to toe. About 95% of the time you will use full-length people in elevation, meaning not looking down or up at them (you shouldn't see the tops of their heads).

- Men, women, children, and groups of two and three people in various situations. Remember that, visually, three is a magic number. A group of three (or another odd number) people usually looks better than a group of four.

RENDERING PEOPLE BY HAND

One option is to fill in the shape of the person with solid gray or black for a silhouette effect. If you choose to do something more realistic, always keep in mind that you want the architecture and design to be the focal point of your drawing—this is not a portrait! To keep people visually in the background, we will do the opposite of what we would do to make something the focal point:

- Low contrast: When rendering people, including skin, clothes, shoes, and so forth, they should be neither the darkest nor lightest things on the page; stick to medium values (values 2–5 on the value scale from Lesson 10).

- Muted colors: Nothing too bright! The eye immediately goes to saturated colors.

Adding people at the correct scale is easy by hand, because your elevation is already in scale, so use your architect's scale to check the height of your person to an appropriate scale—around 6' for a man and 5'6" for a woman.

ADDING PEOPLE IN PHOTOSHOP

(These techniques are demonstrated in Section 6, Video 1 in MyKit.)

Find a person image and open it in Photoshop, then drag and drop it into your drawing. It will come in as its own layer. Use Transform-scale to scale to the correct size (hold down the shift key to constrain proportions). Adjust the translucency of your people layer to keep the people from being the focal point. Alternately, you could select the person and fill with white, gray, or black for a silhouette effect.

REQUIRED ASSIGNMENT

Lesson 16 Section 7
Homework

HOMEWORK ASSIGNMENT

Render an elevation either by hand or in Photoshop. You can use one of the floor plan elevation in the Appendix provided earlier, or create your own.

REQUIRED READING

Lesson 16 Section 8
Homework Examples

STUDENT WORK—FIGURES 16.8.1–16.8.2

FIGURE 16.8.1

FIGURE 16.8.2

Figure 16.8.3 shows an elevation rendered by hand with marker and pen. The student then scanned in the drawing and altered it in Photoshop® using the techniques from this chapter for the final result, Figure 16.8.4.

FIGURE 16.8.3

FIGURE 16.8.4

LESSON **17**

Digital Tools

Lesson Overview

Lesson 17 is written in five sections:

- Lesson 17, Section 1: Google SketchUp® introduction and example.

- Lesson 17, Section 2: Google SketchUp basics.

- Lesson 17, Section 3: Adobe Photoshop® enhancements.

- Lesson 17, Section 4: Homework exercise.

- Lesson 17, Section 5: Student work.

NOTE
Most design students are visual learners. MyKit instruction for this lesson includes:

- Section 3, Video 1 demonstrates Adobe Photoshop techniques.
 - 17.2.1: Sketch-up
 - 17.3.1: Photoshop set—up
 - 17.3.2: Photoshop reflections

Lesson 17 Section 1
SketchUp

GOOGLE SKETCHUP—FIGURES 17.1.1–17.1.2

Google SketchUp is a great tool for laying out perspective drawings. It is especially useful if you have a complex space that you are having trouble visualizing. What you print out from Google SketchUp is not something that you would show a client—instead, trace over it and add color, value, and your own personal style, just as you would with any other drawing.

Figure 17.1.1 shows a student drawing created in Google SketchUp. This drawing looks stiff and computer generated. Figure 17.1.2 shows an overlay that the student completed with markers. The result is much more realistic and appealing than the first version.

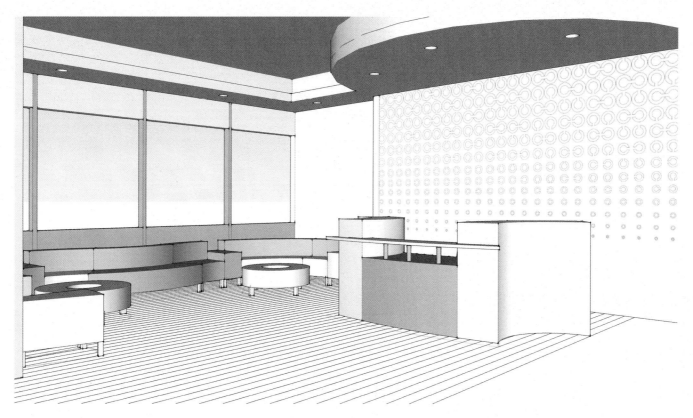

FIGURE 17.1.1

Perhaps the most exciting thing about Goggle SketchUp is that it's free! This is unusual; 3D modeling software is generally very expensive. There are actually two versions of Google SketchUp; one is free, and the other, Google SketchUp Pro, is $500. The Pro version has great layout tools for creating presentations, but you don't need the Pro version to create 3D layouts to trace over. Download the most recent version of Google SketchUp at sketchup.google.com. You can also download a trial version of Google SketchUp Pro for free once you have become proficient in Google SketchUp (the trial version will work for 8 hours after download).

The Google SketchUp website has fantastic training. I highly recommend that you utilize the self-paced tutorials! On the left side of the Google SketchUp Web page (sketchup .google.com), click on "Training" and then "Self-Paced Tutorials." I recommend that you begin with "Start a Drawing Part 1." There are also training videos on the website that do not have the interactive component of the tutorials.

Following is some information to get you started with Google SketchUp. It is a very easy, intuitive program that you can learn quickly.

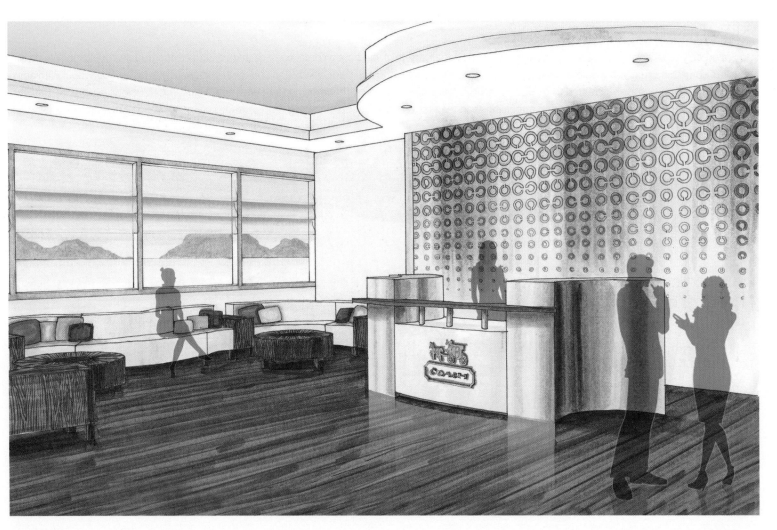

FIGURE 17.1.2

REQUIRED READING

Lesson 17 Section 2
Beginning with Google SketchUp

A Google SketchUp dialog box will open when you launch the program. Click on "Choose a Template," then select "Architectural Design–Feet and Inches," and then select "Start using SketchUp."

Two important elements of the Google SketchUp workspace are the value control box (VCB) and status bar:

1. The VCB is in the lower-right corner of your screen; here you can see and type in lengths. The default unit is inches, just like in AutoCAD® (example: if you type in "4" and hit enter, Google SketchUp will assume you mean 4 inches, not 4 feet).

2. Check the status bar often. It is in the lower-left corner, and tells you what to do next.

Two important concepts of Google SketchUp are as follows:

1. Everything is either an EDGE or a SURFACE, and surfaces must have bounding edges.

2. Geometry is sticky. If two 3D objects are touching each other, they will stick to each other. You can avoid this by creating components (similar to blocks in AutoCAD). Components are not sticky.

These concepts will make sense when you begin playing with some of the tools. Begin with the following five tools. Practice drawing, erasing, moving, and pulling shapes into 3D.

Line

Push/Pull

Erase

Move/Copy

Orbit (this tool allows you to view your design from different angles)

One of the best things about Google SketchUp is that it helps you draw geometric shapes (although you are not confined to only geometric shapes). As you draw with the Line tool, the line you are drawing will snap parallel to an axis as you approach an axis. Additionally, your line turns from black to red when you are drawing equal to the x axis, black to green when you are equal to the y axis, and black to blue when you are equal to the z axis.

You can lock to the red axis with the right-pointing arrow on your keyboard.

You can lock to the green axis with the left-pointing arrow on your keyboard.

You can lock to the blue axis with the up- or down-pointing arrows on your keyboard.

Using inferencing also helps you draw. To use inferencing, hover your mouse over a point to inference, and you will see a color appear:

Green = endpoint

Cyan = midpoint

Blue = on face

Red = on edge

Black = intersect

Some of the Google SketchUp features are described next.

 SELECT

Single-click on a line to select it (hold down shift to add/subtract from a selection, or control to add).

Double-click to select the bounding edges and face.

Triple-click to select an entire object.

Drag a window right or left to select, just as in AutoCAD.

SHORTCUTS

Spacebar for select.

M for Move.

P for Push/Pull.

R for Rectangle.

Press mouse wheel for orbit.

Roll middle button on mouse to zoom.

Press mouse wheel and shift key to pan.

RECTANGLE

Will infer a square and a golden section.

To type in coordinates: x, y in the VCB.

ARCS

There are no curves in Google SketchUp; there are only small straight-line segments. Twelve segments is the default; to change this, type #s (example: 4s = 4 segments).
Click the first and second points for length. The third point is the bulge/radius of the arc.

MOVE/COPY/ARRAY

Press "M," then hold "Ctrl" to change to copy.

For array, press "M," then tap "Ctrl" to place, then type #x (5x for 5 copies) or #/ for an internal array.

ROTATE

Place the protractor on a point to choose a base point (Q); pressing shift will lock it to the axis.

COMPONENTS

To avoid sticky geometry, make groups and components. Select and press "G."

Right-click on an entity to see and modify its information.

IMPORTING A FLOOR PLAN FROM AUTOCAD

With this method you can import a floor plan from AutoCAD and draw shapes on top of it in Goggle SketchUp, using your floor plan as a template.

1. Create a new file in Google SketchUp and draw a line that you will erase later (this makes the floor plan come in as a component, which saves you a few steps).

2. Open the "File" menu, and then click "Import."

3. In the Open dialog box, select the AutoCAD file (make sure to change the file type to "all supported file types" or "all files").

4. Check the scale by measuring something that you know the size of. If the scale is wrong you can type in the correct size, and it will resize the entire floor plan.

5. Open the layers, select them all except layer 0, and press the – symbol.

6. In the dialog box, choose "move selected layers to default layer."

7. Make a new layer titled "floor plan."

8. Right-click on the floor plan layer, and under "entity info" change the layer to floor plan.

9. Now your floor plan is all on one layer, and you can turn the visibility on/off in the layers box.

GOOGLE EARTH®

Once you build your 3D model, you can put it in Google Earth. Google Earth combines satellite imagery, maps, terrain, 3D buildings, and other geographic information to create a 3D map of the world. You can download Google Earth for free at earth.google.com.

Google Earth is a very powerful tool for exploring a current building or a real-life site. Use Building Maker to do a quick massing model—this is very easy, and it will take only 5 minutes to learn. There is a video available at http://sketchup.google.com/3dwh/buildingmaker.html.

With Building Maker you can also do a realistic solar study of your site.

 ## GOOGLE 3D WAREHOUSE®

The Google 3D Warehouse is an online repository of 3D models (everything from buildings to people). Anyone can search for and download models, but to publish your own, you'll need to sign in using your Google account (this is free as well).

Publishing your models to the Google 3D Warehouse is a great way to showcase your work. If you model 3D buildings and would like to share them with the world, you can do so in Google Earth. Only the very best models are selected for inclusion in this layer—not just anyone can post.

Lesson 17 Section 3
Adobe Photoshop Enhancements

ADOBE PHOTOSHOP ENHANCEMENTS—FIGURES 17.3.1–17.3.3

When you have completed your drawing, you may want to scan it into Adobe Photoshop for enhancement. (See the Section 3 Video Lesson.) Adobe Photoshop has many fantastic tools, some of which we discussed in Lessons 15 and 16.

SHADOWS

One method is to use the burn tool to paint over an area and make it darker. You can do this freehand, or select an area for the shadow. For selecting a shadow area, I like to use the lasso tool with the alt/option key to make straight lines (see the Section 3 Video Lesson for a demonstration). Then go to View-Show-Selection Edges to turn off the selection edges (the "marching ants") temporarily. Either paint over the area with the burn tool, or go to Image-Adjustments-Brightness/Contrast and use the sliders to create a shadow that you are happy with (usually 50% brightness); remember the number that you choose so that you can keep all of your shadows consistent.

LIGHTS

Begin by using the lasso tool to select an area to represent a beam of light. Create a new layer, and fill the area with a gradient of light yellow to transparent. Change the layer opacity to 25%. You can copy the light beam and drag it to the other two lights.

OUTER GLOW

For light fixtures, select your light fixture, choose Edit-Copy, create and name a new layer, and Edit-Paste on the new layer. Double-click next to the layer name to bring up the FX dialog box. Click on "outer glow" and adjust the sliders. See Figure 17.3.1 for an example of this method.

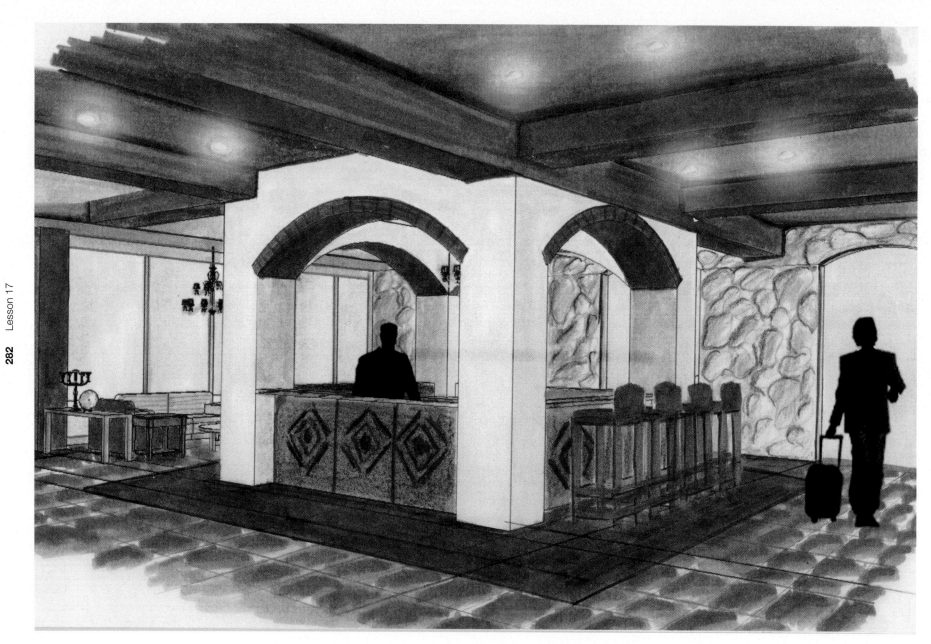

FIGURE 17.3.1

INNER GLOW

For illuminated or backlit objects, such as architectural resin with a light behind it, select your object to be illuminated, choose Edit-Copy, create and name a new layer, and Edit-Paste on the new layer. Double-click next to the layer name to bring up the FX dialog box. Click on "inner glow" and adjust the sliders. You can even change the color of the glow by double-clicking on the color swatch (great for neon and LEDs).

LENS FLARE

This is a filter that adds sparkle to reflective surfaces. Always apply it to its own layer, so that you can control the location and opacity of the lens flare. Create a new layer and fill it with black. Then select Filter-Render-Lens Flare. Locate it approximately where you want it (you can move it later), and keep the brightness around 100% (this can also be adjusted later), then click OK. In the layer dialog box, with the lens flare layer highlighted, change the mode from normal to screen. You can adjust the opacity of the layer to lighten the lens flare effect.

REFLECTIONS

Reflections are extremely important to your drawing. Realistic reflections are easy to create in Adobe Photoshop. For reflections on a floor, select an object that touches the floor and then choose Edit-Copy. Create and name a new layer, and Edit-Paste on the new layer. Then choose Edit-Transform-Flip Vertical. Line up a corner of the reflection to the object, and use Edit-Transform-Skew to pull the reflection into the correct perspective. Remember that lines on the reflection will recede to the SAME VANISHING POINT as that of the object being reflected. Reduce the opacity of the reflection layer. See Figure 17.3.2 for an example of this method.

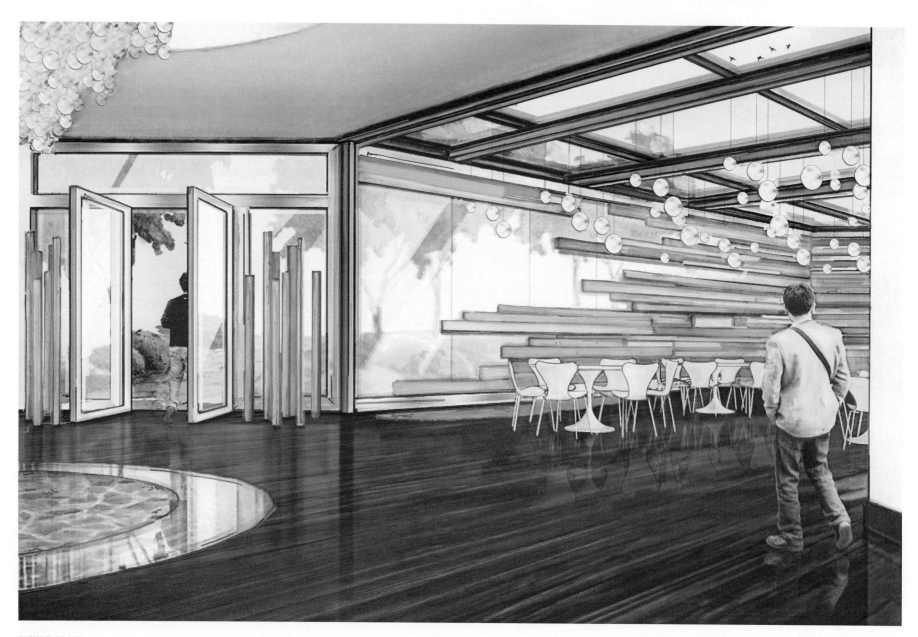

FIGURE 17.3.2

PEOPLE

Find a person/people image and open it in Adobe Photoshop, then drag and drop it into your drawing. It will come in as its own layer. Use Transform-Scale to scale it to the correct size (hold down the shift key to constrain the proportions). Adjust the translucency of your people layer to keep the people from being the focal point. Alternately, you could select the person image and fill with white, gray, or black for a silhouette effect. See Figure 17.3.3 for an example of this method.

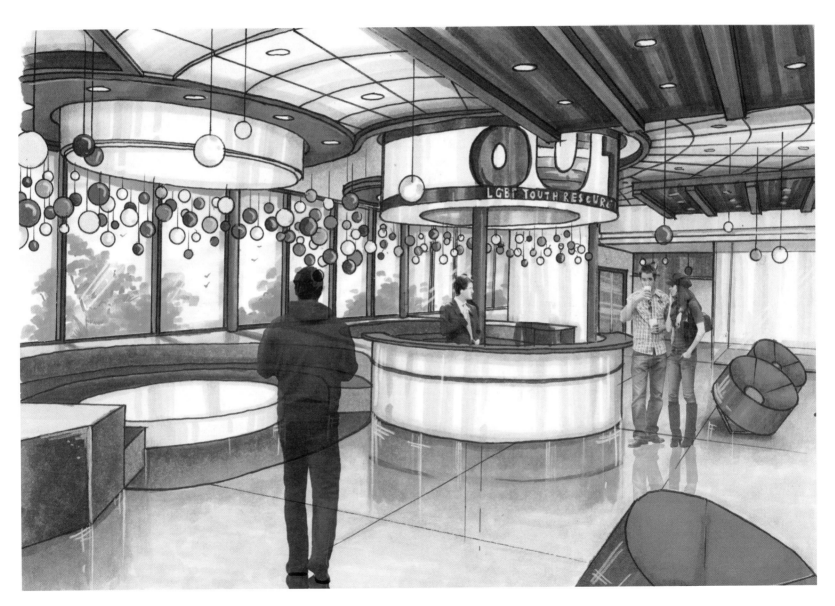

FIGURE 17.3.3

WINDOWS/LANDSCAPE

Choose the area of the drawing that will be open to the outside with a selection tool. Delete it. Find an exterior scene that you like from an image search or your own photo. Open the exterior scene in Adobe Photoshop, then drag and drop it into your drawing. It will come in as its own layer. Click on the layer name and drag it beneath the drawing layer so that the only part visible is through the window area that you just deleted. Use Transform-Scale to scale it to the correct size (hold down the shift key to constrain the proportions). You can make the drawing layer translucent to help you adjust the scale of the exterior scene correctly. Add glass on top.

GLASS

Create a separate layer for your glass so that you can control the opacity (usually 50%), so the background under the glass is still visible (for example, an exterior scene outside of a window). Fill the area with a subtle gradient of light blue to even lighter blue. Change the foreground color to white and add three stripes of varying widths with the airbrush tool to look like highlights.

REQUIRED ASSIGNMENT

Lesson 17 Section 4
Homework

HOMEWORK ASSIGNMENT

1. Create a design in Google SketchUp. Overlay it with tracing paper or print it onto vellum and render in marker; or

2. Scan a hand drawing and enhance it in Adobe Photoshop.

Lesson 17 Section 5
Homework Examples

STUDENT WORK—FIGURE 17.5.1

FIGURE 17.5.1

Trace Files

Trace File 1

Trace File 2

Trace File 3

Trace File 4

Trace File 5

Trace File 6

Trace File 7

Trace File 8

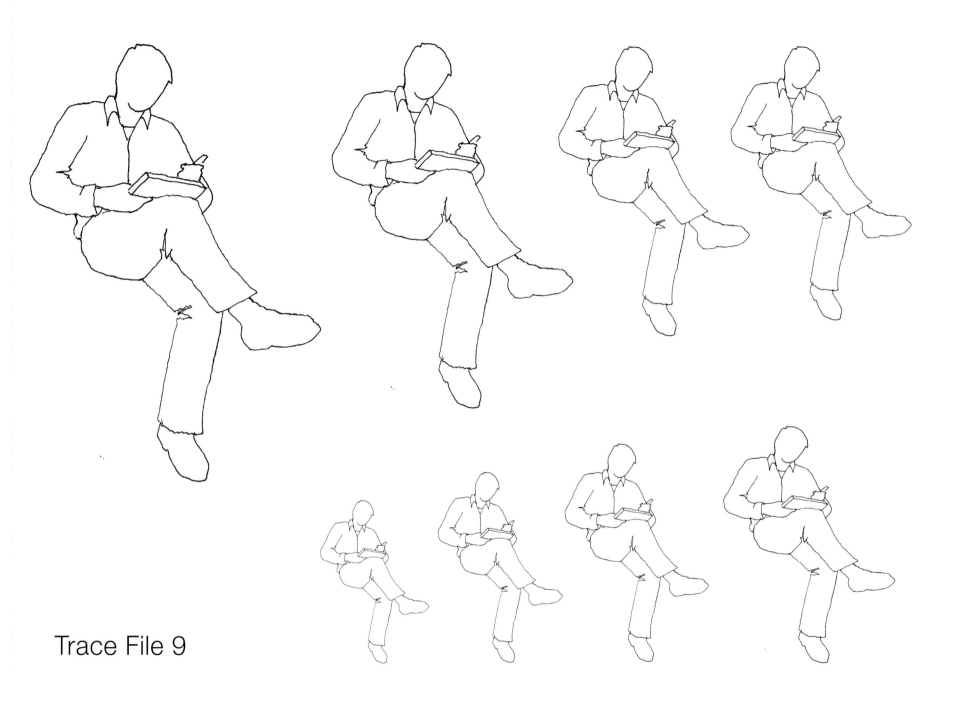

Trace File 9

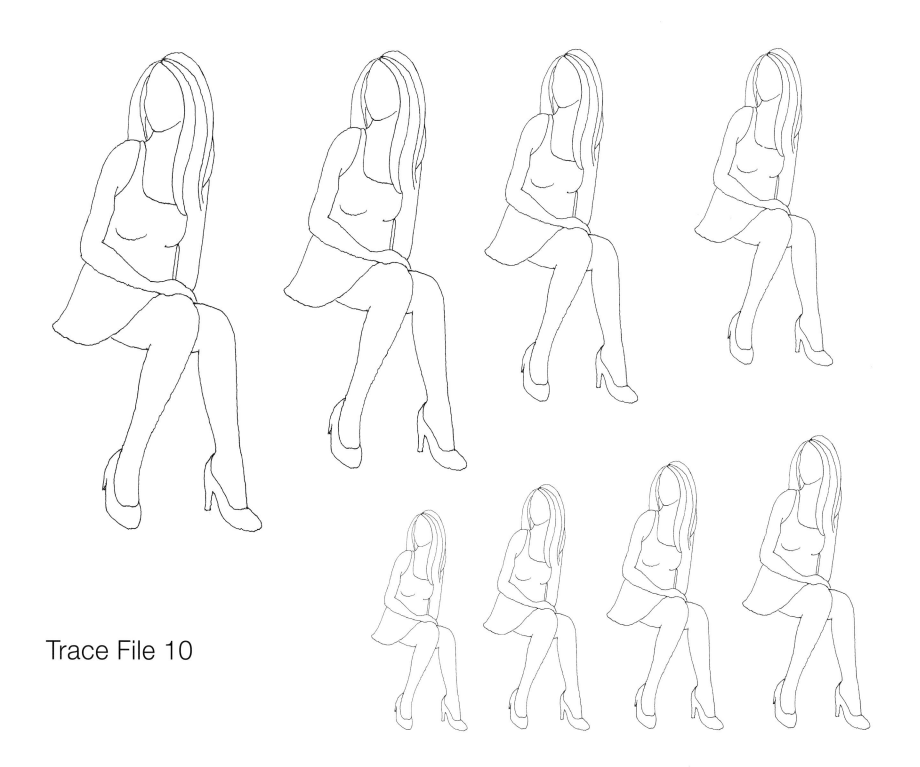

Trace File 10

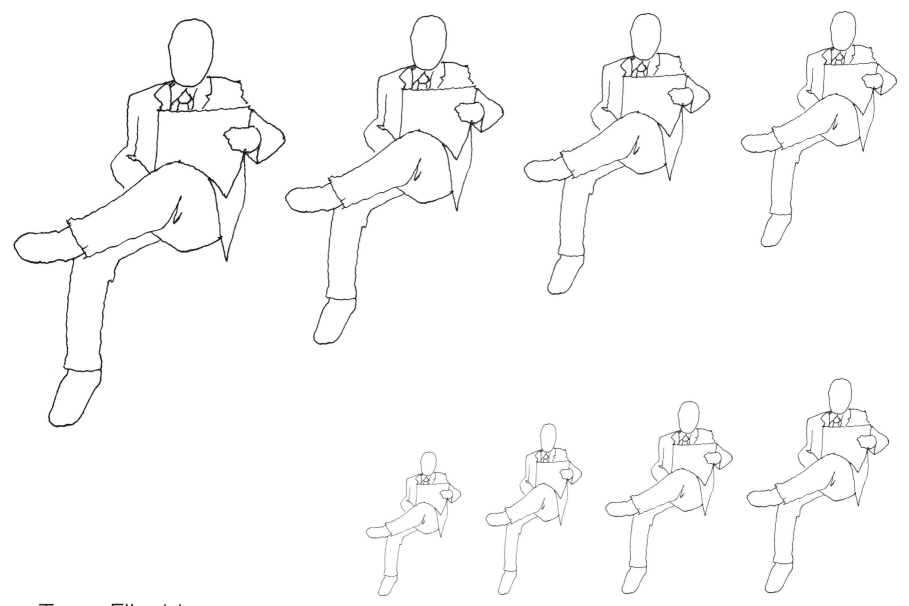

Trace File 11

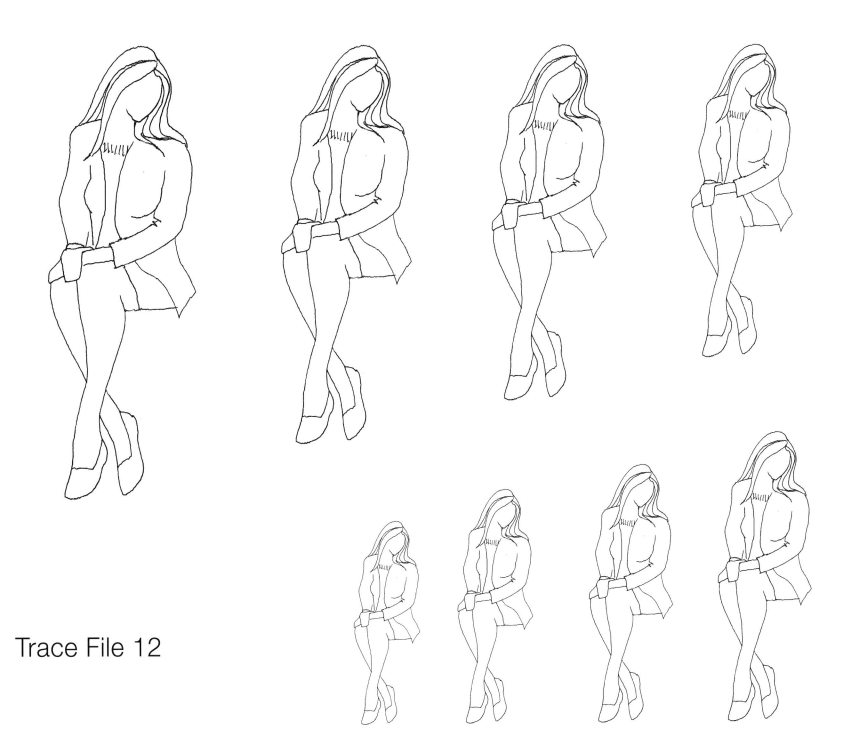

Trace File 12

Trace File 13

Trace File 14

Trace File 15

Trace File 16

Trace File 17

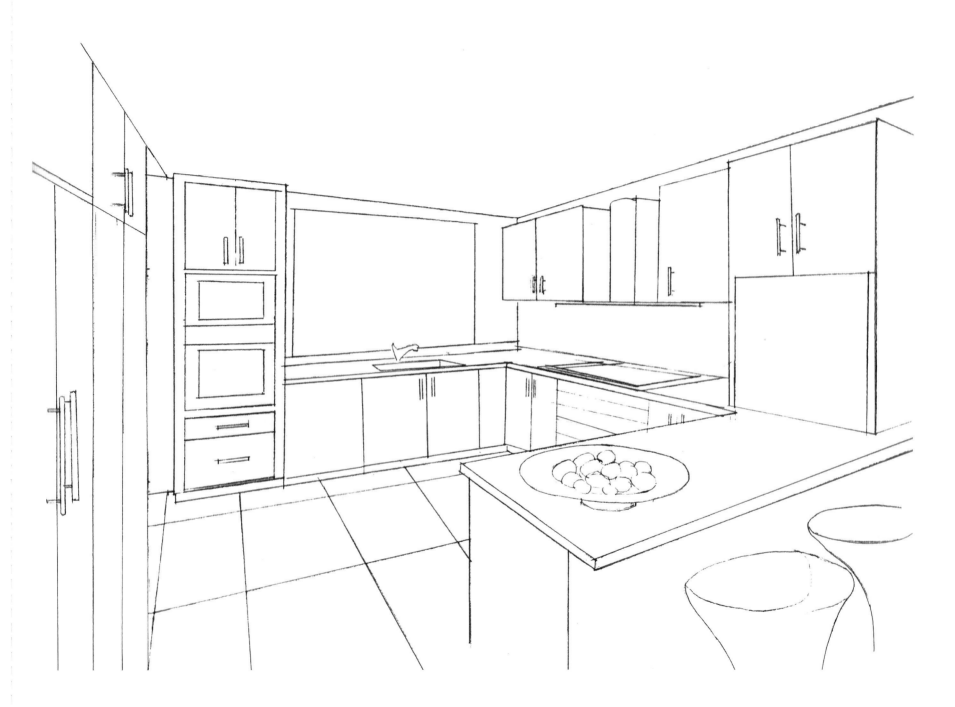

Trace File 18

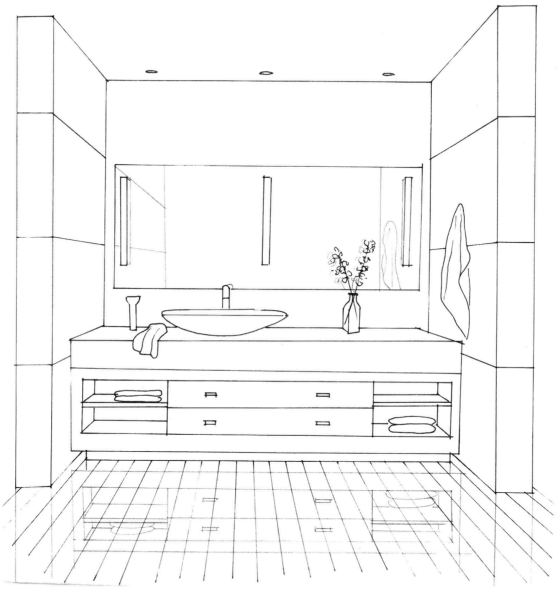

Trace File 19

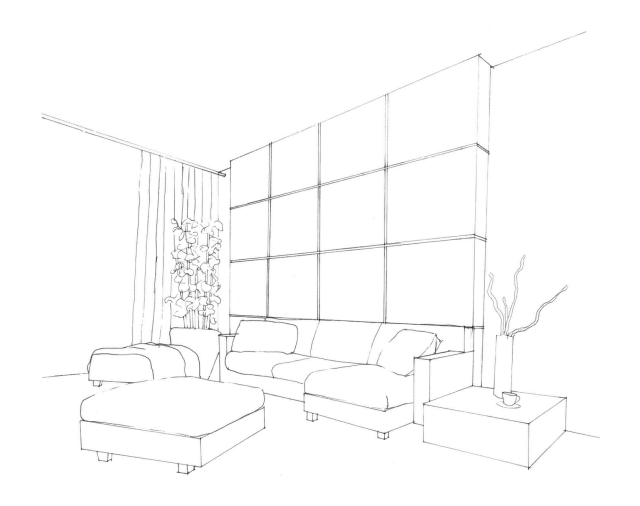

Trace File 20

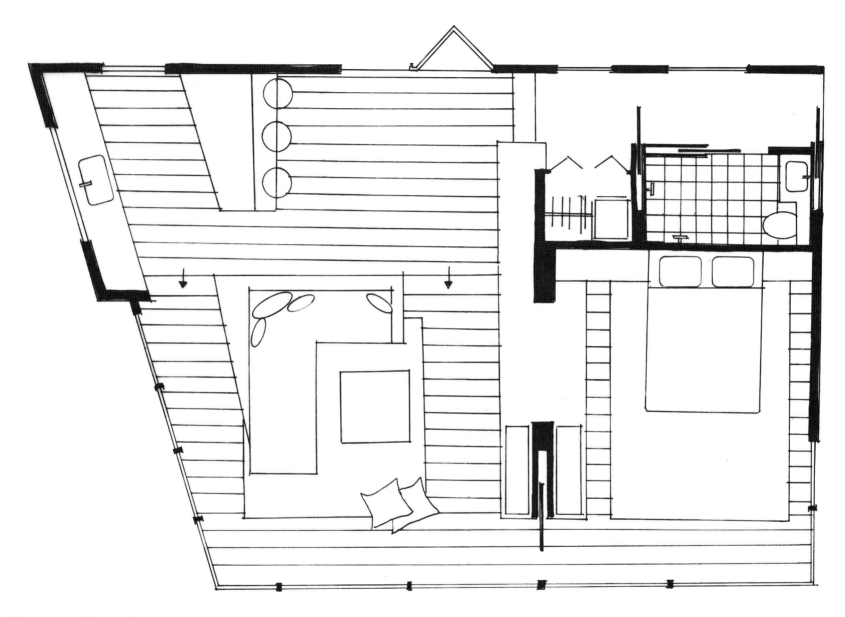

Trace File 21

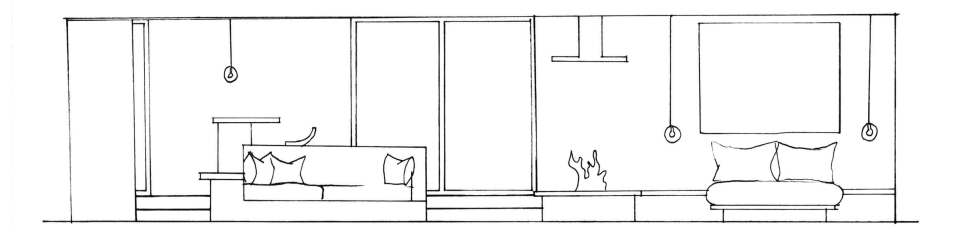

Trace File 22

INDEX